Byzantine Art

JANNIC DURAND

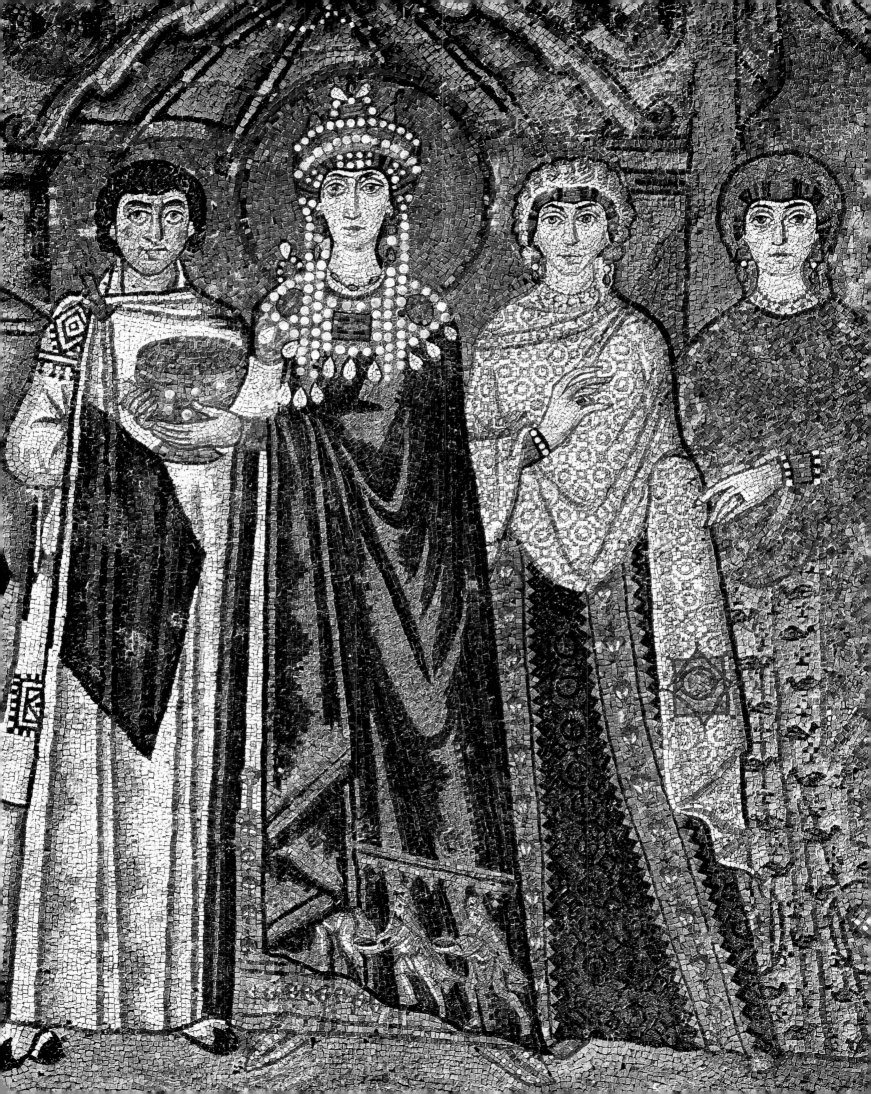

Byzantine Art

JANNIC DURAND

·TERRAIL·

| Cover illustration
**CHRIST BETWEEN CONSTANTINE IX
MONOMACHOS AND EMPRESS ZOE**
| Detail. Mid-11th century,
mosaic.
Istanbul, Hagia Sophia, south gallery.

| Page 2
THEODORA AND HER COURT
| Detail. After 540, mosaic.
Ravenna, San Vitale,
south presbyterium wall.

English Translation: Murray Wyllie

Editor: Jean-Claude Dubost
Editorial Assistants: Geneviève Meunier, Hélène Roquejoffre and Christine Mormina
Editorial Aides: Robert Bared, Ann Sautier-Greening
Graphic Design: Véronique Rossi
Cover Design: Laurent Gudin
Maps: Christine Mormina, Véronique Rossi
Iconography: Caterina D'Agostino
Typesetting and Filmsetting: DV Arts Graphiques, Chartres
Photoengraving: Litho Service T. Zamboni, Verona

Published with the assistance of the French Ministry responsible for Culture
Centre National du Livre (The National Book Centre)

© FINEST SA/ÉDITIONS PIERRE TERRAIL, PARIS 1999
The Art Book Subsidiary of BAYARD PRESSE SA
English edition: © 1999
Publisher's N°: 272
ISBN 2-87939-222-5
Printed in Italy

THE VEROLI CASKET
Detail. 10th century, Constantinople,
ivory, 40 × 16 × 11 cm
(15 3/4 × 6 1/4 × 4 3/8 in.).
London, Victoria and Albert Museum. |

Page 6 |
DEESIS CHRIST
Latter half of the 13th century,
Constantinople,
mosaic.
Istanbul, Hagia Sophia, south gallery. |

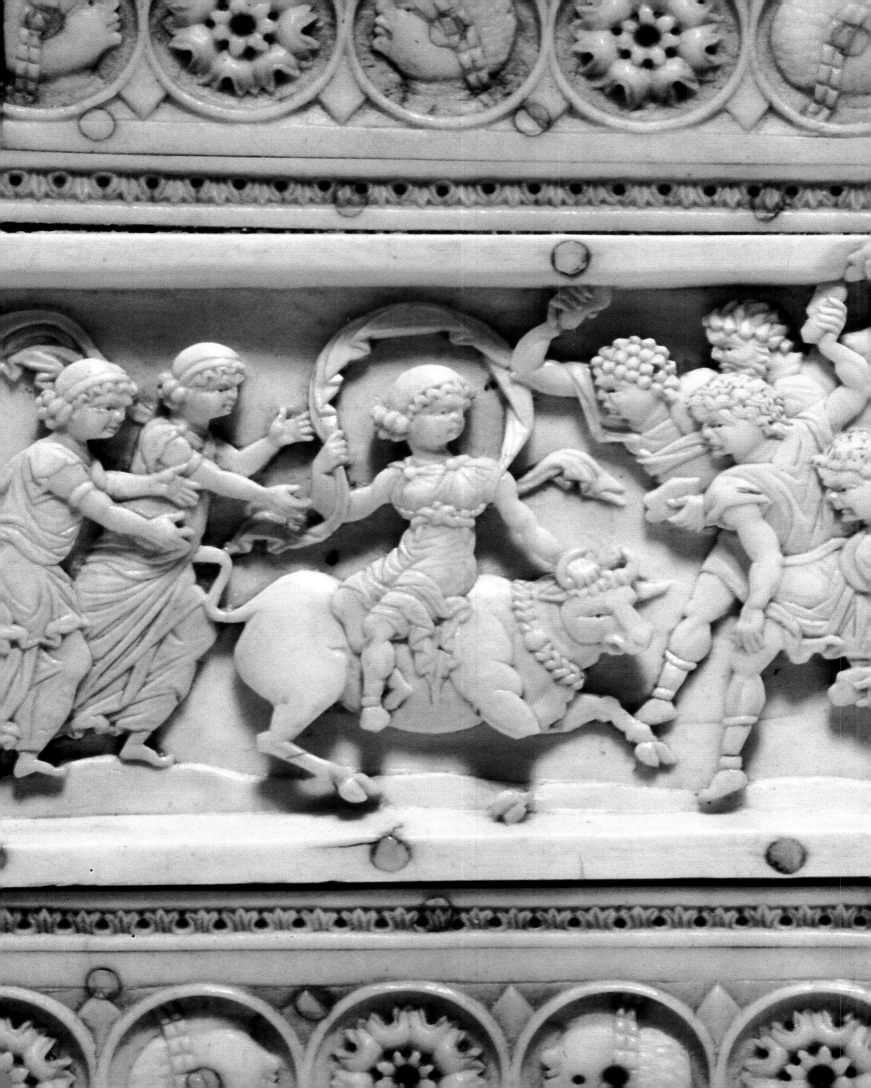

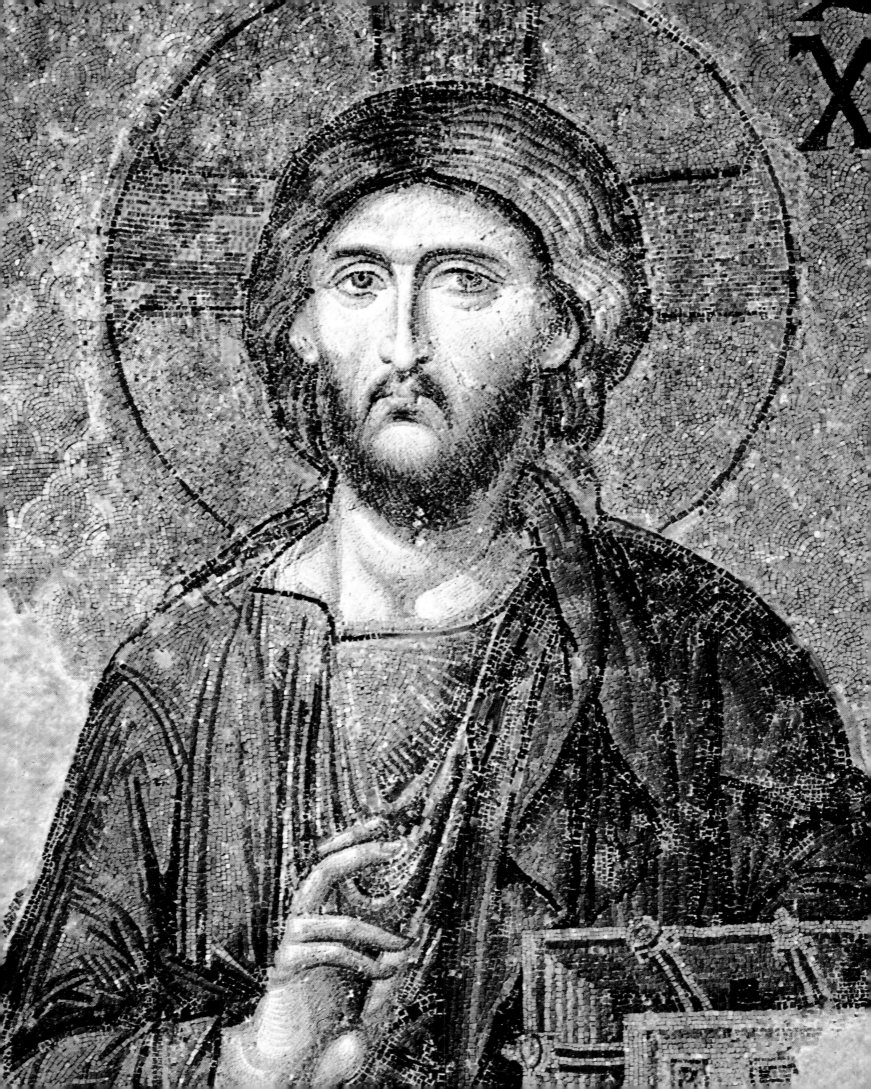

Contents

INTRODUCTION

The history of the Byzantine Empire begins with the founding of Constantinople. In 324, Constantine the Great chose the ancient Greek town of Byzantium to become the capital of his Eastern Roman Empire. From its ideal site on the shores of the Bosphorus, where Europe and Asia meet, it commanded the entire Greek-speaking and Hellenized eastern Mediterranean basin. Over a thousand years later, on 29 May 1453, the fall of Constantinople to the Ottoman Turks marked the final act in the saga of a moribund Empire, by then virtually shrunk to the capital city alone, imprisoned behind its mighty ramparts.

Shortly before founding his "New Rome", Constantine had imposed official recognition of Christianity, a religion which previous Emperors had constantly fought against in vain. By the late 4th century, the new religion had made such rapid strides that practically the entire Roman Empire was Christianized. Henceforth the Emperor derived his power from God. Byzantium was thus simultaneously heir to Greece, Imperial Rome, the East, and Christianity.

Treated with disdain by 17th and 18th-century writers, the entire history of the Christian Empire of the East was long regarded as a lingering "decadence" of the Roman Empire and judged harshly. One needs only think of Gibbon and his celebrated *Decline and Fall of the Roman Empire*, or Voltaire's gibes about dens of scheming women, and squabbles over the sex of angels, or his diatribes against those tearful, bloodstained "centuries of horrors and miracles". Since then, historians have done justice to Byzantine history, and have endeavoured to place it within a more objective context.

For its part, Byzantine art long shared the same discredit as Western medieval art. The theoreticians and seminal minds of the Renaissance, the 17th century, and the Enlightenment, overwhelmingly dismissed medieval art as "Gothic". Virtually everything that took place from the 5th century onwards, when the Goths invaded Italy and overthrew the Western Empire, was considered barbaric. The Eastern Empire had indeed survived, but had soon changed beyond all recognition, and, to such thinkers, Byzantine art represented no more than a sterile offshoot, an oriental corruption of classical antiquity, exacerbated by the excesses of religious fanaticism. Up until the 19th century, its artistic creations, disparagingly described as "Greek works of the Late Roman empire", seemed transfixed in a quasi-ritual expression of immutable tradition. Byron and Théophile Gautier found something "Gothic" about Hagia Sophia while Didron cruelly remarked: "The Greek artist is a slave to tradition, like an animal to its instinct; he creates figures the way the

THE HESYCHAST COUNCIL OF CONSTANTINOPLE, 1351
1370-1375, Constantinople, paint on parchment. Greek Manuscript 1242, fol. 5 v, 33.5 × 24 cm (13 1/4 × 9 1/2 in.). Paris, Bibliothèque Nationale de France.

† ἰωέν Χῶ τῶ Θῶ πιστὸς Βασιλα
Καυτοκράτωρ Ρωμαι παλεολογος
απελθοκατακυζηνος

swallow builds its nest, or the bee its hive." It was a judgement without appeal: Byzantine art might grudgingly be credited with an occasional achievement, but was deemed ultimately devoid of any creative spark. And yet, since the Renaissance, Europe had also endeavoured to rediscover the vestiges of antiquity through the study of Byzantine history, literature and legal texts. Scholarship depended upon coinage, inscriptions and above all precious manuscript copies of ancient Greek texts. Travellers – emissaries, merchants, spies and renegades –, eager for evidence of all sorts, were led on a tireless quest to the East. Gradually, the adjective "Byzantine", derived from the ancient Greek name for the city of Constantinople, came to be used to designate the Eastern medieval era and to distinguish it from classical antiquity. Textual study led in turn to an interest in works of art; Byzantine art slowly but surely acquired a veritable identity of its own. The architectural eclecticism of the late 19th century contributed to its rediscovery, introducing, alongside the Gothic revival, a fanciful neo-Byzantine style, the prime French examples of which remain Notre-Dame de Fourvière in Lyons, the Cathedral and Notre-Dame-de-la-Garde in Marseilles, and the Sacré-Cœur in Paris. Finally, modern artists like Matisse, Chagall and Léger were inspired by the fragmented coloured tesserae of Byzantine mosaics and the hieratic icon figures, while Larionov, Malevitch and Mondrian were influenced by iconoclasm.

Today, the art of Byzantium is readily identified with a number of universally acknowledged masterpieces such as the basilica of Hagia Sophia in Constantinople, the mosaic portraits of Justinian and Theodora in Ravenna, and the church frescos in Mistra. Yet it is too often perceived as an art which was almost only religious, endlessly reproducing the same perfect images of Christ, the Virgin, the biblical story of Salvation and the lives of the saints. This over-simplified view probably derives to a large degree from the fascinating effect of Byzantine icons with their gold backgrounds and their impassive sacred figures, seemingly frozen in a venerable tranquil beauty. Again, such an effect may have been heightened by the frequent confusion between Byzantine art proper, and Russian, Balkan and Greek art since the 15th century, which ought strictly to be categorized as post-Byzantine. Yet Byzantine art was also imperial and oriental and could prove itself to be inventive, narrative and colourful, not averse to the picturesque nor to the treatment of secular themes. Over more than a thousand years of often turbulent history, the forms of classical art amidst which the Byzantine Empire had emerged were inevitably subject to many changes. Ultimately, however, Byzantine art in its entirety revolved around a curious paradox: a Christian Empire which was to remain profoundly attached throughout to its prestigious origins in classical antiquity. And this paradox is also indubitably the basis of its inherent grandeur.

1. Early Byzantine Art (4th-6th century)

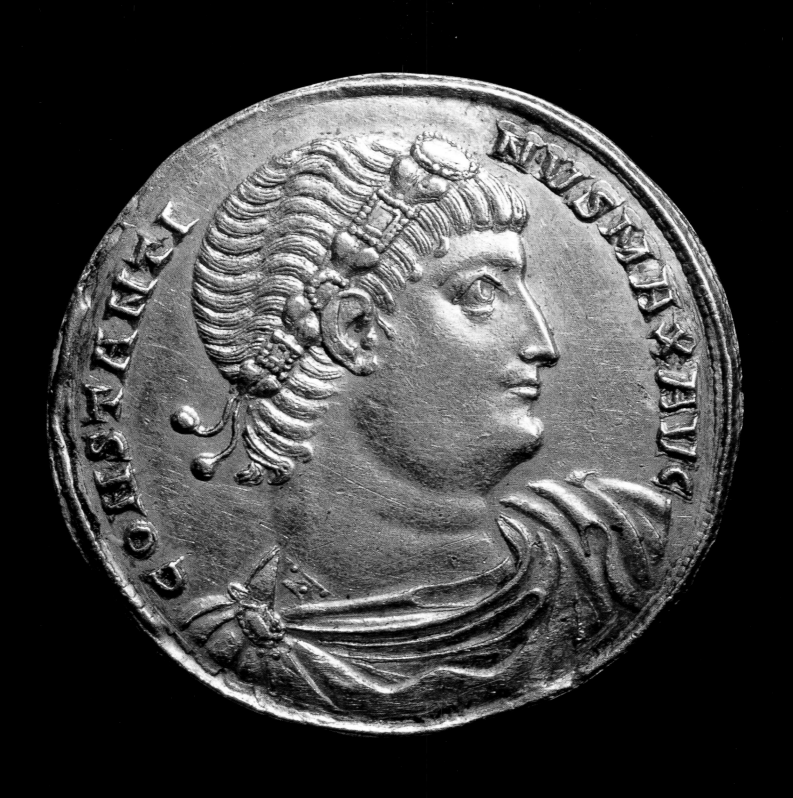

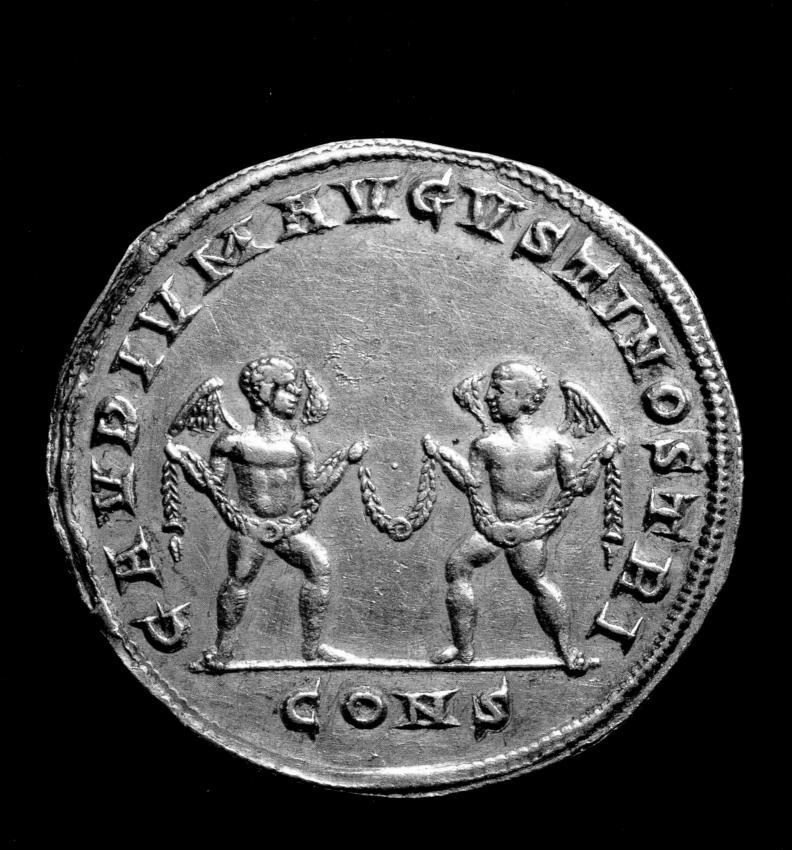

GOLD MULTIPLE OF CONSTANTINE

Obverse: Constantine. Reverse:
winged spirits bearing a garland.
Minted in Constantinople during the
reign of Constantine (311-337),
gold, diameter 3.4 cm (1 3/8 in.).
Paris, Bibliothèque Nationale de France,
Cabinet des Médailles.

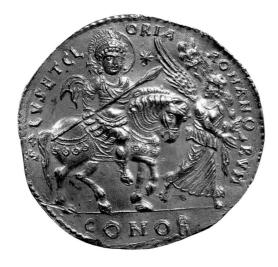

GOLD MEDALLION OF JUSTINIAN

Obverse: Justinian. Reverse: adventus
(triumphal entry) of Justinian.
534 (?), Constantinople,
galvanoplasty, diameter 8.6 cm
(3 3/8 in.).
Paris, Bibliothèque Nationale de France,
Cabinet des Médailles.

On 11 May 330, in strict accordance with pagan rites, Constantinople, the new Eastern capital of the Roman Empire, was formally inaugurated. Christianity, however, had been officially recognized in 313-314, and behind the scenes the Church had begun to grow into a powerful institution until ultimately, in 392 and 393, the Theodosian edicts banning pagan cults and the Olympic Games consecrated the triumph of Christianity as the lawful religion of the entire Roman Empire.

But increasingly, day by day, the political partition of the Empire between Greek East and Latin West, established by Diocletian in the late 3rd century, was becoming a reality. In 395, Theodosios died. He had made one son, Arkadios, heir to the East, and had bequeathed the West to another, Honorios. The split between the two Empires was finally and permanently sealed. Constantinople, capital of the Roman Empire of the East, was now the rival of Rome.

Birth of an Empire

In the course of the 5th century, the Western Empire reeled under the onslaught of massive invasions, and finally collapsed in 476 when Odoacer, one of the barbarian chieftains in Italy, deposed the last Emperor and sent the now obsolete imperial insignia to Constantinople. Relatively unscathed, the Eastern Roman Empire survived and transformed itself into what modern historians were later to call the "Byzantine" Empire: Roman in origin and by political and social tradition, Greek in language and culture, and fundamentally Christian. Church and State increasingly joined forces; theological arguments concerning the Virgin and the True Nature of Christ swiftly assumed a political dimension at the Ecumenical Councils of Ephesus (431) and Chalcedon (451). Yet the Emperors still clung to the idea of a universal Empire. Leo and Zeno kept a close eye on the internal evolution of the Germanic kingdoms of the West; Anastasios (491-518) saw Clovis as a counterbalance to Theodoric's power in Italy and, as Gregory of Tours recorded, hailed the Frankish king's victories by offering him the consular purple and insignia.

The dream of a reunified Roman Empire suddenly took shape with Justinian (527-565), the most tangible signs of revival being the reconquest of Ostrogothic Italy by Belisarius and Narses and the partial recovery of North Africa and southern Spain. Furthermore, the peace signed with the Persians in 532 apparently warded off danger in the East, and throughout the Empire frontier defences were strengthened by new fortifications. The economy was also restored: the tax system was reformed, trade was encouraged and, in particular, imperial workshops flourished with official backing. At the root of this process lay a new codification of the law, set out in the celebrated *Codex Justinianus* and the *Digest*. State power found expression in a series of grandiose monu-

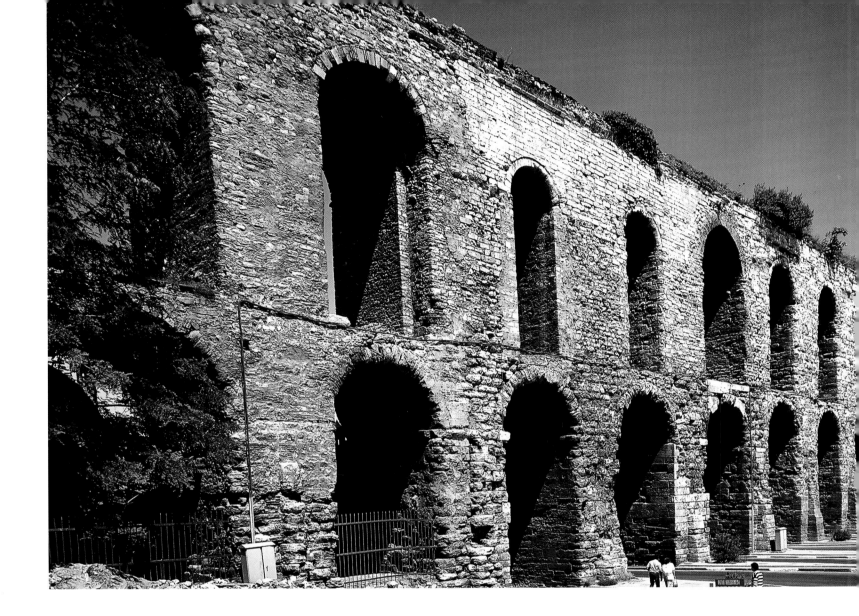

THE "VALENS" AQUEDUCT
2nd century, restored
by Valens in the 4th century,
with subsequent rebuilding.
Istanbul, Turquey.

ments built throughout the Empire; Hagia Sophia in Constantinople and the churches in Ravenna still stand today as the most palpable symbols of Justinian's majestic reign. Yet the glory remained tenuous. Bloodily repressed rebellions such as the "Nika" revolt at the outset of the reign, along with internal unrest, pointed to an Empire exhausted by titanic effort. Procopius celebrated Justinian's victories and his architectural feats in the *Histories* and *De Aedificiis*; yet he also probably wrote the *Secret History*, an often scurrilous pamphlet which denounced the abuses perpetrated by the Emperor, his wife Theodora, and their entourage. Reconquered territory was soon lost again and Justinian's dream evaporated. In 568, the Lombards invaded Italy and swiftly occupied almost the entire country, although Ravenna was to remain Byzantine until 751. In the east, the Persians forced Justinian to pay a crushing tribute, and under the latter's successors – Justin II, Tiberios and Maurice – hostilities resumed. Finally, in the north, the Slavs captured Sirmium in 582, settling south of the Danube and threatening Thessaloníki. Nevertheless, by the time "Justinian's century" drew to a close, the achievements and setbacks of a chequered reign had given the Byzantine Empire a veritable identity.

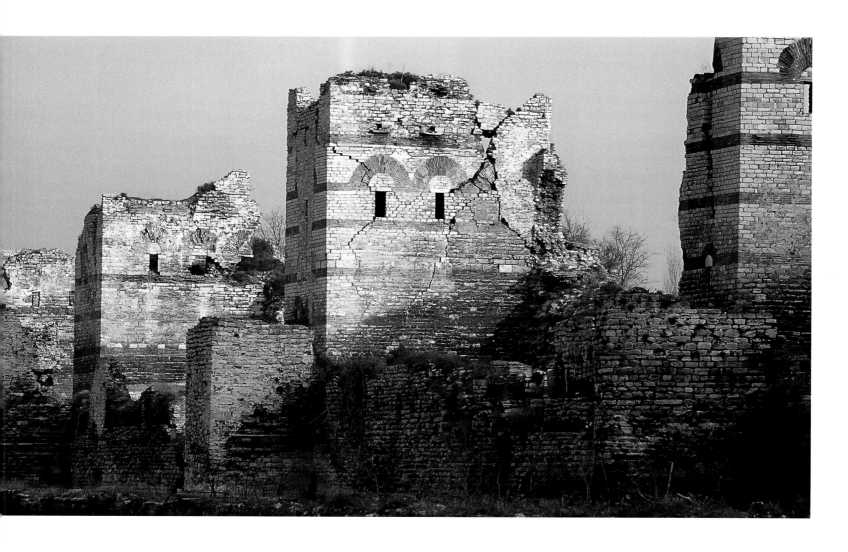

THE THEODOSIAN WALLS

Early 5th century,
with subsequent rebuilding.
Istanbul, Turquey.

The expression "early Byzantine art" is usually applied to the various artistic manifestations characteristic of the whole eastern Mediterranean basin between the early 4th and the late 6th century, but also covers those territories of the former Western Roman Empire reconquered by Justinian, particularly Ravenna where Byzantine presence lasted longest. As was the case with imperial institutions, there was no abrupt hiatus between the ultimate achievements of classical art and those which, later than the founding of Constantinople, can by their date and geographical location already be considered "Byzantine". It would therefore be futile to attempt to assign a precise beginning to Byzantine art. Although the earliest Byzantine works unquestionably perpetuate the forms of classical art, it is equally obvious that, two centuries after the founding of Constantinople, the art of "Justinian's century" no longer really belonged to antiquity. There are many reasons for this, a key one probably involving the gradual adaptation of the classical heritage to the expression of an art which was both Christian and Imperial, to the detriment of civic and pagan traditions.

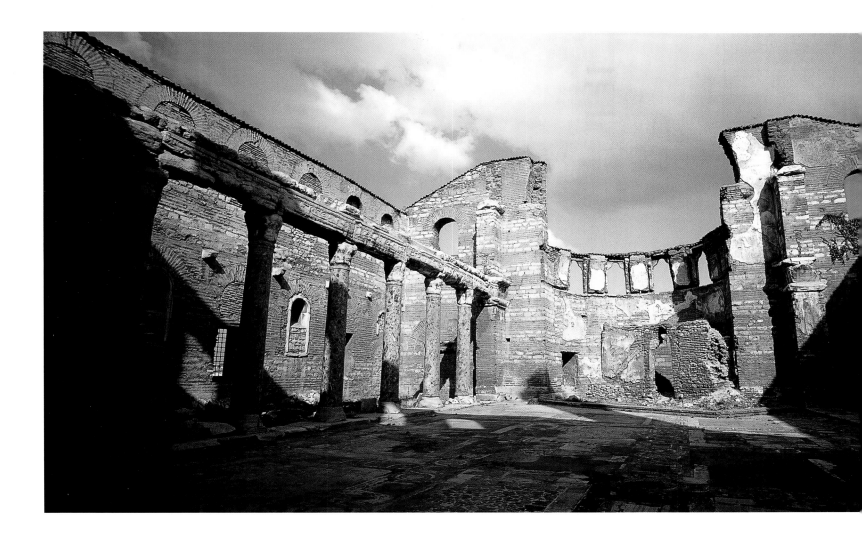

Architecture: the classical heritage

This evolution is well illustrated by architecture and monumental décor. The architects of Constantine and his successors designed the new capital Constantinople in the tradition of classical urbanism. Within the old Greek city of Byzantium, based around the south side of the present-day Topkapi promontory where the ancient acropolis formerly stood, they laid out the seat of imperial power, the Great Palace. Modern excavations have revealed some elements of the latter, in particular fragments of mosaic paving featuring secular decoration from the age of Justinian. The architects extended the Hippodrome, the modified contours of which have survived down to the present day. Nearby was located Constantinople's spiritual centre, the Great Church – on the site of the future Hagia Sophia – consecrated in 360 under Constantius II and which was to be rebuilt twice, under Theodosios II and later Justinian. From there, a main colonnaded thoroughfare which came to be called the *Mese* (or "middle street") ran west to Constantine's forum, then on to a second public square, Theodosios' forum or *Forum Tauri*, embellished with two triumphal arches, some vestiges of which– marble columns with peacock-feather decoration –have survived to the south of

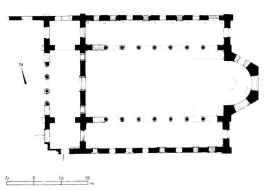

BASILICA OF ST JOHN, THE STOUDIOS MONASTERY (IMRAHOR CAMII)
Interior view facing north, and plan.
Latter half of the 5th century.
Istanbul, Turquey.

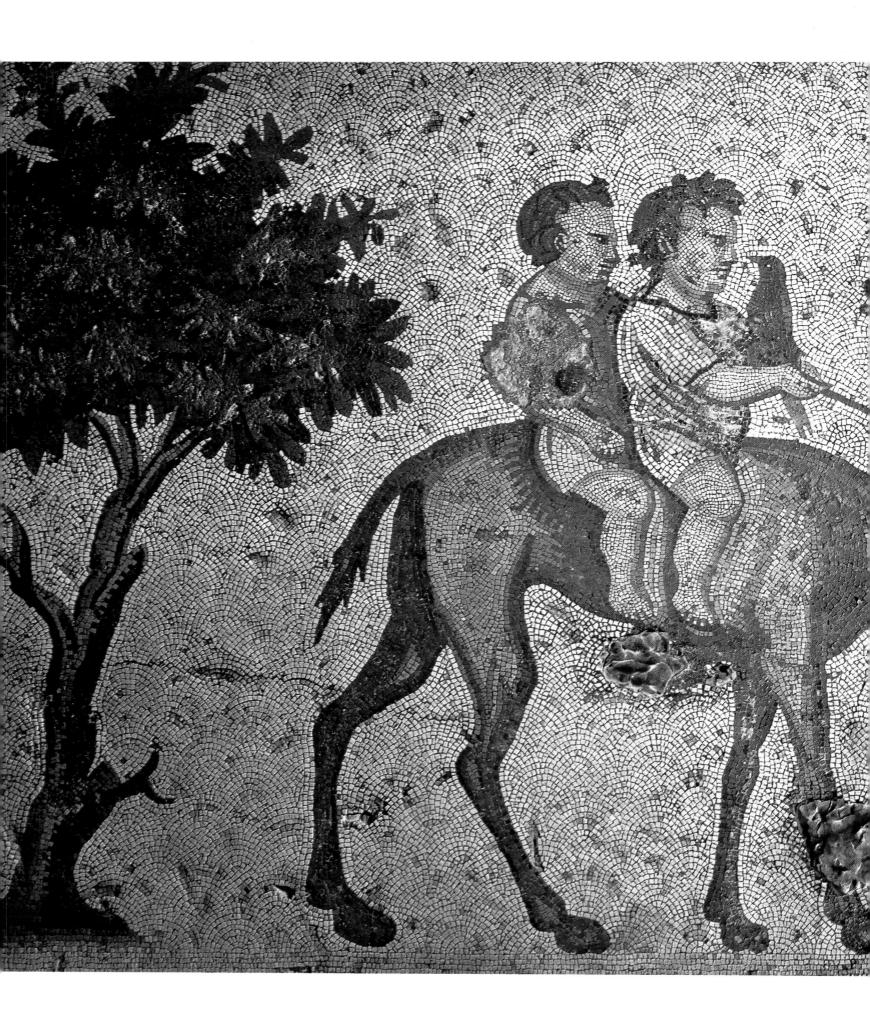

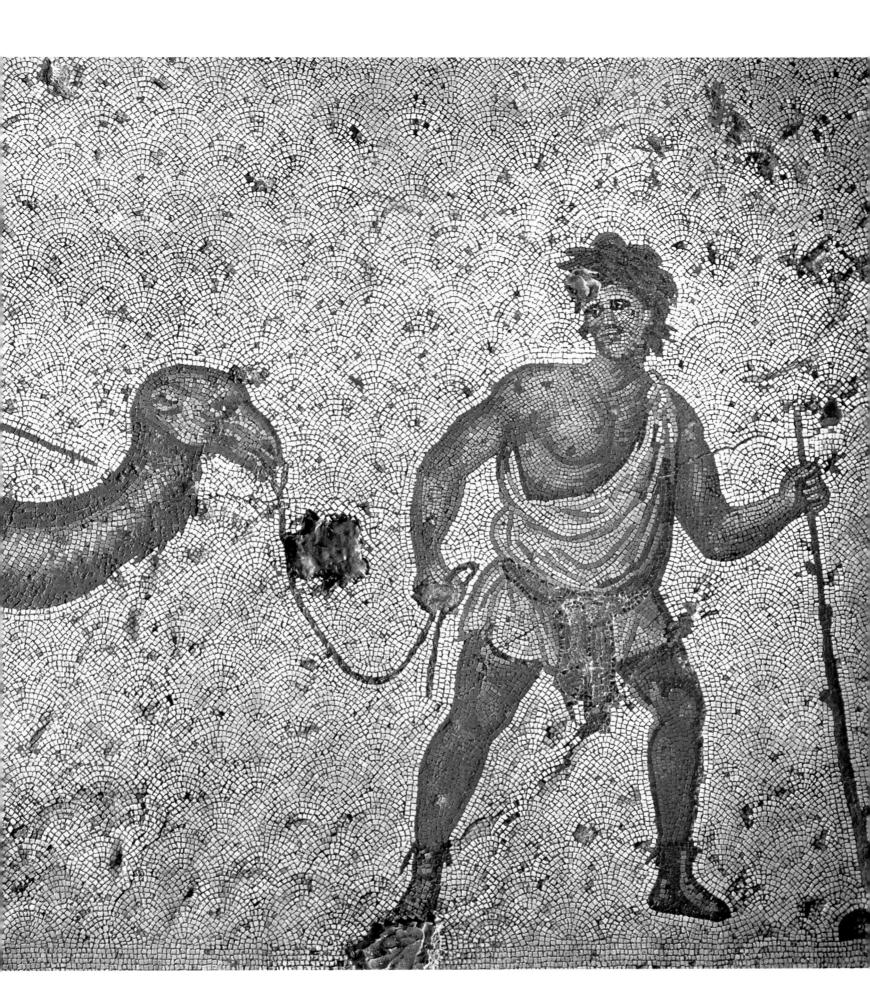

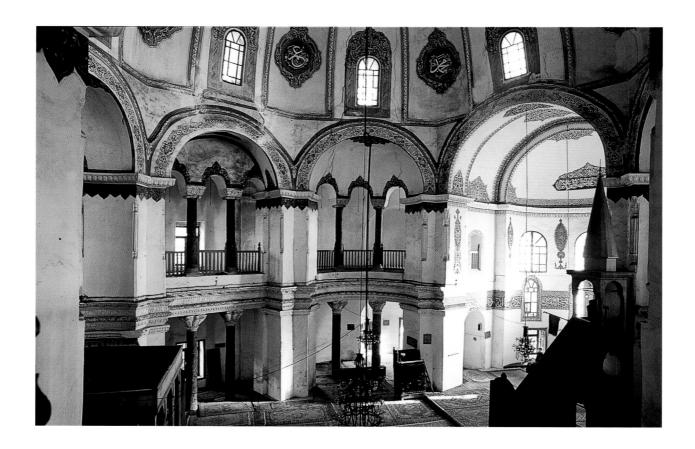

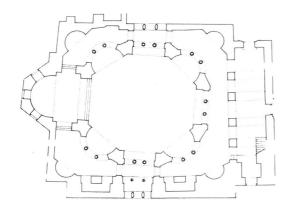

**CHURCH OF SS SERGIUS AND BACCHUS
(KÜÇÜK AYASOFYA)**

Interior view and plan.
Built between 526 and 536.
Istanbul, Turquey.

| Pages 18-19
MOSAICS FROM THE GREAT PALACE
Detail. Late 5th century-
early 6th century.
Museum of the Great Palace Mosaics,
Istanbul, Turquey.

present-day Beyazit Meydani. Beyond Theodosios' forum, the *Mese* divided into two avenues – the routes of which are still visible in modern Istanbul – in turn punctuated by squares. The water supply was provided by a large aqueduct, known as the Valens aqueduct, which still today towers over an entire district of Istanbul, as well as by both open-air cisterns such as the Mocius in the south-west and the Aetius and Aspar in the north-west, and underground cisterns like those in the vicinity of the Palace which the Turks call the "Submerged Palace" *(Yerebatan Sarayi)* and the "Thousand and One Columns" *(Binbir Direk)*. These underground cisterns form two vast rooms with vaults supported on rows of columns. As in any city of classical antiquity, the aqueduct and cisterns supplied fountains and public and private baths. In the fora and at crossroads, the Emperors erected ceremonial statues and columns bearing their effigies, such as those of Constantine, Arkadios and Marcian, a few vestiges of which are still standing. Many prestigious classical sites were stripped of their statuary which was then used to embellish the city like a museum. At the Hippodrome, the bronze "Serpentine Column" from Delphi, and the obelisk of Thutmose III from Karnak stood proudly in the *spina*, while the famous "Horses of San Marco" adorned the imperial box where they remained until plundered by the Venetians in the 13th century. For centuries, the Byzantines went about their daily lives amidst such vestiges of classical splendour.

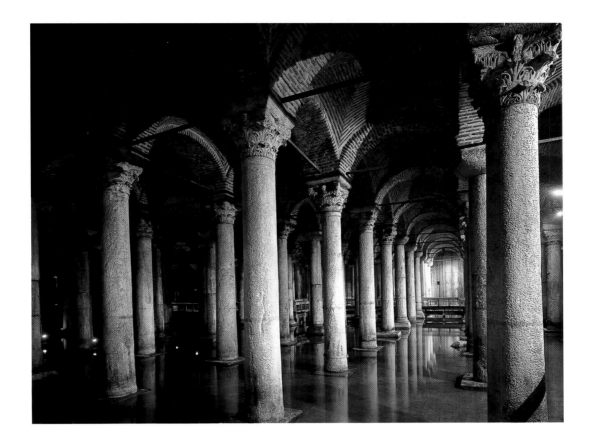

YEREBATAN SARAYI CISTERN
6th century.
Istanbul, Turquey.

However, by the late 4th century, due to the threat of Germanic invasions – particularly from the Goths quartered in the areas north of the Danube – the wall bounding the western part of Constantine's city had to be reinforced by mighty ramparts. These were erected farther to the west to encompass the suburban cisterns and encircled the entire city to the east. Solidly built in alternating courses of brick and stone, they formed twin defensive lines separated by a wide ditch and bristled with towers. For centuries they were to render the city impregnable. Meanwhile, Christianity began to leave its mark on the urban landscape. Drawing on the examples of those classical edifices which could be best adapted to the rites of the new religion, the Christians built two main types of churches. The first type was the basilica with a long central timber-roofed nave separated from the aisles by colonnades and provided at one end with a semicircular apse; in front there was usually a vast porticoed court, or *atrium*. The second type, designed for funerary purposes or serving as a shrine, derived from the classical pantheons or the circular and polygonal reception halls in Roman palaces. Here the plan was inscribed within a square and the central space, surrounded by lower buildings, was capped by a domed roof. In Constantinople, the basilica of the Stoudios monastery (Imrahor Camii), impressive vestiges of which still stand, provides an excellent example of the first type. This basilica was dedicated to St John the Baptist and built in the late 5th century.

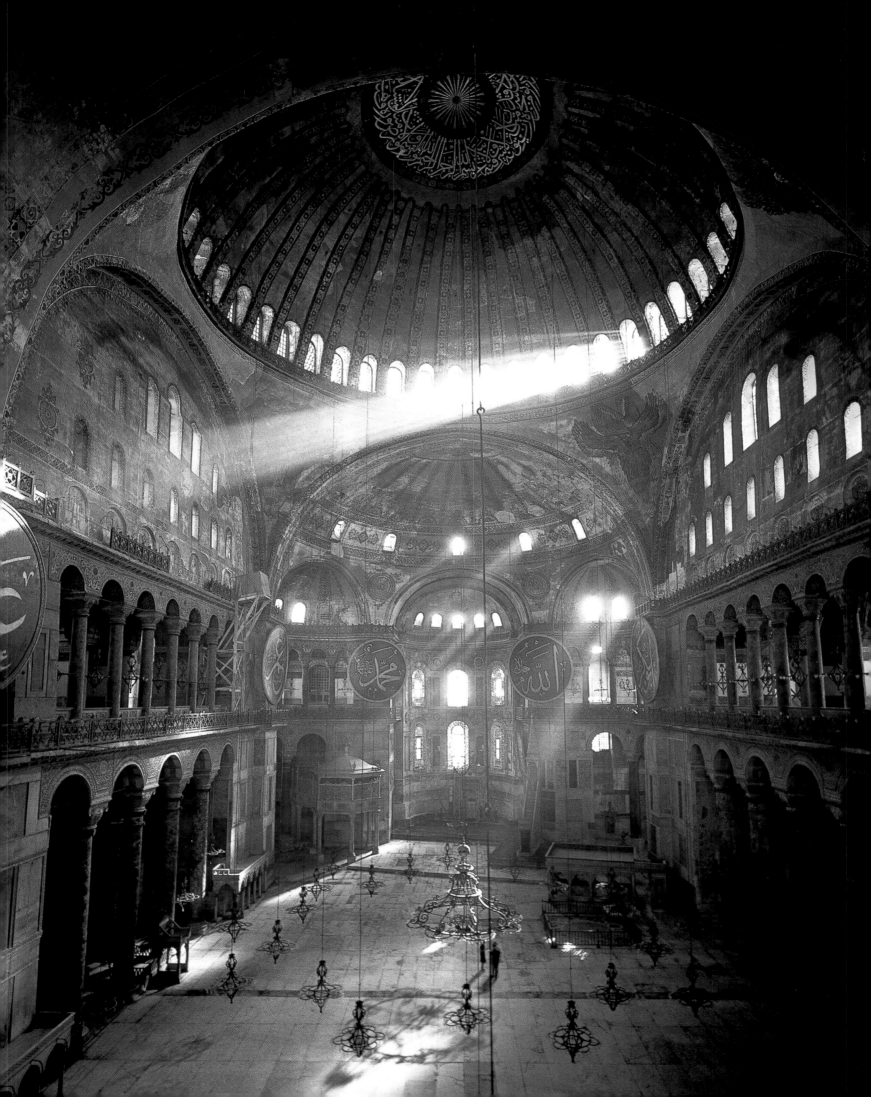

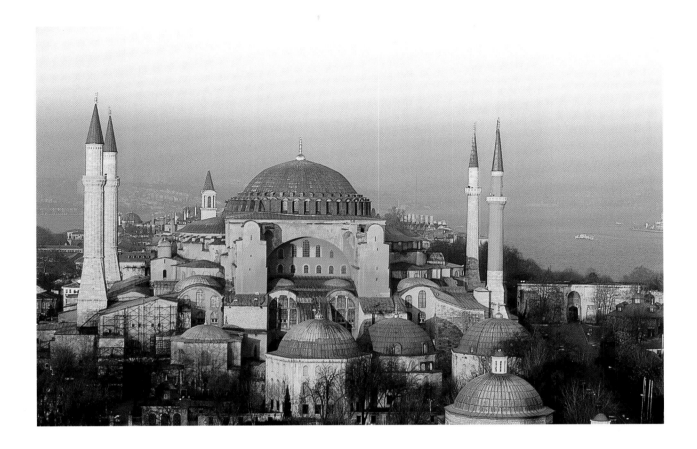

Formerly preceded by a porticoed atrium, it retains some of the mono-lithic green marble columns with large white marble Corinthian cap-itals carrying a moulded architrave once surmounted by gallery bays. The second, or central-plan type of building, is well illustrated by the church of SS Sergius and Bacchus, converted into a mosque by the Turks. Built between 526 and 536 thanks to the patronage of Justinian and Theodora, the church is octagonally shaped with four semicircular exedrae and has galleries and a domed roof. Despite its relatively small size, a few constructional irregularities, and layers of whitewash dating from the Ottoman period, it remains impressive by the nobility of its interior proportions and the refinement of its sculpted decoration, notably of the marble entablature supporting the gallery bays along the entire length of which runs an inscription paying tribute to the imperial couple. The church built by Princess Anicia Juliana in honour of St Polyeuctus around 520-530 and brought to light by excavations no doubt belonged to this same category. The numerous elements of sculpted décor retrieved, all executed in Proconnesian marble, are remarkably opulent: spandrels with vine leaf decoration, niches housing peacocks with fanned tails, columns with inlaid stones and coloured glass, and capitals entirely sculpted with stylized floral motifs. It was moreover from this building, derelict since the 11th century, that came the famous *Pilastri Acritani,* now in Venice.

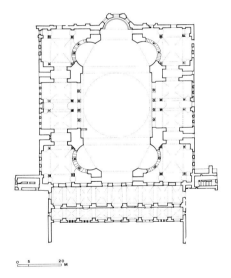

HAGIA SOFIA
View from the south, and plan.
Istanbul, Turquey.

HAGIA SOFIA
Interior view facing east.
Istanbul, Turquey.

However the crowning achievement of Justinian's reign, and indeed of all Byzantine architecture, remains Hagia Sophia. It was the largest edifice ever built by the Byzantines and one of the most impressive in Christendom. The Byzantines themselves regarded it as the fruit of divine intervention. Begun in 532 and consecrated in 537, it was the work of the architects Anthemios of Tralles and Isidorus of Miletus – not known to have previously designed anything which could have possibly anticipated this colossal and profoundly original building. Its novelty lay in its combination of both basilica and central-plan types. From the former it derived its galleried nave separated from the aisles by colonnades, while from the latter it took its gigantic dome – over 30 metres, or 100 feet, in diameter, and standing on four massive relieving arches. Two of these arches surmount the lateral tympanum walls and bays in the nave, while the remaining pair open onto lower half-domes; these in turn lead, to the west, to two large exedrae and, to the east, to three more exedrae, one of which forms the apse. The vast aisles, surmounted by galleries, add to the overall width of the building which is practically inscribed in a square (75 × 70 metres, approximately 225 × 210 feet). The aisles and galleries contribute to the general balance of thrusts, as do the twin narthexes to the west, the innermost of which is provided with galleries. They also help conceal the enormous mass of the lateral relieving arches supporting the dome, and the bases of the mighty buttresses outside. With Hagia Sophia, however, the architectural techniques of the day had been pushed to their extreme limits. In 558, the dome collapsed and was immediately rebuilt with additional reinforcement to the north and south arches. Throughout the building there are signs of irregularities, last-minute alterations, and improvisations which betray the architects' dilemma at how to master such a vast undertaking. The east wall tended to lean outwards and, as the edifice had begun to buckle even as building work was in progress, some of the columns showing obvious signs of fatigue had to be hooped. From the exterior, the ensemble can appear rather ponderous; this overall impression is not only due to the masonrywork added in the course of numerous restorations, and the four soaring vertical minarets dating from the Ottoman period fail to conceal the effect. On the other hand, inside the building, the vast volume of the nave, the stupendously high walls, the breathtaking curves of the dome and relieving arches contrasting with the long horizontal lines of the galleries, and the apparent weightlessness of the dome itself which, thanks to the corona of light streaming from the windows at its base, seems to float over the nave, all combine to create an unprecedented impression of power and harmony. It is therefore easy to understand both Justinian's pride on entering Hagia Sophia, when he is said to have exclaimed: "Solomon, I have outbuilt you", and the fascination exercised ever since by the sublime majesty of his church. The interior decoration is every bit as remarkable. Marble, in a variety of colours, was used lavishly, and faces the entire structure as far as the

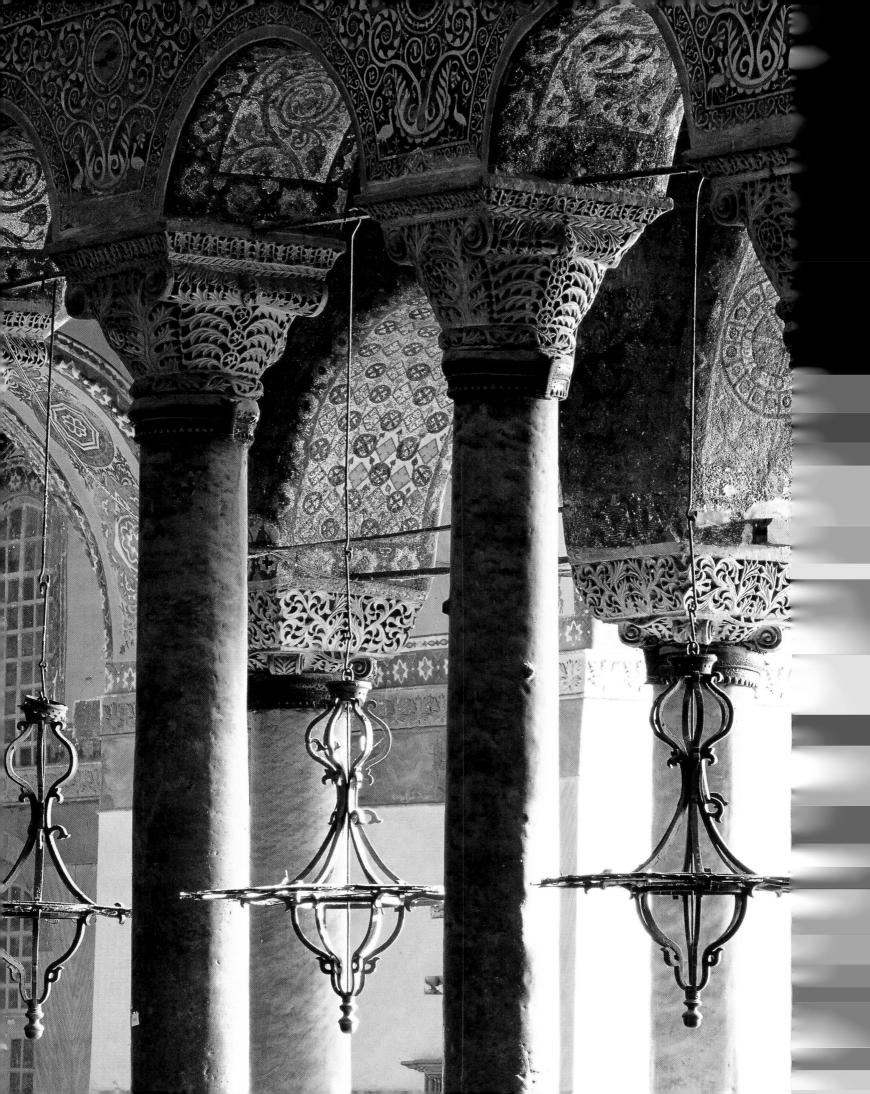

upper areas over the galleries. Justinian had porphyry columns brought from Egypt to be reused in the exedrae and also thin facing sheets of the same material, while the green marble columns were carved in Thessaly. The white marble capitals, the plain basket shapes of which have decorative scrolls on either side, are entirely sculpted with stylized acanthus foliage, which also appears on the white marble spandrels of the grand arcades and galleries, centrally stamped with a porphyry disc. In the aisles and inner narthex, mosaics on gold background dating from the reign of Justinian can still be seen. Throughout the upper areas of the church, light must have shimmered on the gold backgrounds of yet other mosaic compositions – nowadays vanished without trace or transformed over the ages – adding further to the monumental splendour.

Apart from Constantinople, none of the cities of the Empire underwent such radical transformation and, until the 7th century, hardly changed in appearance. The majority, however, were fortified from the 3rd century. Pagan temples were progressively closed down, serving where needed as quarries for the building of churches or, more rarely, converted directly to Christian use, like the Parthenon in Athens which was dedicated to the Virgin. The religious buildings erected throughout the Empire display obvious structural affinities. This is the case with the basilica which, moreover, was the commonest type in both the East and the West as it had a simple structure and was quick to build, involving no particular

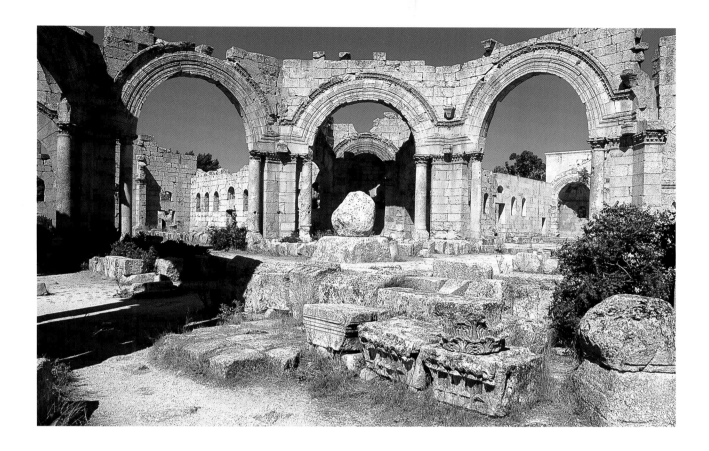

THE ST SYMEON THE STYLITE COMPLEX
Octagonal interior courtyard.
Late 5th century.
Qal'at Sema'ân, Syria.

Pages 28-29 |
CHURCH OF SANT' APOLLINARE NUOVO
Interior view, looking towards
the apse.
Late 5th century.
Ravenna, Italy.

technical expertise. The opulence lay entirely in such features as marble columns, sculpted capitals, polychrome paving, marble facing, mosaic-work in the apse or upper areas, painted or gilded ceilings suspended from the roof timbers, and in details of interior fittings such as ambo, chancel screen or ciborium. It was relatively straightforward either to make the best of reused marbles stripped from derelict classical buildings or to ship the required material from existing quarries such as those in Proconnesus, Phrygia, Karystos, Thasos, Thessaly, etc. Entire "prefabri-cated" churches were even shipped around the Mediterranean, as shown for instance by the cargo retrieved from the *Marzamemi* wreck off the coast of Sicily. Accordingly, surviving buildings and those brought to light by excavations display an apparent uniformity, particularly in Greece and Asia Minor. In the latter regions, moreover, some buildings display obvious affinities with the churches of Constantinople. This is the case with the 5th-century *Acheiropoiete* basilica of the Virgin in Thessaloníki, the elevation of which is similar to that of the Stoudios monastery, while the Latin cross plan of the 6th-century church of St John in Ephesus, formerly roofed with six domes, replicates that of the long-vanished Church of the Holy Apostles.

The other imperial provinces displayed a greater degree of autonomy. In Palestine, from the reign of Constantine, basilicas had been built on sites hallowed by the life of Christ on earth. The church of the Nativity in

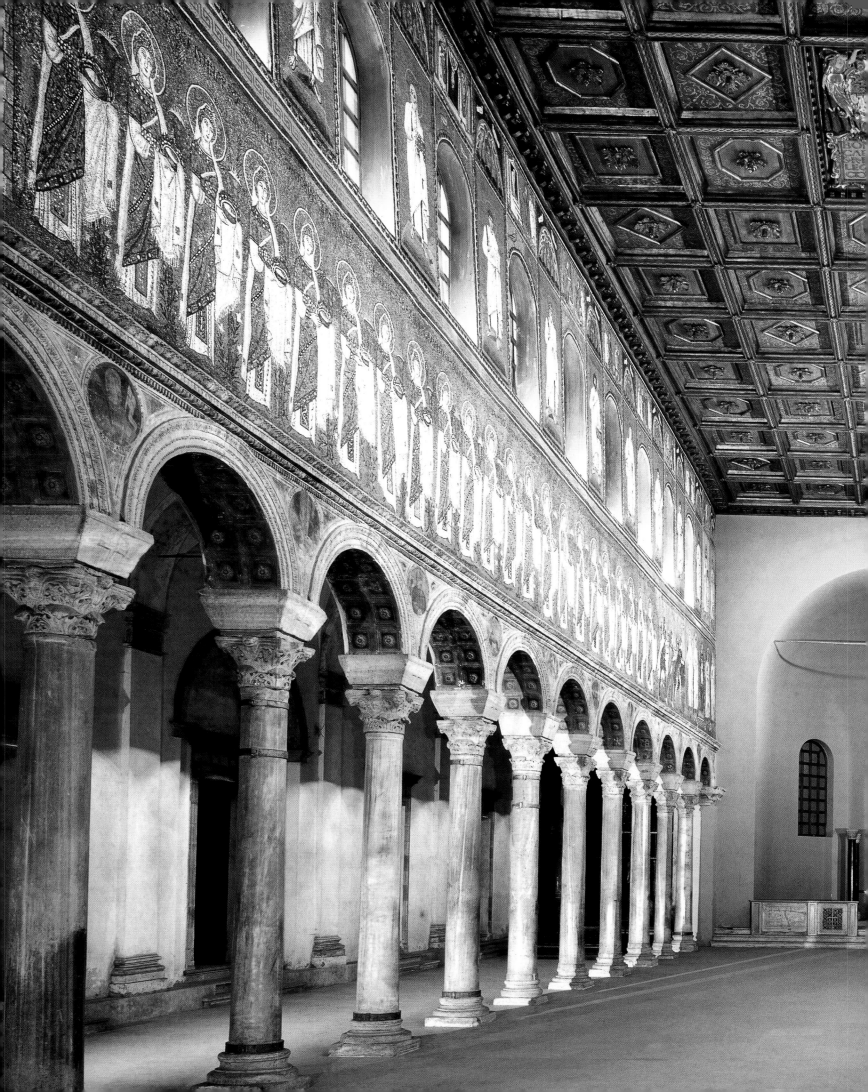

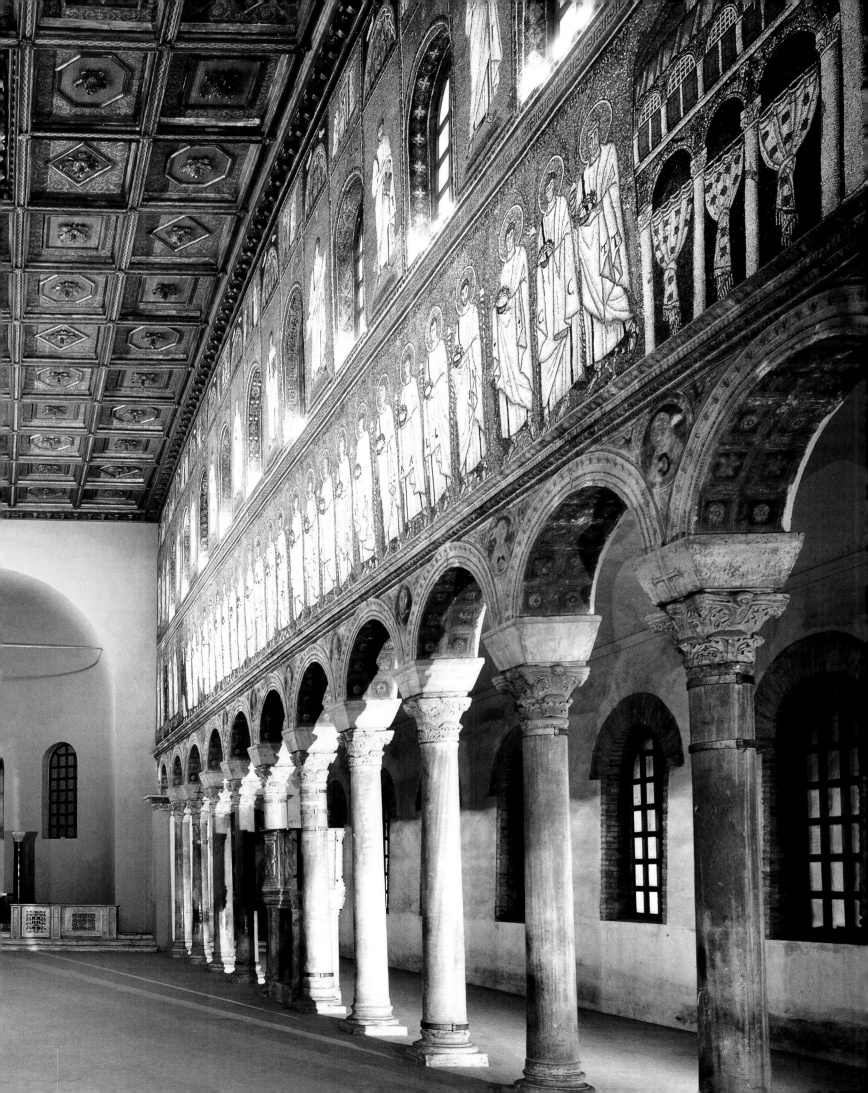

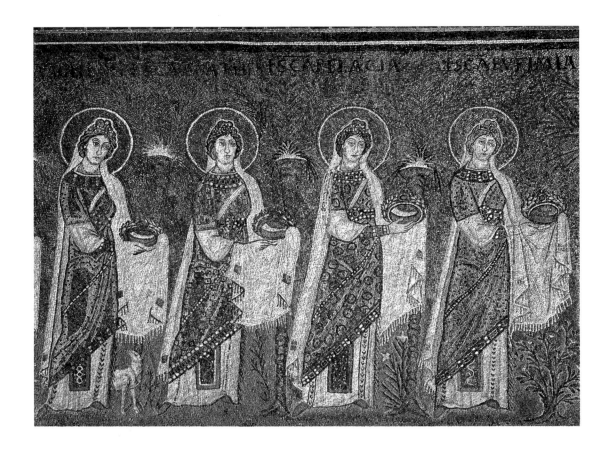

PROCESSION OF VIRGINS
Mid-6th century,
mosaic, detail.
Ravenna, Sant' Apollinare Nuovo,
north wall of the nave.

Bethlehem and the church of the Holy Sepulchre in Jerusalem had successfully combined the traditional basilica, preceded by an atrium, with a shrine or martyrium to Christ: the nave of the Bethlehem church opened onto an octagon housing the Grotto of the Nativity, while that in Jerusalem seems to have originally extended into an open courtyard where the Sepulchre was protected by a vast canopy. Specific liturgical layouts, related to martyria, as in Palestine or Syria, were found throughout the Empire. One of the most interesting examples is that of the great 5th-century basilica of St Demetrios in Thessaloníki, built partially over the public baths where the saint is traditionally believed to have been martyred.

Syria was distinguished not only by widespread use of stone bonding rather than marble, but also by the construction of some outstanding and remarkably large edifices. One of the most significant was the complex built at Qala'at Sema'ân to glorify the spot where the ascetic St Symeon the Stylite spent almost forty years of his life on a pillar. Begun in the late 5th century, the martyrium was a large cruciform building, some 100 metres (300 feet) long, impressive vestiges of which still stand; it included a central octagon housing the saint's pillar from which radiated four basilicas with three naves, the eastern one containing three apses. Relatively untouched by Constantinopolitan influences, Syrian architecture was in its turn to spread to the north as far as Armenia, and

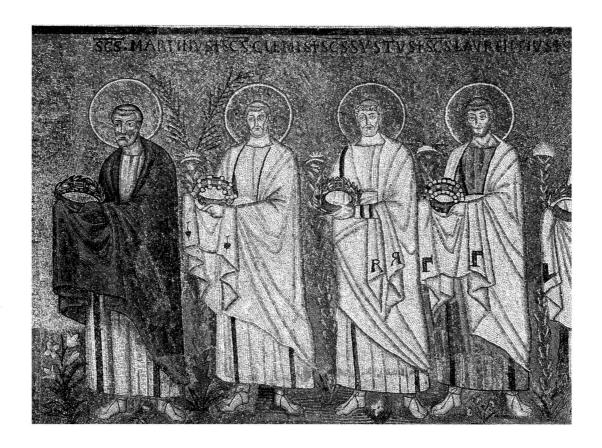

PROCESSION OF MARTYRS
Mid-6th century,
mosaic, detail.
Ravenna, Sant' Apollinare Nuovo,
south wall of the nave.

southwards down to Sinai, as witnessed – although it was an imperial foundation – by the fortified monastery church of St Catherine, built between 548 and 565. The church is built in local stone and the twin towers on the façade are reminiscent of many contemporary buildings in Syria, such as Qalblôseh, Rouhaïha or Qasr Ibn Ouardân. On the other hand, the admirable mosaic in the apse, representing the Transfiguration, is probably the work of artists from Constantinople and offers a distant oriental echo of its splendid Ravenna counterparts.

Indeed, along with Hagia Sophia in Constantinople, the churches in Ravenna are to the modern eye the most palpable achievements of Justinian's "golden age". Yet the Ravenna buildings by no means all date back to the reconquest of the city by Belisarius in 540. The purely Latin Mausoleum of Galla Placidia was built in the 5th century, even before the fall of the Western Empire, at a time when Ravenna had become a favourite residence for the court. The basilica of Sant' Apollinare Nuovo, with its fine capitals imported from Proconnesus, together with both the Arian and Orthodox baptistries were built under the reign of the Ostrogoths. Nevertheless, the mosaics on the walls of the nave of Sant' Apollinare Nuovo featuring the magnificent, solemnly rhythmical procession of male and female saints offering Christ and the Virgin their martyr's crowns seem to us to embody the supreme spiritual values of early Byzantine art. Even San Vitale, the most extraordinary of the

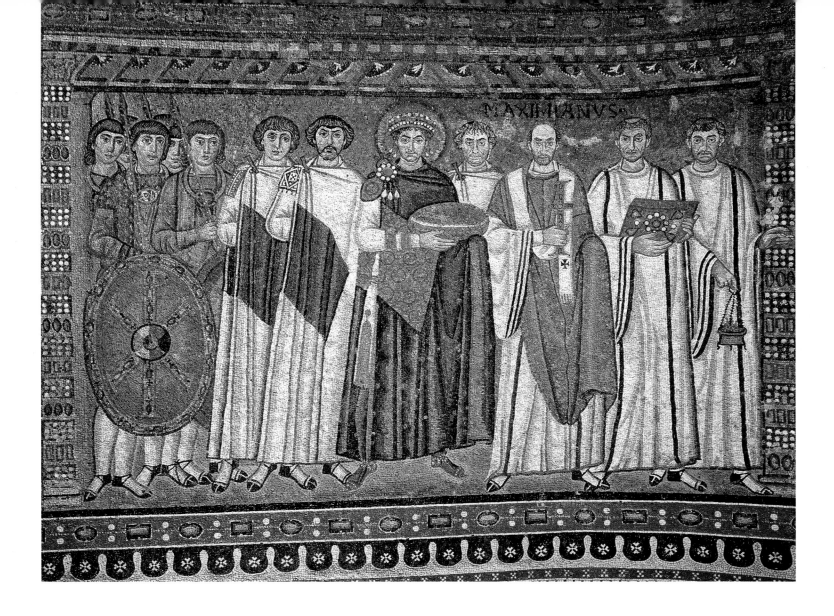

MAXIMIANVS

JUSTINIAN AND HIS COURT
After 540, mosaic.
Ravenna, San Vitale, north
wall of the presbyterium.

Ravenna churches, begun around 526 and consecrated in 547, must have been partially completed by the time of the reconquest. Yet the central plan with its dome – which has been somewhat exaggeratedly compared to that of SS Sergius and Bacchus in Constantinople –, the majestic spatial effect, the marble decoration and the capitals sculpted with stylized acanthus foliage, bear the unmistakable stamp of perfectly assimilated Byzantine influence. Above all, the two post-540 mosaic panels in the presbytery leading to the apse, representing Justinian and Theodora, constitute a justifiably celebrated pinnacle of early Byzantine art. In the first, Justinian, depicted holding an offering bowl, is surrounded by soldiers and civil and ecclesiastical dignitaries, including Maximian, archbishop of Ravenna, the only figure identified by an inscription. The second shows the Empress Theodora, also holding an offering bowl, with her servants and ladies-in-waiting at her sides. The figures seem to have been captured in a snapshot instant of their luxurious existence, an impression deliberately heightened by the gesture of the servant drawing back a curtain, or the detail of the jet of water spurting in Theodora's palace fountain. But the solemnly aligned, slow-moving protagonists, all shown frontally, weightless, not

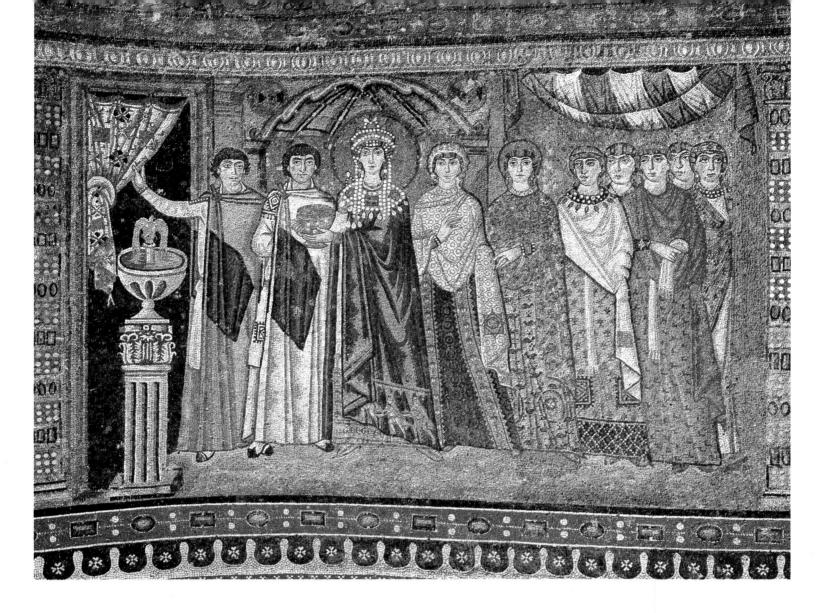

really in contact with the ground, together with their discreetly elongated proportions, slender feet, and faces with implacably staring eyes forming an impenetrable mask, the sumptuous costumes shimmering with colour, the lavish use of gold and, finally, the frame which surrounds both panels and creates an impassable barrier, are all features which render the figures timeless, transfixing them in a kind of eternity. These two mosaic panels immediately symbolized the reconquest of Italy – veritable imperial "icons" intended to ensure, by proxy, the permanent presence of the sovereigns in the sanctuary of the church; they are also one of the most resonant expressions of Byzantium's theocratic conception of power. Indeed, the figure of Christ is clearly visible in the domed roof of the apse above the imperial couple, symbolically bestowing power and divine grace upon them.

The last days of classical sculpture

Although early Byzantine sculpture, like the architecture of the same period, falls into the classical tradition, the triumph of Christianity and the gradual decline of civic institutions to the advantage of an

authoritarian Empire entailed irremediable changes. The great statuary which, for centuries, had given substance to mythological gods and heroes remained implicitly tainted with pagan connotations, dangerous in the eyes of the Church. Throughout the Empire, moreover, antique statues are known to have been smashed by Christian communities in outbursts of religious fervour; others were piously buried away in hiding places by the last adherents of paganism; a few, bearing the sign of the Cross, were even adopted by the new religion and Constantinople is known to have had few qualms about using such spoils as ornamentation. And yet statues of Christ or the Virgin were rare.

On the other hand, the tradition of grand statuary lived on in official art, long accustomed to celebrating the Emperor, his family, public dignitaries and the circus games. In Constantinople, in the 5th and 6th centuries, statues honouring victorious charioteers were still being erected, like those of the driver Porphyrius, the two bases of which are in the collections of Istanbul Archaeological Museum. In the 6th century, the Anatolian cities of Ephesus and Aphrodisias still put up statues of local magistrates, proof of the notable survival of a genre which, although by then stereotyped, was deeply rooted in Graeco-Roman tradition. The consuls Flavius Palmatus of Aphrodisias and Stephen of Ephesus are both represented standing stiffly, wearing similar togas, a large tail of which is folded across their body and held over their left arm. The only traces of veritable portraiture lie in the lively features of Flavius, with his thick head of hair, and in Stephen's ageing countenance. Yet brilliant examples of imperial statuary were still produced between the reign of Constantine and that of Justinian, one of the most oustanding being the celebrated porphyry group of *Tetrarchs* now in Venice. The lack of subtlety in the sculpted portraiture of the Constantinian dynasty – unlike the imperial effigies which appear on its coinage – was no doubt due to the use of porphyry, a hard material and one that was difficult to work. By the late 4th century, however, the portraits of the Theodosian age, carved in Constantinople from high-quality marble, display a refined art; the sculptors succeeded in idealizing their models and transfiguring their features, as in the admirable juvenile head of Arkadios, crowned with a diadem of large round pearls, in Istanbul Archaeological Museum. Dating from the turn of the century, there is the astonishing so-called "Ariadne" head in the Louvre, with its almost terrifying gaze. The true identity of the model and whether the sculpture itself hails from Constantinople or Rome are questions which remain open to debate. Finally, the splendid portrait of Theodora in the collections of the Castello Sforzesco museum in Milan, dating from the first half of the 6th century and displaying a rare psychological intensity, demonstrates that the art of the sculptors of the "age of Justinian" could still match that of their finest classical counterparts. In imperial statuary, bronze was as commonly used as marble, as can be seen for instance by the 4th-century head of Constantine discovered at Nis in Serbia, or the almost 12-foot-

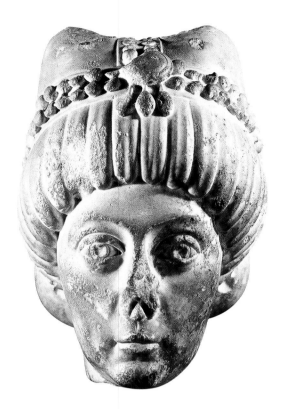

ALLEGED HEAD OF THEODORA
C. 530-540, marble,
height 27 cm (10 5/8 in.).
Milan, Castello Sforzesco Museum.

HEAD OF ARKADIOS
C. 400, marble,
height 33 cm (13 in.).
Archaeological Museum, Istanbul.

high (4 metres) "Colossus" today in Barletta. The latter statue, representing the standing figure of an emperor with lively, almost fierce features, is probably that of Leo I, which formerly stood on top of his votive column in Constantinople. Justinian also had his equestrian statue cast and placed in the *Augusteon*; and the image of this long-vanished monument has come down to us in a drawing in a Budapest collection, as well as in the gold medallion of the Emperor on horseback, formerly in the Cabinet des Médailles in Paris.

Sculptors more commonly carved narrative bas-reliefs which had less obvious pagan connotations than grand statuary and could also serve imperial propaganda purposes. In Constantinople, a few vestiges remain of the votive columns of Theodosios and Arkadios which, like Trajan's column in Rome, bore series of spiralling reliefs. The base of the obelisk, moved to the Hippodrome under Theodosios, depicts the triumphal ceremonies which were held there, while the pedestal, carved with two dedicatory inscriptions, features scenes displaying the difficulties encountered in transporting the monument. Despite the ravages of time, the quality of the sculpture is not unworthy of antique works, although the style, with its obvious classical ring, is rendered hieratic and solemn by the deliberate use of "inverted" perspective: the most important figures, although placed in the background in the imperial box or the upper galleries, are depicted much larger in size, while the scale of the minor figures in the foreground is correspondingly reduced. Narrative bas-reliefs were also widely used in funerary sculpture. In the course of the 4th century, however, pagan iconography disappeared from sarcophagi, while Christian themes flourished, in particular in a series of 4th and 5th-century marble sarcophagi from Asia Minor with deeply carved architectural decoration. Yet from the 5th century, in both Constantinople and Ravenna, there emerged a distinct preference for symbolic images (including lambs, birds and peacocks) or for the Cross, depicted either standing alone, or borne by a pair of flying angels. One of the finest examples is in Istanbul Archaeological Museum: a child's sarcophagus dating from around 400, in which the angels seem once more to display the perfection of classical Greek works.

However, these few masterpieces ought not to obscure the growing aversion to the figurative and narrative traditions of classical sculpture. In Constantinople and in the provinces, creativity expressed itself in other ways, in the ornamental and decorative sculpture of buildings. It was there that innovation was to be found, notably in sculpted capitals. The classical Ionic and Corinthian orders, often combined, survived for a time, albeit occasionally in debased form, but this did not prevent the rapid development in the 5th century of the perfectly composite "double zone" capital with no veritable link between its superimposed scenes. Above all, the following century witnessed the triumphant adoption of the "basket" capital, probably an invention of the Constantinople workshops. Its simple, entirely openwork form, with a mesh of stylized vege-

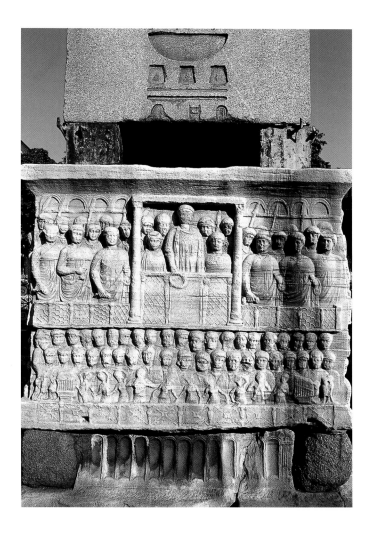

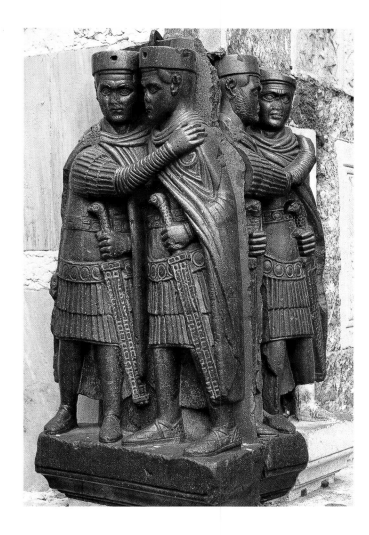

THE TETRARCHS GROUP
Early 4th century, porphyry.
Venice, basilica of San Marco,
south-west exterior corner.

BASE OF THE THEODOSIAN OBELISK
IN THE HIPPODROME: THE EMPEROR
IN THE IMPERIAL BOX
C. 390-395, marble.
Istanbul, Turquey.

tation or forcefully detached interlacing, soon spread throughout the whole Mediterranean basin. In reality, sculpture had been primarily ornamental from the reign of Justinian and was to remain so throughout the entire medieval Byzantine period.

Incunabular painting

In the 4th century the *codex*, or modern form of book which appeared at the beginning of our era, replaced the *volumen* or scroll and, in doing so, utterly transformed manuscript illumination. Until then, illustration had consisted of a limited number of light touches designed not to peel away in the course of repeated rolling and unrolling. With the advent of flat sheets, it could now develop into authentic, richly expressed painting, enlarged where necessary to the format of the entire page. At the same time, fragile papyrus was gradually being replaced by thicker, harder-wearing parchment. Although the scroll would never completely disappear, after the 6th century the use of papyrus was confined to the diplomatic documents drawn up by the hidebound imperial chancellery.

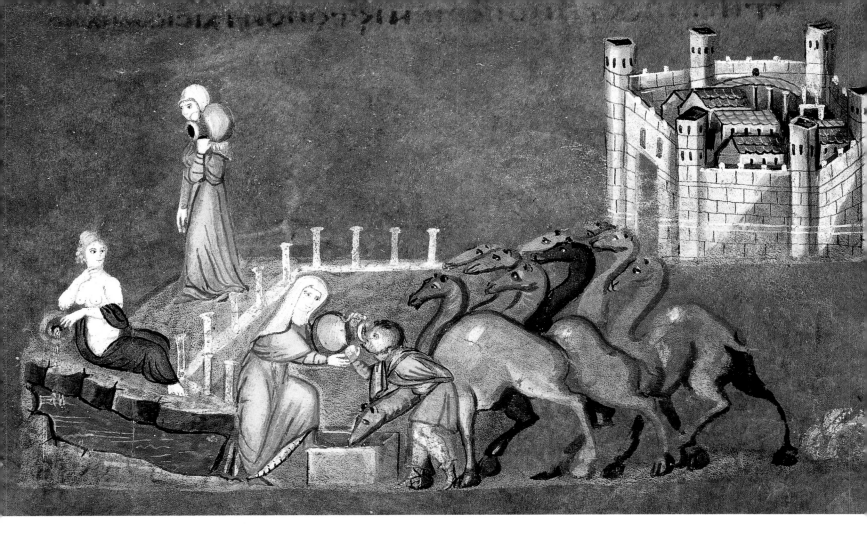

THE VIENNA GENESIS:
REBECCA AND ELIEZER

6th century, paint on parchment.
Codex theol. Gr. 31, fol. 7,
31 × 25 cm (12 1/4 × 9 7/8 in.),
detail.

Vienna, Österreichische Nationalbibliothek.

No more than a handful of illustrated late classical manuscripts – Greek or Latin – have come down to us and, as a result, our knowledge of painting in the early Byzantine centuries is extremely hazy. Constantine had recruited scholars from Alexandria and had installed the so-called "Octagon" library in the Palace, probably along with a workshop of copyists and illuminators, although no trace of their activities has survived. Our only extant record of a pictorial tradition which dated back to remotest antiquity is provided, at most, by a few 4th and 5th-century painted papyri discovered in Egypt, notably at Oxyrhynchos and Antinoë, featuring rapidly sketched classical-style illusionist figures. In fact, the history of Byzantine painting does not begin before the 6th century. Again, only one illustrated Greek codex, produced in the early 6th century for Princess Anicia Juliana, can definitely be attributed to Constantinople: the famous pharmacological treatise by Dioskorides, a Greek physician contemporary with Augustus, which is in the collections of the Austrian National Library in Vienna. Three other Greek manuscripts, however, written on purple parchment and also dating from the 6th century – the Vienna Genesis, the Gospels in the treasury of Rossano cathedral in Calabria, and the fragments of the Sinopa Gospels in the French Bibliothèque Nationale – can also be credibly attributed to the Eastern Empire, as can be the remains of the Cotton Genesis, in London, probably of Egyptian origin.

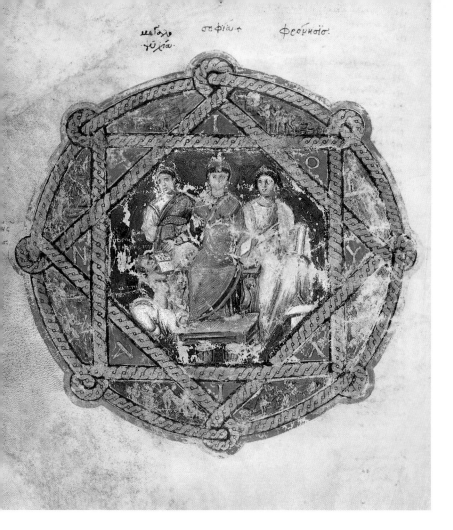

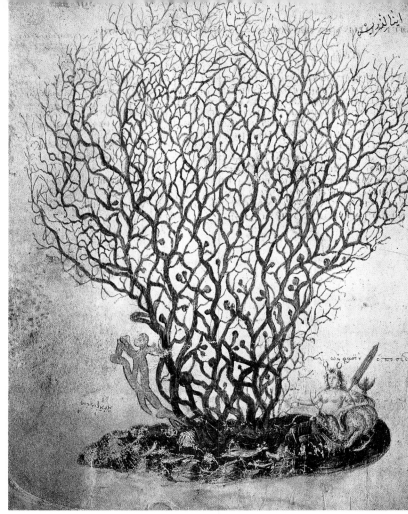

All of these display the formal perfection achieved by painting in the golden age of "Justinian's century". On the dedicatory page of the Vienna Dioskorides, set within an eight-pointed star inscribed in a circle, Princess Anicia appears enthroned between the allegorical figures of Magnanimity and Prudence; another figure, personifying "The Grateful Arts", lies prostrated at her feet, while a cherub offers her a codex. All around, in the grisaille-executed spandrels – and in allusion to the princess' role as patroness of architecture – other *putti* are depicted as masons and carpenters, like the goldsmith cupids in the Vetii house in Pompeii. Here, Hellenistic tradition is combined with the hieratic style of the central medallion in which the figures stand out against an almost abstract plain blue background. Inside the manuscript, the full-page illustrations of several hundred plants provide a much better display of illusionistic expertise derived from the conventions of classical painting, as can be seen in the brisk, yet accurately-executed drawing of coral with its shadow effect, shown protruding from water teeming with marine fauna and in which a symbolic personification of the Sea appears, bearing an oar and wearing lobster claws in her hair.

The tendency to formal abstraction is more apparent in the Vienna Genesis and the Rossano and Sinopa Gospels, which are usually attributed an oriental origin (Syria, Palestine, Mesopotamia?). Yet the memory of classical art is still vivid, as demonstrated in the Vienna volume by the

DIOSKORIDES, *DE MATERIA MEDICA*:
CORAL
Early 6th century, Constantinople, paint on parchment.
Codex Med. Gr. 136, fol. 391 v, 37 × 26.6 cm (14 5/8 × 10 1/2 in.), detail.
Vienna, Österreichische Nationalbibliothek.

DIOSKORIDES, *DE MATERIA MEDICA*:
PRINCESS ANICIA JULIANA
Early 6th century, Constantinople, paint on parchment.
Codex Med. Gr. 1, fol. 6 v, 36.5 × 26.6 cm (14 3/8 × 10 1/2 in.), detail.
Vienna, Österreichische Nationalbibliothek.

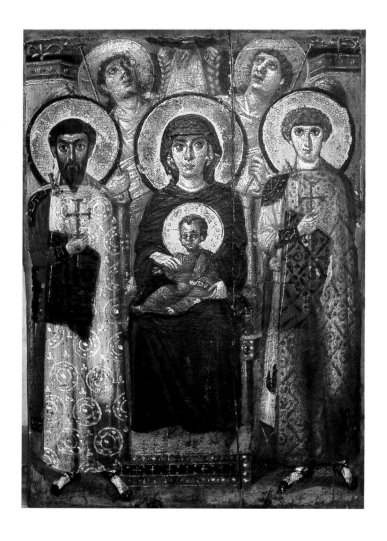

allegory of the Spring from which Rebecca is drawing water: a young nymph, sitting holding a pitcher from which the water is flowing. The juxtaposed touches of colour which give shape to bodies and objects, along with the shadow effects, still derive from Pompeian frescos. In the Rossano Gospels, on the other hand, the portrait of St Luke shows greater stylization; flat patches of colour feature prominently and perspective is less in evidence, even if the picture is based on the classical model of the poet or philosopher with his attendant Muse. The paintings in the Syriac evangeliary from Rabbula, now in Florence, executed at Zagba monastery in Mesopotamia and dated 586, are even farther removed from the antique tradition: the proportions of the figures do not obey the classical canon; outlines have become perfunctory, the drapes more geometrical and sinuous, while the gradation of less subtle, harsher colours is prompted more by a desire to create a decorative, expressive effect than by any illusionistic attempt to master form and contour.

Similar trends are to be seen in the rare surviving examples of icons painted on wood, all of which hail from Sinai or were discovered in

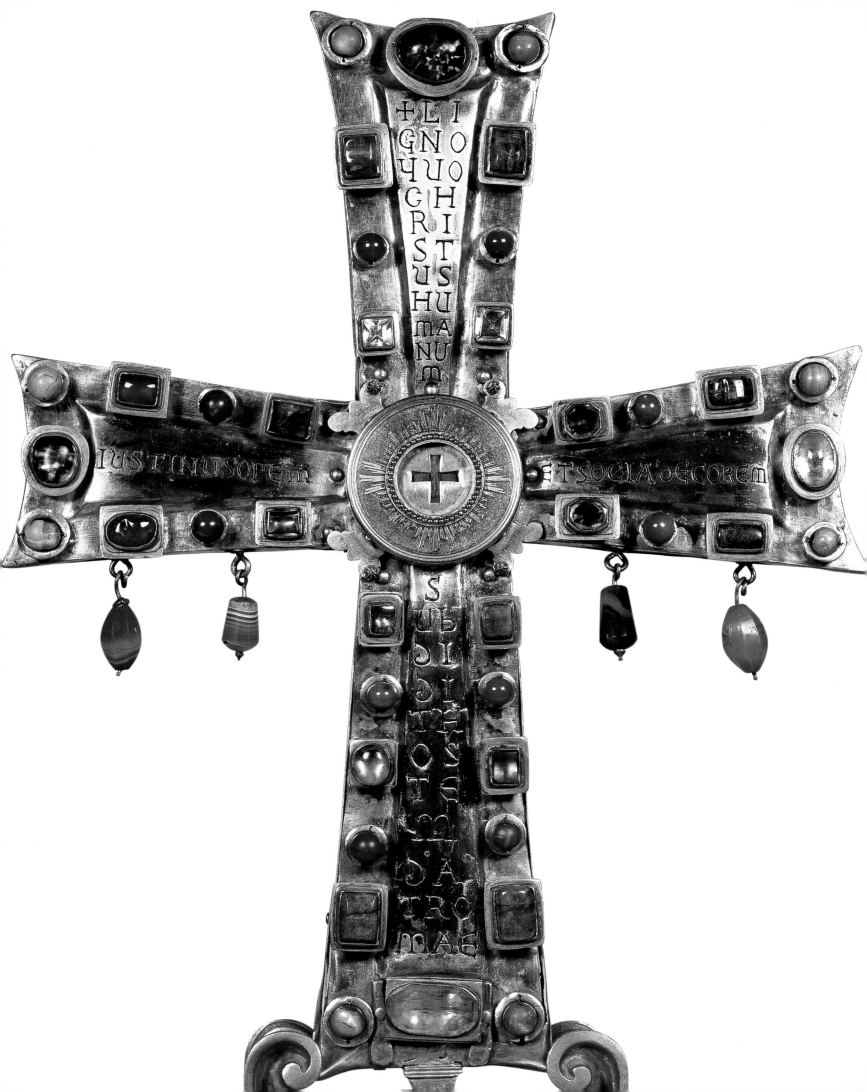

Egypt. The type, like the encaustic painting technique involved, perhaps derived in part from the painted funerary portraits attested by the Romano-Egyptian series from Fayum and Antinoë dating from the early centuries of our era. Yet there were also painted Roman official imperial portraits, distributed throughout the provinces to assure the symbolic presence of the Emperor, along with painted panels featuring pagan gods, and these probably served as more immediate prototypes for this category of Christian imagery. One of the most extraordinary of the little group of Sinai icons, still kept locally, depicts the Virgin and Child flanked by SS George and Theodore. It displays a consummate synthesis of the various trends influencing late classical art. The hieratic aspect of the ensemble, the transfixed posture of the Virgin, and the frontal representation of the two saints – whose impassive mask-like faces recall those of the imperial couple in Ravenna – all bear witness to a general stylization and flattening of forms which in turn heightens the expression of intense spirituality. Yet the cherished classical notion of pictorial depth of space is still very much alive: on the one hand, the three tiered rows of figures stand out against an architectural background, behind which a blue sky appears, and, on the other hand, the shadows cast by the figures are clearly visible on the ground in front of them. The central figure of the Christ Child, sitting on his mother's knee, still retains the classical artistic sense of volume and animation, while the angels turning and raising their faces towards the divine hand recapture the disquieting grace of Hellenistic sculpture. In some Sinai icons, as for instance that of SS Sergius and Bacchus, now in Kiev, the tendency towards abstraction is carried even farther; on the contrary, in others, such as the great Christ Blessing, which is still in the monastery, or an icon of St John the Baptist, also in Kiev, it is virtually absent and, in an astonishing manner, gives a forceful new lease of life to classicism. Yet all these icons were already at Mount Sinai in the early 7th century when the monastery was cut off from the rest of the Empire by the Arab conquest. They therefore date back to its foundation, in the 6th century, and are all more or less contemporary despite stylistic variations, whether painted in Constantinople itself or by artists thoroughly familiar with the art of the capital. At all events they are quite distinct from the provincially executed icons discovered in Egypt at Fayum and Baouît (the Apa Ména icon, now in the Louvre), which belong to Coptic rather than to Byzantine art.

Luxury arts and crafts: a political instrument

Constantinople also established itself as one of the major industrial centres of the Mediterranean world, grouping together most of the luxury arts necessary for its development and expanding influence. Constantine himself had taken the precaution of setting up workshops in his new capital and of encouraging them – as his successors did in

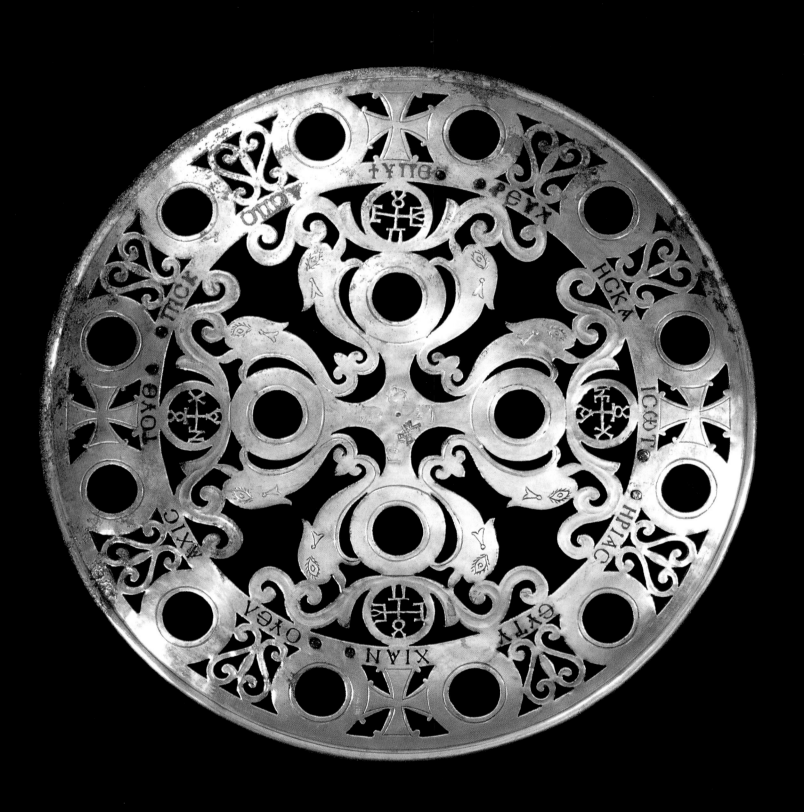

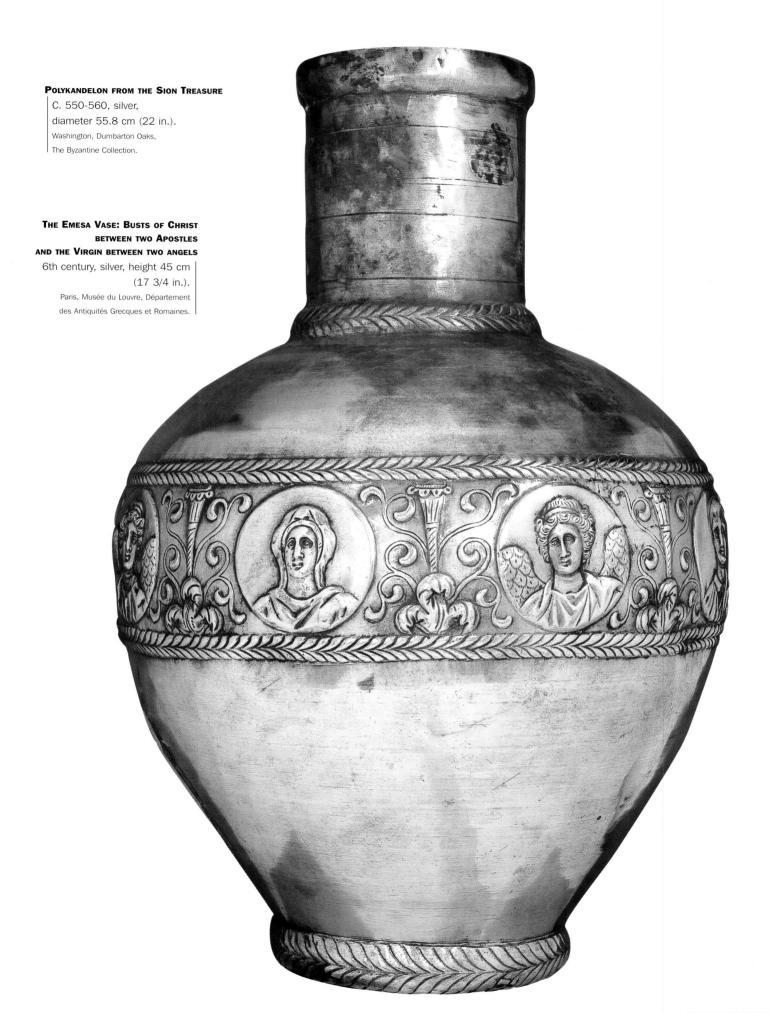

POLYKANDELON FROM THE SION TREASURE

C. 550-560, silver,

diameter 55.8 cm (22 in.).

Washington, Dumbarton Oaks,

The Byzantine Collection.

THE EMESA VASE: BUSTS OF CHRIST
BETWEEN TWO APOSTLES
AND THE VIRGIN BETWEEN TWO ANGELS

6th century, silver, height 45 cm
(17 3/4 in.).

Paris, Musée du Louvre, Département
des Antiquités Grecques et Romaines.

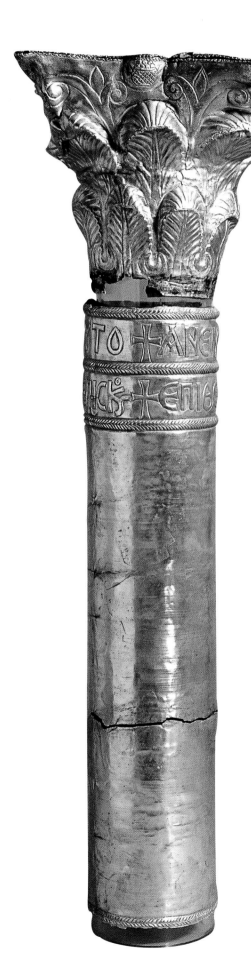

their turn – by granting monopolies, privileges and exemptions calculated to recruit the most skilled craftsmen. The latter, associated by sector of activity, subsequently settled in the districts which would still be inhabited by their descendants in medieval Constantinople. The gold and silversmiths set up their workshops and shops along the *Mese*. The bronzeworkers moved into the area to the north-west of Hagia Sophia, and by the 5th century had given their name to one of the city's holiest shrines, that of the 'Bronzeworkers' *(Chalkoprateia)* Virgin. The glassmakers occupied another neighbourhood, farther to the north along the Golden Horn. Finally, the silk trade established itself in the vicinity of the Palace and silk materials were soon on display in the "House of Lights", readily identifiable by its nocturnal lighting. This localized system facilitated the State's task of supervising and regulating crafts. The craftsmen banded together in corporations, governed by a corpus of laws later incorporated in the code promulgated under Justinian. The working of precious materials like silk, gold or silver was strictly regulated, as attested to by the use of hallmarks for pieces made with precious metals.

Henceforth, all the major maritime trade routes led to Constantinople. Precious stones, ivory, and raw silk from Africa, India and China were shipped there via south-eastern Mediterranean ports. Persia was long a staging post on the Far Eastern Silk Road. Under Justinian, the breeding of silkworms was introduced into the Empire. This event, mentioned by Procopius almost as an anecdotal aside, in fact implied a perfectly controlled infrastructure and no doubt represented the fruition of a long-cherished Byzantine ambition.

The major urban centres in the Empire also bustled with activity. Tyre, Tripoli, Antioch and Damascus were famed for their silk factories. Sidon produced a celebrated purple dye and Syria was reputed for its glassware. One Life of St Simeon offers us a glimpse of an Emesa glassmaker's workshop, showing the kiln around which wretches are huddling for warmth while watching the glass being blown, and occasionally shattering. In these regions, and as far away as Sardis in Asia Minor, excavations have brought to light numerous items of blown glassware with moulded or engraved decoration, often of high quality. Alexandria, the second city of the Empire, was distinguished for its workshops in which silk, wool and various precious materials were processed. The majority of the luxury industries were nevertheless no doubt concentrated in Constantinople. Unlike the provincial cities or those others which had been short-lived centres of power in the 3rd century, from the reign of Constantine onwards his eponymous capital became for centuries the permanent seat of the imperial court and the supreme authorities of Church and State.

Luxury arts and crafts were one of the instruments of imperial policy; imperial prestige required luxury and splendour. *Largitas* ('generosity') was one of the ancient cardinal virtues of imperial government, the hallmark of a propitious reign. The Emperor was expected to hand out

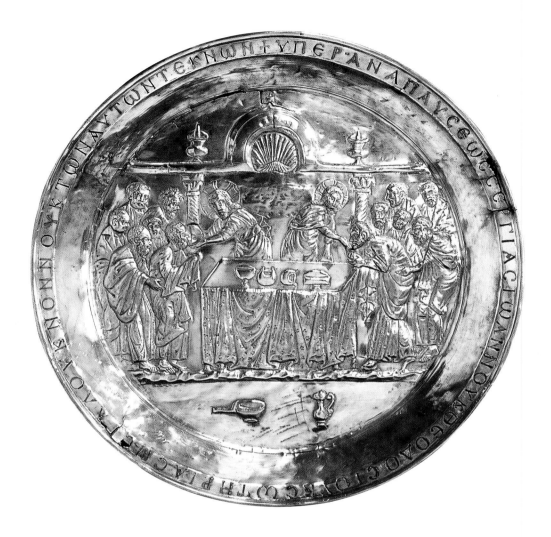

tokens of his favour among his entourage and, on various occasions, gold, silver, medals and even large silver plates *(missoria)* were distributed in his name, like the Theodosios plate in Madrid, celebrating, in 388, the *decennalia* or tenth anniversary of the reign and depicting the Emperor and his two sons above an allegorical representation of Prosperity. Consuls had long been in the habit of offering gifts in the form of silver plates, and when they took up office they would send sculpted ivory diptychs to select contacts and acquaintances. Above all, the Church was the beneficiary of imperial liberality. Constantine showered the churches of Rome, Constantinople and Jerusalem with gifts. In Rome, under the successive pontificates, the *Liber Pontificalis* recorded this largesse which assumed even greater proportions after the demise of the Western Empire: Justin I, Justinian, and Justin II, for instance, offered very many precious gold and silver vases, bookbindings, candelabra and chandeliers. Justin II's reliquary cross, still in the Vatican and bearing on the reverse side the portrait of the imperial couple, is one of the rare vestiges of this prodigality. Throughout the Empire, the mortal remains of saints were shrouded in the finest silks. There are textual accounts of the sumptuous gifts lavished on the churches of Constantinople. The *Description of*

PATEN FROM THE RIHA (KAPER KORAON) TREASURE
C. 570-580, silver, diameter 35 cm (13 3/4 in.).
Washington, Dumbarton Oaks, The Byzantine Collection.

COLUMN FROM THE SION TREASURE
Mid-6th century, silver, height 59 cm (23 1/4 in.).
Washington, Dumbarton Oaks, The Byzantine Collection.

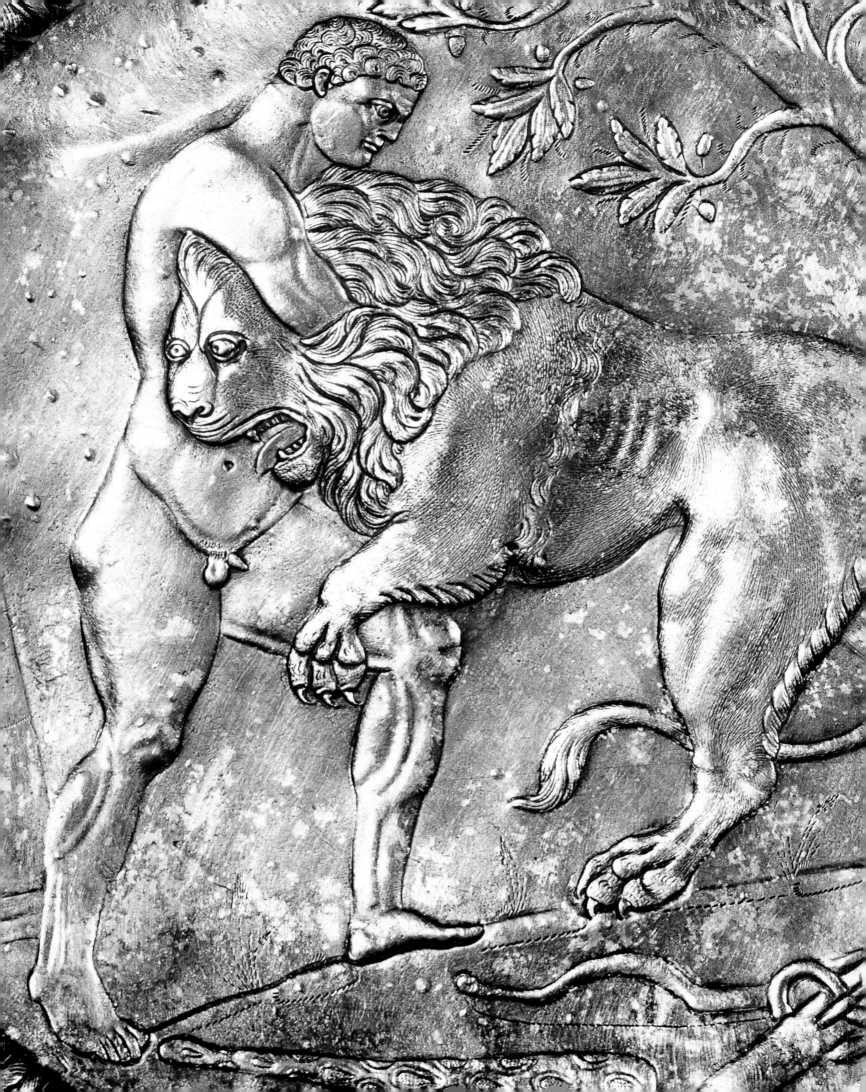

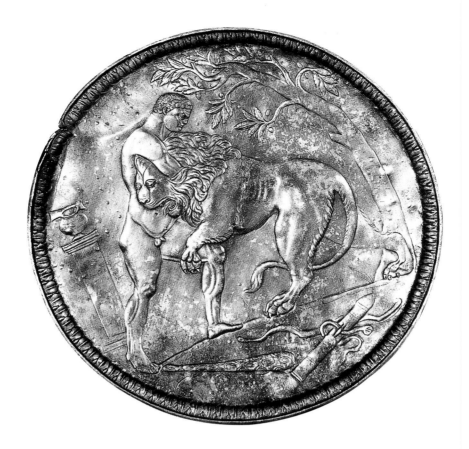

Hagia Sophia, written by Paul the Silentiary for its dedication in 562, has preserved the memory of the golden altar and its surmounting silver ciborium, the candelabra, woven gold hangings, silk curtains and other treasures bestowed upon the Great Church by Justinian.

The might of the Empire was expressed in the magnificent gifts which were offered to foreign sovereigns and invariably accompanied embassies or attempts to form alliances, as witnessed by the silk garments and expensive works of art sent to Attila by Theodosios II or, in the case of Gaul, the precious objects and gold medals sent by Tiberios II to King Childeric who proudly exhibited them; or again, by the relic of the True Cross offered by Justin II to Queen Radegonde who received it with pomp and reverence in Poitiers. Acts such as these all contributed to the universal and enduring prestige of the Empire.

In contrast to the lavish splendour conjured up by textual accounts, our actual knowledge of the luxury arts of the early Byzantine period is restricted to a small number of surviving pieces in collections. Silk provides a significant example. Only one fragment, embellished with the monogram of Emperor Herakleios (610-641), discovered in St Madelberte's shrine in Liège, can be definitely attributed to the Constantinopolitan workshops. In the case of the others, discovered in Egyptian necropolises or inside Early Middle-Age reliquaries, it is impossible to identify the various imperial textile centres involved. A few vestiges with Christian

HERCULES AND THE NEMEAN LION
6th century, silver dish,
traces of gilding,
diameter 40 cm (15 3/4 in.).
Paris, Bibliothèque Nationale de France,
Cabinet des Médailles.

motifs, such as the fragments of a *Story of Joseph* in the treasury of Sens cathedral, offer tangible examples of themes attested to by historical and literary sources, and may be compared with the figures of the Magi that appear above the hem of Theodora's mantle in the Ravenna mosaic. At the same time, pagan iconographic themes, particularly those taken from the Dionysiac cycle, were still popular. Such precious textiles were obviously different from the Egyptian woollen materials, found in their thousands. Indeed, whatever the intrinsic beauty of the latter, with a few notable exceptions, they conform to stylistic criteria increasingly foreign to Byzantium and which already belong to Coptic art.

Most of the precious metalwork pieces known today have been brought to light by excavation or chance discovery. Those which, like Justin's cross in Rome, miraculously survived the vicissitudes of time in ecclesiastical treasuries are quite exceptional. On the other hand, the treasures discovered in Syria, Cyprus, Asia Minor, the Greek islands or Italy, no doubt buried during the 7th-century Arab invasions, have revealed impressive ensembles. Even farther afield, isolated pieces have been unearthed: in the valleys of the Don, Dnieper and Volga in Russia, in France and Spain, like the Theodosian *missorium*, and even in England, like the silver plate in the Sutton Hoo treasure, now in the British Museum, all attesting to the sheer geographical extent to which Byzantine splendour wielded its influence. The forms, iconography, and manufacturing and decorative techniques involved are those of Roman gold and silverware, and in the case of 4th and 5th-century works it is often impossible to determine whether they are Western or Eastern in origin. On the other hand, from the reign of Anastasios in the late 5th century, the use of hallmarks – which continued right up to the first half of the 7th century – allows definite attribution to the Eastern Empire. Usually five in number, these feature the imperial effigy and monogram – and can thus be relatively accurately dated – as well as the names of the imperial inspectors. Although such hallmarks suggest a Constantinopolitan origin for the pieces bearing them, it is quite possible that other cities of the Empire may have been granted a dispensation to use them. And there are unhallmarked works – and some of the finest at that – which are indisputably Byzantine, such as the Emesa vase in the Louvre.

The relatively abundant silver tableware, occasionally with gold or niello decoration, derives from the Roman tradition. At least up until the 7th century, large dishes and salvers, ewers, patera, goblets and spoons retained traditional Late Roman Empire forms, perpetuating the major themes of classical iconography, whether mythological (the Hercules Plate in the Cabinet des Médailles in Paris; the "Silenius Plate" in Saint Petersburg; the "Muses Ewer" in Moscow, the Louvre patera from Cherchell, etc.) or imperial (Constantius II's *Adventus* Plate in Saint Petersburg). From the 4th century, however, the triumph of Christianity led to the emergence of religious gold and silverplate which flourished in the 6th century. Formally derived from classical tradition, such pieces

PAIR OF BRACELETS
6th-7th centuries,
gold, pearls, precious stones,
diameter 8.3 cm (3 1/4 in.).
Metropolitan Museum of Art, New York.

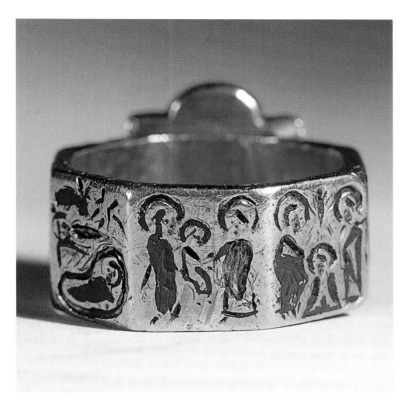

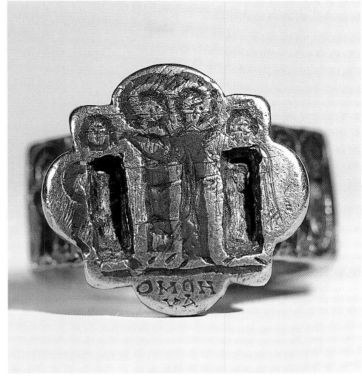

WEDDING RING
6th-7th centuries, gold and niello,
diameter 2.3 cm (7/8 in.).
Washington, Dumbarton Oaks,
The Byzantine Collection.

JEWELS FROM THE MERSIN TREASURE
6th-7th centuries,
gold and *opus interrasile*,
height of the cross 5.7 cm (2 1/4 in.).
St Petersburg, The Hermitage.

bore Christianized decoration and inscriptions. The major treasures discovered in Syria – from Antioch and Kaper Koraon, and now principally divided between several American museum collections – have revealed series of crosses, chalices, patens, liturgical fans, censers, book covers, reliquary or shrine covers and lamps. The so-called Sion collection, discovered in 1963 in Lycia, and divided between Dumbarton Oaks, Washington, and Antalya Archaeological Museum, included more than fifty pieces of silverware. Among the most remarkable are an impressive series of lamps shaped like openwork vases, and multiple-light chandeliers *(polykandela)* which hung from chains; they were made from a thick, round, rectangular or cruciform sheet of metal with an openwork decoration of dolphins and stylized plant motifs on which the little lamp recipients stood. The Sion Treasure also contained an altar-stone faced with strips of silver, as well as silver columns – no doubt lampstands but nevertheless reminiscent of the monumental columns of gold and silverwork that supported *ciboria.* Columns of this type featured on one of the patens in the so-called Riha Treasure from Kaper Koraon, depicting Christ giving communion to the Apostles. They help support a beam on which are placed a pair of lamps, while other liturgical objects – a chalice, a ewer and a patera – appear on, and in front of, the altar. These treasures, each consisting of several dozen kilos of precious metal, make the vast imperial sums – hundred of kilos – known to

DIPTYCH LEAF: ARCHANGEL
5th or early 6th century, ivory,
height 42.8 cm (16 7/8 in.).
London, British Museum.

THE ANASTASIOS DIPTYCH
517, Constantinople, ivory,
height 36 cm (14 1/8 in.).
Paris, Bibliothèque Nationale de France,
Cabinet des Médailles.

have been bestowed on the churches of Rome and Constantinople quite plausible. The objects combined Christian themes with the classical decorative repertory of lush palmettes, beads, leaf-and-dart patterns, laurel wreaths, acanthus and vine foliage... Bronze, widely employed to make everyday objects such as containers, candlesticks, scales and weights, was sometimes used instead of precious metal for liturgical objects, particularly lamps, as is shown by a series of peacock or griffin-shaped lamps perched on a tall tripod support, and a whole range of *polykandela*.

Jewellery was equally dazzling. Imperial finery is only familiar to us because it appears, for instance, in the Ravenna mosaics or royal portraits. Nevertheless, enough jewels have survived to allow an appreciation of their essential aspects. Classical traditions were still alive, particularly *opus interrasile* work which consisted of piercing a series of openwork motifs into the metal, a technique which appeared in Roman jewellery from the 3rd century and which seemingly continued to flourish up till the 7th century. It is common on most jewels, as shown by the fine ensemble discovered at Mersin in Cilicia, today in the Hermitage. The prevailing fashion, however, was for pearls and coloured cabochons, so much in evidence on monuments with figurative decoration. Above all, Christianization made constant progress. Depictions of the Cross, angels, the Annunciation, or the Crucifixion increasingly replaced pagan apotropaic themes and secular inscriptions of a magical or erotic nature. Wedding belts now portrayed Christ blessing the bride and groom, as did the bezels of wedding rings, while for some of the most sumptuous of the latter the ring itself was occasionally decorated with Gospel scenes. During the Late Roman Empire, both in the West and the East, ivory – as precious as gold or silk – suddenly came back into fashion and in eastern regions remained so until the dawn of the 7th century. An outstanding series of 5th and 6th-century consular diptychs has come down to us, all precisely dated with the year of the incumbents' accession to the consulship. Curiously, all the 5th-century works are Roman while all the 6th-century ones are from Constantinople. The latter, remarkably comprehensive series, opens with those of Areobindus, consul in 506, and ends with that of Justin, consul in 540. The diptychs, often more than one foot high (40 centimetres), consist of twin leaves, sculpted on one side with, on the back, a sunken section intended to hold a layer of wax which could be written upon. The decorative sculpture features either the monogram or bust portrait of the consul, set in the centre of stylized acanthus leaves or large cornucopia, or the solemn image of the consul enthroned above circus games, holding his most conspicuous attribute of office: the *mappa*, a cloth which he used to wave to signal the start of the games. The diptych of Anastasios, in the Cabinet des Médailles in Paris and dated 517, belongs to the latter type. There are obvious references to classical art, to mention only the iconography and the classical style of the drapes. But, as with other official ivories, these

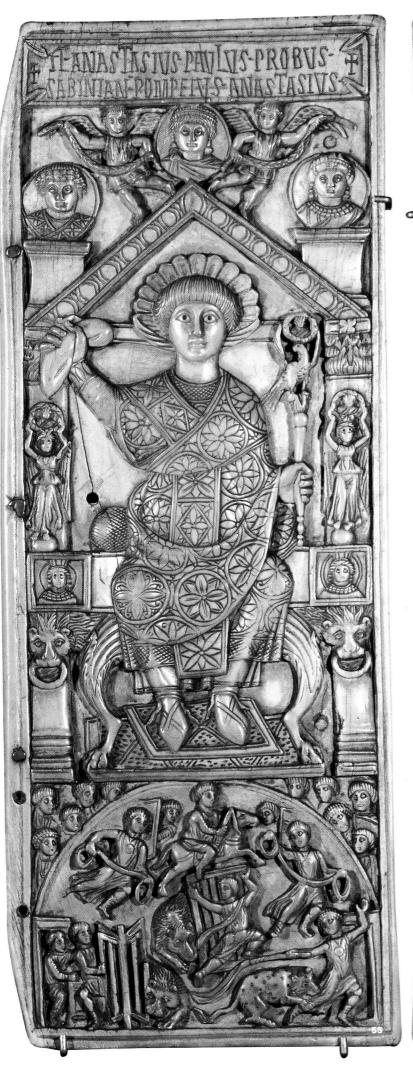

ANASTASIVS·PAVLVS·PROBVS·
SABINIAN·POMPEIVS·ANASTASIVS·

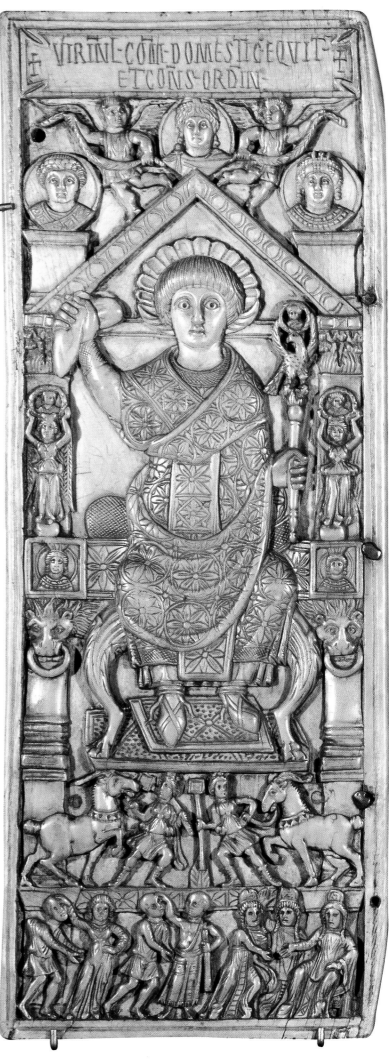

VIRINI·COM·DOMESTIC·EQVIT·
ET·CONS·ORDIN·

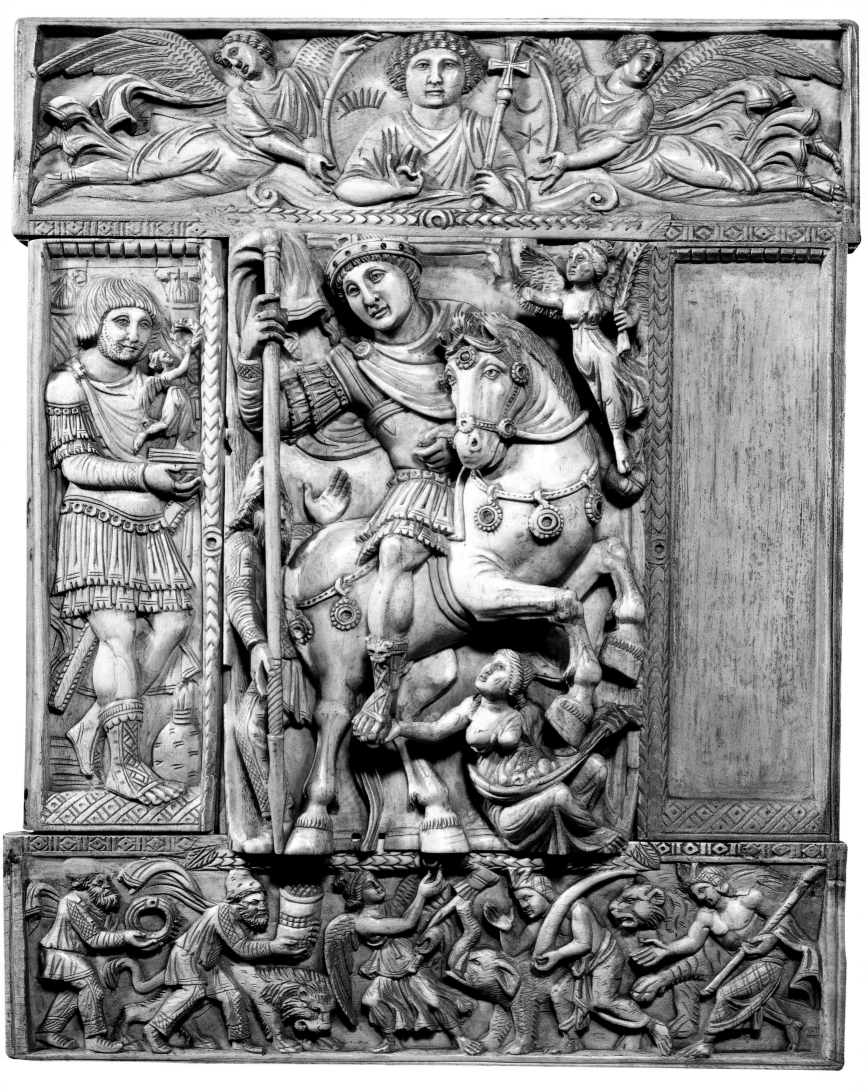

**DIPTYCH LEAF,
THE "BARBERINI IVORY":
TRIUMPHANT EMPEROR**

First half of the 6th century,
Constantinople, ivory,
height 34.2 cm (13 1/2 in.).
Paris, Musée du Louvre,
Département des Objets d'Art.

do not prevent the expression of anticlassical tendencies: disregard for the notions of depth and space, stereotyped treatment of the faces, and inverted perspective which magnifies the picture of the consul and reduces the people in the foreground to tiny figures.

Emperors also had official diptychs sculpted, and it is possible that, as suggested by the inscription, the admirable diptych leaf in the British Museum, depicting an archangel holding the terrestrial globe, is the vestige of one of these. On this ivory, which can be dated to the 5th century, the classicism of the drapes and fullness of the face belong to antiquity, but the luxuriant ornamentation heralds that of Constantinopolitan sculpture of the following century, and the deliberately distorted perspective heightens the immaterial character of the angelic apparition. Unquestionably the most extraordinary of official ivories is the "Barberini Ivory" in the Louvre, sculpted in Constantinople in the first half of the 6th century. Moreover it is the only leaf of an imperial diptych consisting of five assembled ivory panels to have come down to us virtually intact. In the centre, in high relief, and occasionally detached from the background, the triumphant Emperor – perhaps Justinian himself – is shown mounted on a rearing charger, accompanied by a figure of Victory; he has subjugated the Scythian or Persian walking by his side; Earth, seated on the ground, opens a fold of her mantle laden with her fruits and clasps the foot of the victorious Emperor. The lateral panels are treated in lower relief. The bottom panel depicts the conquered peoples bringing their tribute; in the left-hand panel, a general is offering the Emperor a statuette of Victory; finally, in the top panel, set in a mandorla borne by two angels, Christ appears giving his blessing. Two other central panels of imperial diptychs, in equally high relief, thought to represent Empress Ariadne who died in 515, are now in Florence (Bargello) and Vienna (Kunsthistorisches Museum); like the "Barberini Ivory", or the Ravenna mosaics, they offer us an unforgettable image of the supernatural essence of Byzantine imperial power. In Ravenna, however, Christ and the Emperor were still separated, depicted on different walls. In the "Barberini Ivory", for the very first time, they are united within the same image: Byzantine theocracy had discovered its supreme expression.

The same ivoryworkers also produced carvings of a religious nature, diptychs representing Christ and the Virgin, and "five-part" diptychs where the latter figures are surrounded by biblical scenes or episodes from the childhood of Christ. Ivory, like marble or precious metal, was sometimes used to make items of liturgical furniture, of which "Maximian's Chair" is now the only surviving example. This episcopal throne, made in the mid-6th century for Maximian, archbishop of Ravenna, and bearing his monogram, consists of a series of sculpted ivory plaques in a combination of several styles. The scenes on the back of the chair depicting the childhood and life of Christ are so similar to the lateral reliefs in the "Barberini Ivory" that they could justifiably

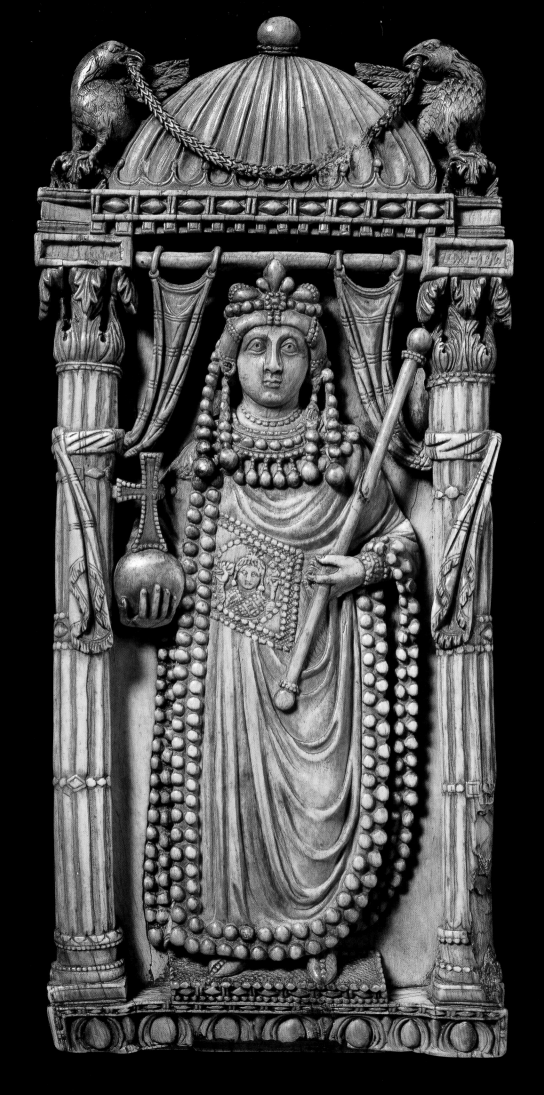

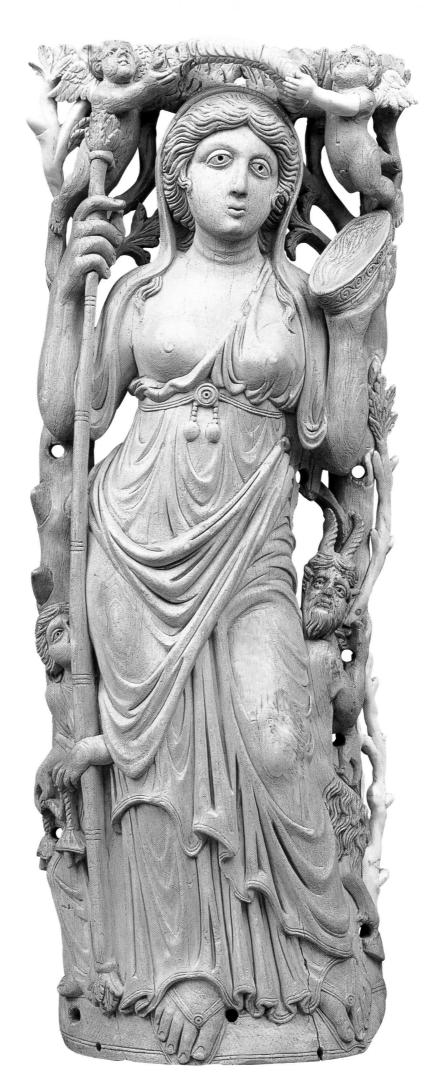

**ORNAMENTAL GROUP: ARIADNE,
SATYR, MAENAD AND PUTTI**
C. 500, Constantinople, ivory,
height 40 cm (15 3/4 in.).
Paris, Musée National du Moyen Âge
et des Thermes de Cluny.

**DIPTYCH LEAF,
THE EMPRESS ARIADNE**
Early 6th century, Constantinople,
ivory, height 30.5 cm (12 in.).
Florence, Museo Nazionale del Bargello.

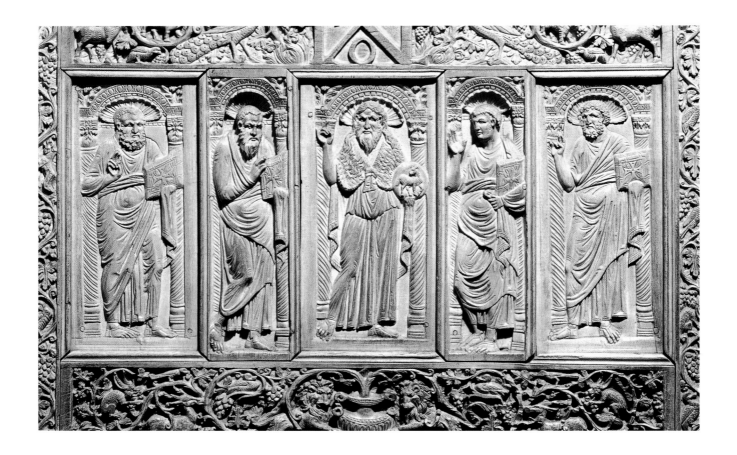

be attributed to workshops in the capital, despite a degree of abstraction, as on some ivories from the latter half of the century (the Murano diptych); on the sides, the characters from the story of Joseph are stockier and more energetic. Finally, on the front of the seat, the rugged, aged features of St John the Baptist and the Evangelists with their vigorous draperies already reveal traits that were to be intensified on later ivories.

Classical paganism, however, was not dead, as attested by the astonishing figure of Ariadne, sculpted in Constantinople in the early 6th century and now in the Musée de Cluny in Paris. In some élite circles, the bare-breasted wife of Dionysos, accompanied by a satyr and a maenad and crowned by two Cupids, no doubt still represented one of the traditional allegories of marriage. But by now, the beautiful mythological figure was scarcely more than a lingering survival, an erudite reference in a completely Christian Empire. In the space of two centuries, classical art had been utterly transformed, and had become Byzantine.

2. The Age of Upheaval (7th-mid-9th century)

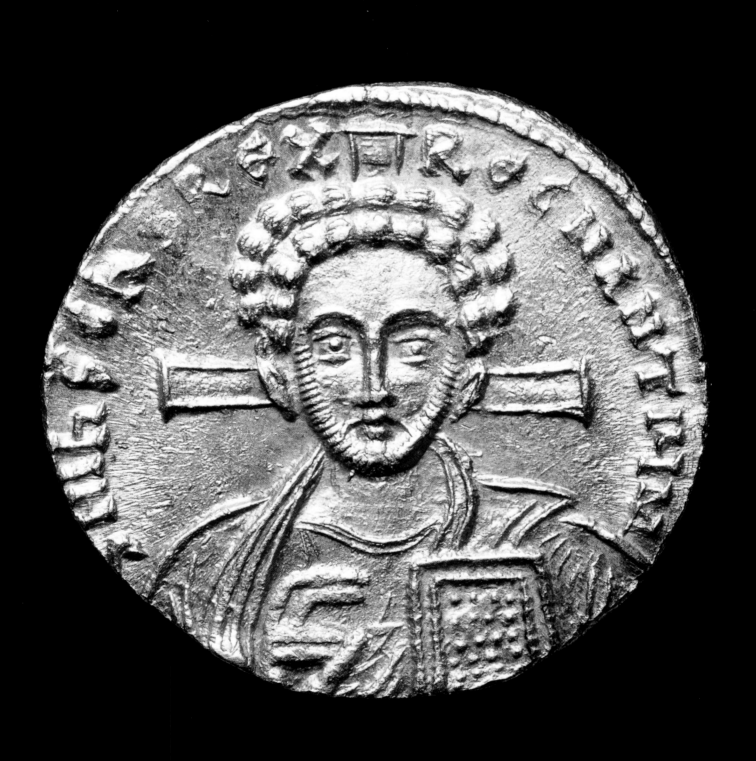

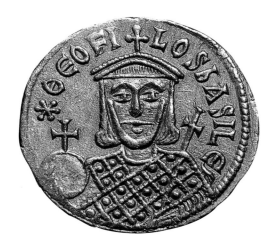

NOMISMA OF THEOPHILOS

Obverse: the Emperor Theophilos.
Reverse: Cross.
829-842, Constantinople, gold,
diameter 2 cm (3/4 in.)
Paris, Bibliothèque Nationale de France,
Cabinet des Médailles.

**ST DEMETRIOS BETWEEN
TWO DONORS, THE BISHOP
AND PREFECT OF THE CITY**
C. 670-680, mosaic.
Thessaloníki, Basilica of St Demetrios.

Pages 62-63
SOLIDUS OF JUSTINIAN II
Obverse: Bust of Christ.
Reverse: Justinian II.
705-711, Constantinople, gold,
diameter 1.8 cm (3/4 in.).
Paris, Bibliothèque Nationale de France,
Cabinet des Médailles.

The two and a half centuries following "the age of Justinian" were entirely taken up by struggle against Persian, Arab and Slav invaders who at times threatened the Empire's very existence. Everyday difficulties were further exacerbated by the outbreak of the well-known "iconoclastic crisis", or "controversy over images", which tore the Empire apart for over a century (726-843).

From the late 6th century the Empire began to break up. The Danube frontier collapsed and the region was abandoned by the Byzantines around 600. Slavs and Avars settled in the Balkans and Greece; only a few permanently besieged cities escaped occupation, notably Thessaloníki – saved by its mighty ramparts – Athens, and perhaps Corinth. In the latter two cities, however, as in several others, urban life retreated to the acropolis, deserting the vulnerable low-lying areas. In the early 7th century, the Persians launched a new offensive, laying to waste Asia Minor and invading Syria and Egypt between 619 and 629, jeopardizing Constantinople's supply of Egyptian wheat. They took Antioch and Jerusalem, where their king Chosroes seized the relic of the True Cross and carried it triumphantly back to Persia. In 626, they laid siege to Constantinople itself. Emperor Herakleios (610-641) was the providential leader who launched the counter-attack, defeated the Persians, reconquered Jerusalem in 627, and recovered the relic of the Cross. The magnificent silver plates discovered in Cyprus, depicting biblical episodes from the life of David and his fight with Goliath, and now shared between the collections of Nicosia Museum and the New York Metropolitan Museum of Art, were possibly made to celebrate this victory as they all bear pre-636 hallmarks. The chronicler Theophanes records, however, that to pay his troops Herakleios had much of the gold and silver plate which his predecessors had offered to the churches of the capital, notably Hagia Sophia, melted down. Above all, no sooner was the Persian danger averted than a new peril threatened the Empire: Arab conquest. Mahomet died in in 632. Four years later, the Arabs invaded Syria; the defeat of the Byzantine armies on the banks of the Yarmuk led to the definitive loss of Syria and Palestine, followed shortly by that of all Egypt. The Arabs gained de facto command of the seas. They moved north and were soon regularly ravaging Asia Minor, pushing on as far as the walls of Constantinople and laying siege to the city from 674 to 678, defeated only by the famous "Greek fire". Under a succession of weak Emperors, imperial authority was constantly beset by crisis. Justinian II (685-695 and 705-711) attempted to turn the tide. Despite several victorious campaigns in Armenia, under a battle-standard depicting the figure of Christ Blessing – which Justinian was the first to have stamped on coinage – he was deposed following setbacks. Reinstated in power, he was nevertheless unable to prevent the fall of Carthage (697) and the loss of North Africa. Finally, he was assassinated and his corpse flung into the sea. His short-lived successors were scarcely more fortunate and, by 717, the Arabs were once again besieging Constantinople. Leo III (717-741)

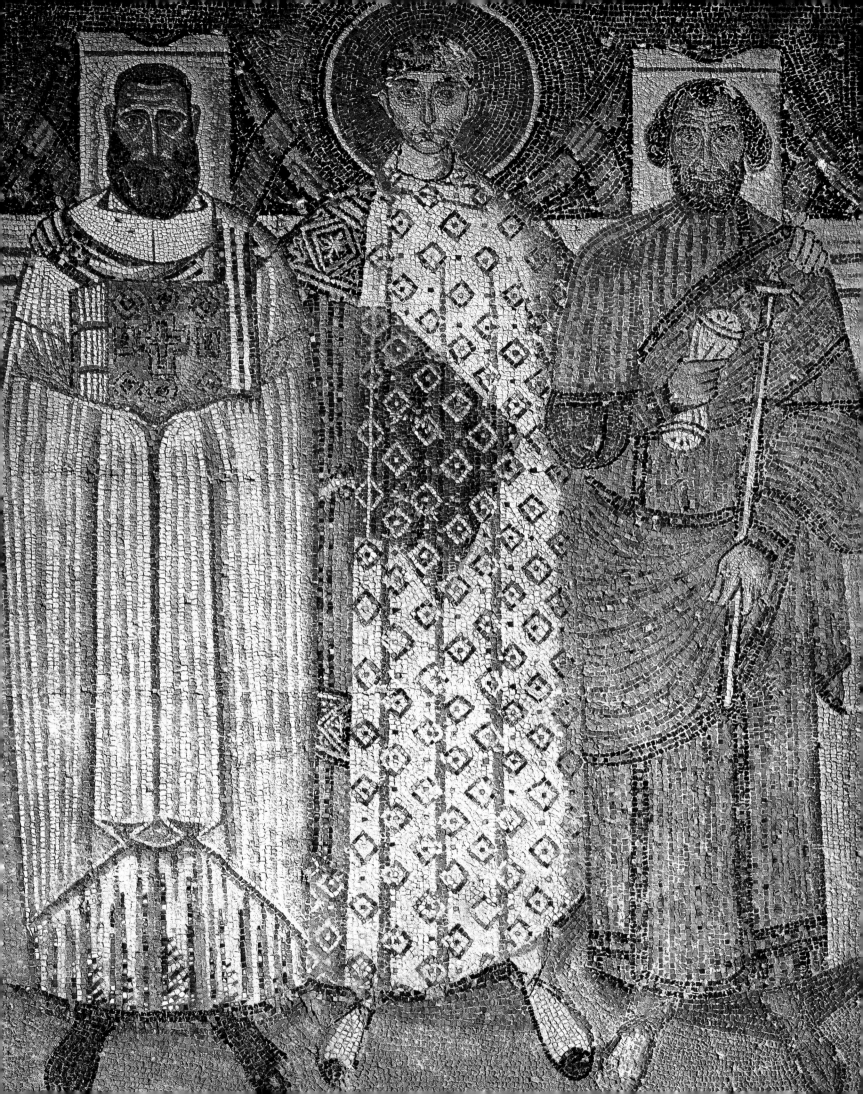

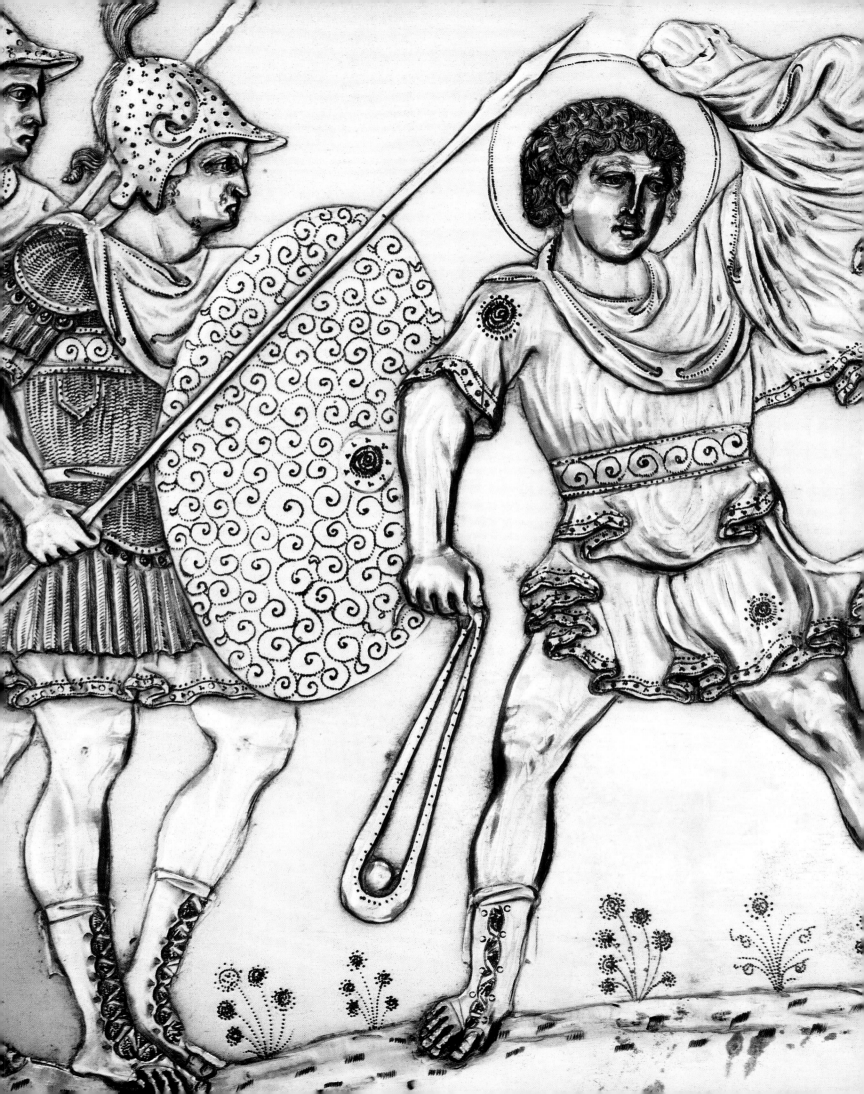

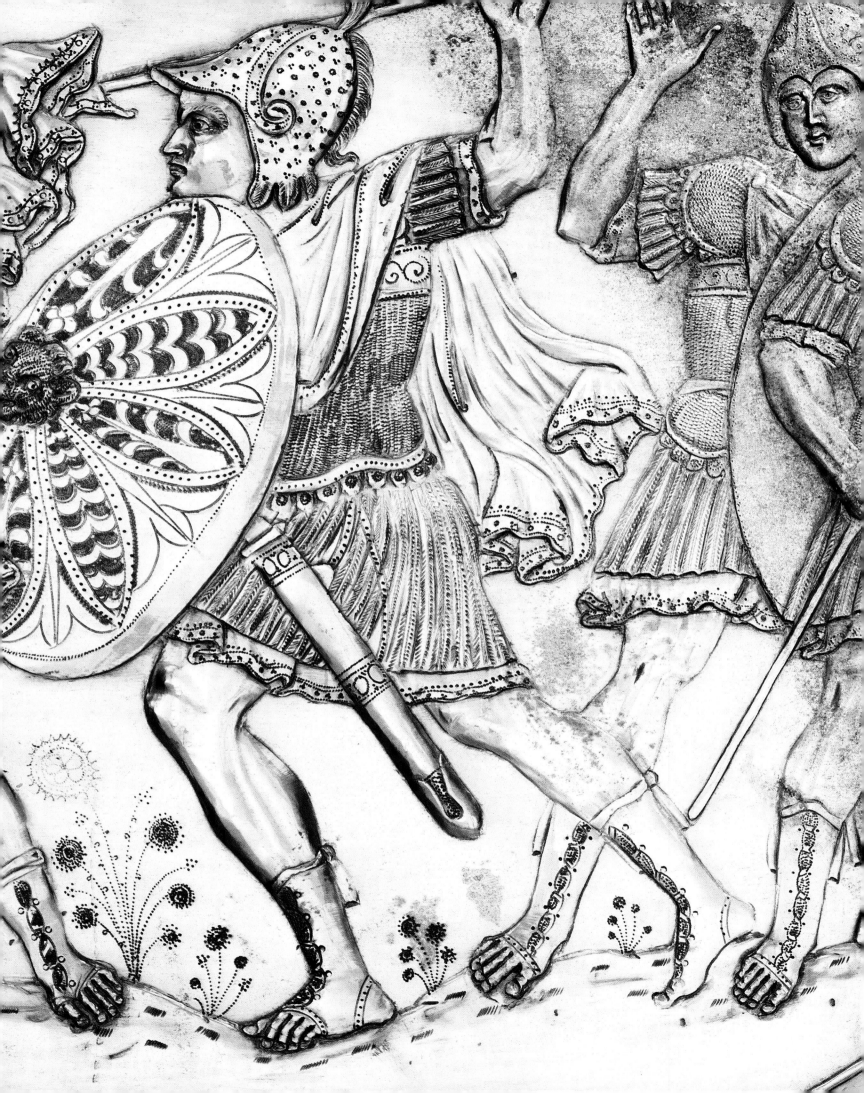

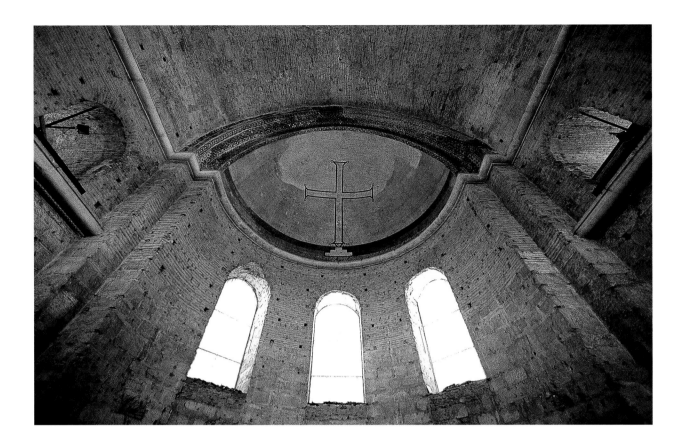

and his son Constantine V (741-775) saved the Empire. The siege of Constantinople was raised. Leo III repelled the Arabs and halted their advance in Asia Minor at the battle of Akroinon in 740. Constantine V redressed the situation in Greece and in the Balkans with regard to the Bulgars, but was powerless to prevent the fall of Ravenna to the Lombards in 751. In their unshakeable determination to restore the Empire however, the two Emperors imposed a brutal reversal of political and religious policy: iconoclasm.

The iconoclastic controversy

Iconoclasm was a religious doctrine which refuted the idea that material images (in Greek: *eikones*, "icons") could possibly express the divine or portray holiness. Accordingly, it opposed the worship or cult of images, banned their production and called for their destruction. Such a doctrine naturally assumed a political dimension when the Emperors decided to adopt it. Byzantine iconoclasm had multifaceted origins and motivations. Byzantine writers were to blame the Islamic prohibition of all divine representation which was said to have contaminated Christianity, particularly in the heresy-prone eastern regions of the Empire from where Leo III's family hailed. No doubt the personal beliefs of the Emperors also played a crucial role. The decrees of Leo III and his son can also

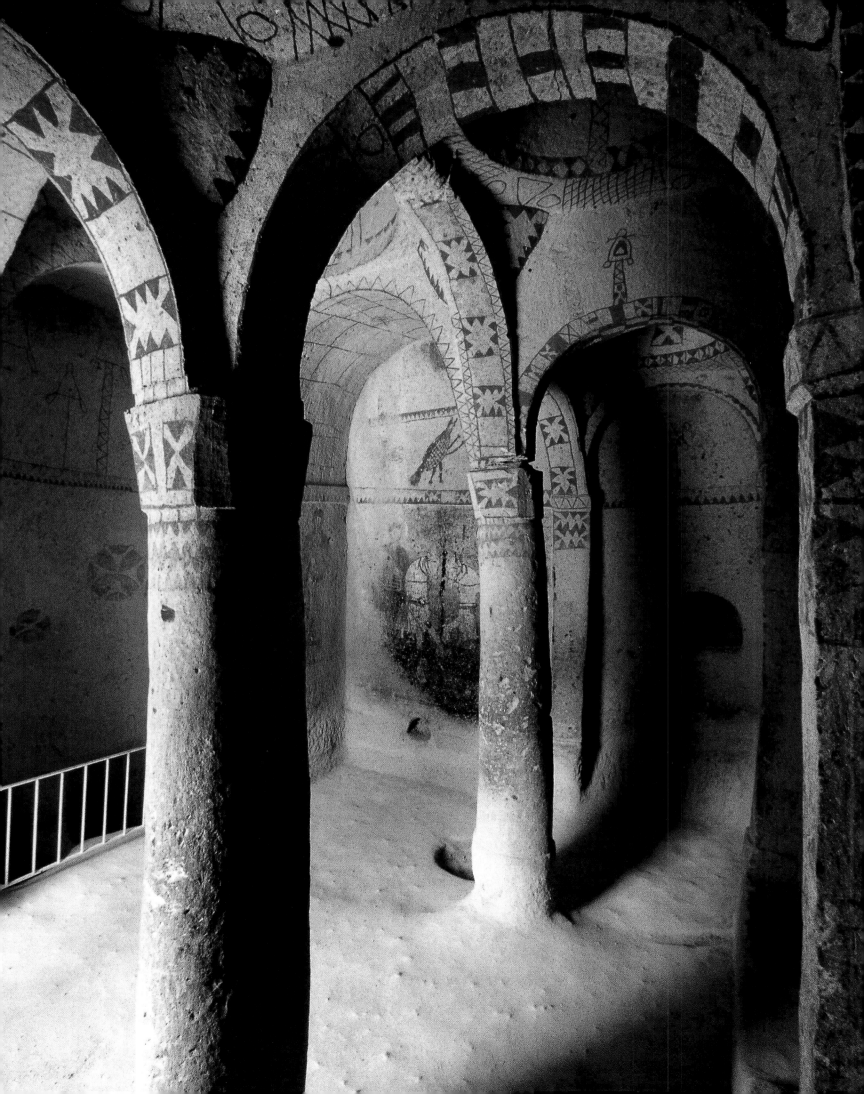

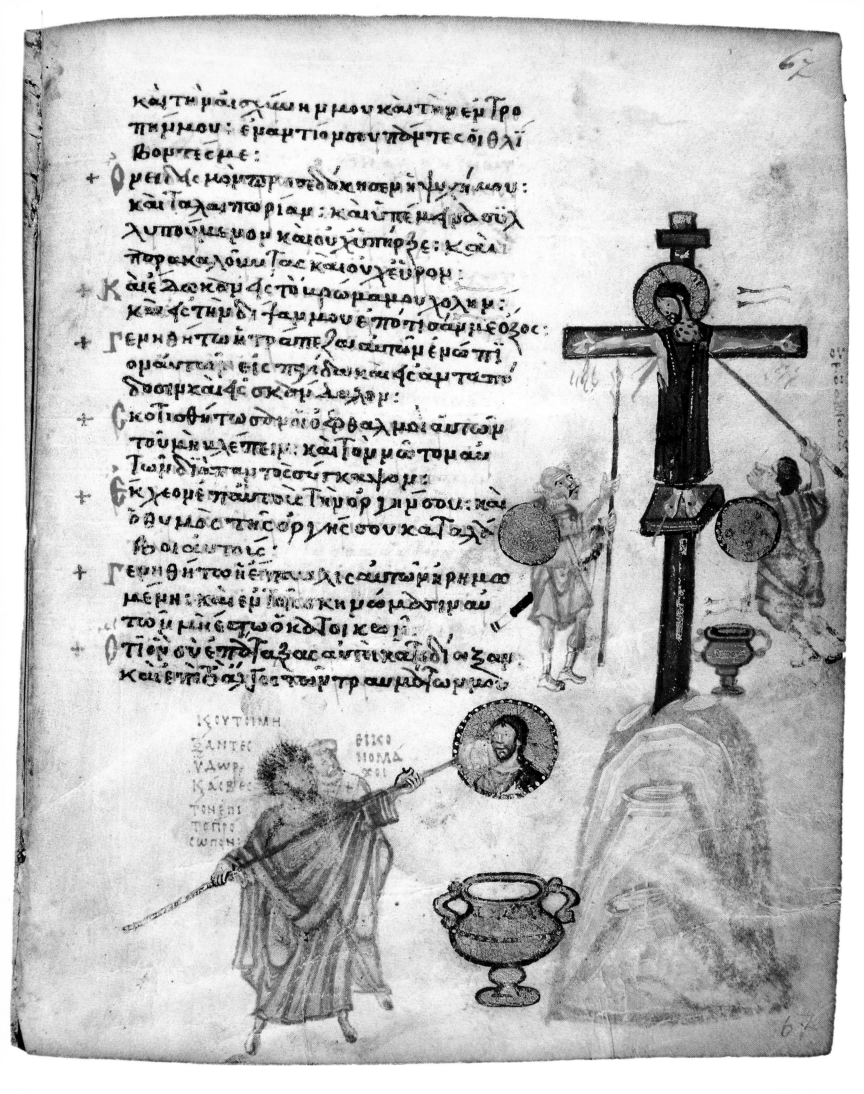

καὶτὴνρᾴσωνημμουκαὶτὴνἐντρο
πὴνμου· ἐναντίονμουπάντεςοἱθλί
βοντέςμε·

+ Ὁρειδεσμόνπαρεκάλεσενεἰψυχήμου·
καὶταλαιπωρίαν· καὶὑπέμειναδῆοὐχ
λυπούμενον· καὶοὐχὑπῆρχε· καὶ
παρακαλοῦντάςκαιουχεῦρον·

+ Καὶἔδωκανἐιςτὸβρῶμάμουχολὴν·
καὶἐστὴνδὶψανμουἐπότισάμεοξος·

+ Γενηθήτωἡτράπεζααὐτῶνἐνώπι
ὁμάντωνεἰςπαγίδακαὶεἰςἀνταπο
δοσινκαὶεἰςσκάνδαλον·

+ Σκοτισθήτωσανοἱὀφθαλμοὶαὐτῶν
τοῦμὴβλέπειν· καὶτὸννῶτοναὐ
τῶνδιαπαντὸςσύγκαμψον·

+ Ἔκχεονἐπ'αὐτοὺςτὴνὀργὴνσου· καὶ
ὁθυμὸςτῆςὀργῆςσουκαταλά
βοιαὐτούς·

+ Γενηθήτωἡἔπαυλιςαὐτῶνἠρημω
μένη· καὶἐντοῖςσκηνώμασιναὐ
τῶνμὴἔστωὁκατοικῶν·

+ Ὅτισὺὃνἐπάταξαςαὐτοὶκαταδίωξαν
καὶἐπὶτὸἄλγοςτῶντραυμάτωνμου

ΙΚΟΥ ΤΟ ΜΗ
ΞΑΝ ΤΗΣ
ΥΔΩΡ
ΚΑΙ ΒΑ
ΤΟΝ ΕΠΙ
ΤΟ ΠΡΟ
ΣΩΠΟΝ

Θ ΕΙΚΟ
ΝΟ ΜΑ
ΧΟΣ

be interpreted as an attempt to re-establish imperial authority in religious matters or even to restore the emperor cult. And persecution of the monks brought rich spoils to the State coffers. But purely religious factors were also decisive. Christianity had taken root in a Graeco-Roman society where the figurative and narrative traditions of classical art had very soon given birth to a religious art, despite some fairly swiftly allayed initial misgivings. By the 6th, and particularly the 7th century, no doubt due to growing insecurity, Byzantine religiosity was giving rise to disturbing manifestations of extremism. Icons depicting Christ, the Virgin and the saints indeed shared the holy essence of their models and, on this account, were infinitely venerable; some were even reputed to be *acheropoietes* (i.e. "not made by human hand"), created as if by some divine intervention. But on a popular level, devotees began to collect scrapings from the icons, claiming that the powder obtained was a miraculous panacea; on occasions, priests would go as far as mix this powder with the blood of Christ in the chalice. Some icons were believed to speak, others to shed tears. It was even said that a certain icon of Christ in Beirut had begun to bleed when it was struck by a Jew! Material image and spiritual reality became dangerously confused. It was such practices that iconoclasm set out to eradicate by all possible means. In 726, Leo III had the picture of Christ over the Imperial Palace gate destroyed and, from 730, despite opposition from the Patriarch and the Pope, ordered the destruction of all religious images. Constantine V went further. At the council summoned at the Palace of Hiereia in 754, the Emperor condemned not only the making, possession and cult of icons, but also the worship of relics, and called for adoration to be restricted to God alone. And he employed force to crush resistance. Opposition leaders Patriarch Germanus and the monk Stephen the Younger were executed. The monasteries, champions of the iconophile tradition, bore the brunt of persecution: monks were exiled and their goods seized by the State. Calm returned under Leo IV, Constantine VI, and his mother, Empress Irene, who restored the cult of images in 787. But a new wave of iconoclasm erupted in 815 under Leo V, who exiled the Patriarch and Theodore, Abbot of the Stoudios monastery, the focus of *iconodoule* thinking in the capital. This "second iconoclasm" was above all a Constantinopolitan phenomenon and, despite savage persecution under Theophilos in the years 827-837, was virtually restricted to court and government circles. In the Palace itself, the Empress and her daughters secretly continued to revere icons. On 11 March 843, a year after Theophilos' death, the orthodox cult of images was officially reinstated.

Art under the iconoclasts

Such a train of events was hardly favourable to the flourishing of the arts. In the 7th century, the break with classical antiquity was consummated and urban traditions finally collapsed. Many cities in Thrace, Greece and

Asia Minor were abandoned and left lying in ruin. Others, like Ephesus, moved to better protected sites or barricaded themselves within a small fortified *kastron*. Social life reverted to essentially rural communities; war, plague, and famine, moreover, brought demographic crisis. In Thessaloníki, a sudden raid by Avars or Slavs around 617 decimated the population, caught unaware gleaning subsistence in the fields beyond the safety of the ramparts. A new code of laws, the *Eclogue*, promulgated under Leo III, had to take into consideration such developments along with juridical practices that had become to a large extent customary. Trade routes disappeared. Even in Constantinople, the reduced population lived amidst monuments to a bygone glory, some of which were falling in ruins. The last public statue had been erected under Herakleios and there are no known buildings in the capital dating from the 7th and 8th centuries. Activity was restricted to repairs to a few monuments like St Irene, after the 740 earthquake or, above all, to reinforcing the defensive ramparts. And the situation was comparable elsewhere in the Empire. Despite its impressive size, the only provincial edifice of note, St Sophia of Thessaloníki, completed under Constantine VI and Empress Irene in the late 8th century, is a heavily built, thick-walled

**JOHN DAMASCENE, SACRA PARALLELA:
BUILDING A BOAT**
Literal illustration of four verses from
the Book of Wisdom of Solomon, 14, 2-5.
First half of the 9th century,
Greek workshop in Italy,
miniature on parchment.
Greek Manuscript 923, fol. 206 v,
36 × 23 cm (14 1/8 × 9 in.), detail.
Paris, Bibliothèque Nationale de France.

construction, more or less inspired by its grand 6th-century counterparts. Other vestiges of artistic activity are rare. One of the most interesting is also in Thessaloníki, in the church of St Demetrios where, around 670-680, three sides of the two east pillars in the nave, near the sanctuary, were embellished with decorative mosaicwork. St Demetrios is depicted several times in these scenes which were actually designed as commemorative plaques. Although the technique still displays confidence, there is a notable flattening of volumes which tends to abstraction and reveals the clear decline in classical tradition.

Under iconoclasm, much official activity no doubt consisted in destroying Christian figurative works, as has been immortalized in a famous miniature in the "Khludov Psalter" in Moscow, which depicts iconoclasts whitewashing an icon of Christ. Religious images were replaced either by large symbolic crosses – such as that to be seen at the top of the domed roof of the apse in St Irene in Constantinople, or those with single or double crossbars on the reverse side of coins – or by purely ornamental compositions. According to the *Life of St Stephen the Younger*, the holy images in the church of the Virgin at Blachernai were replaced by bird, animal and plant motifs. Religious images were forbidden in imperial art: not a

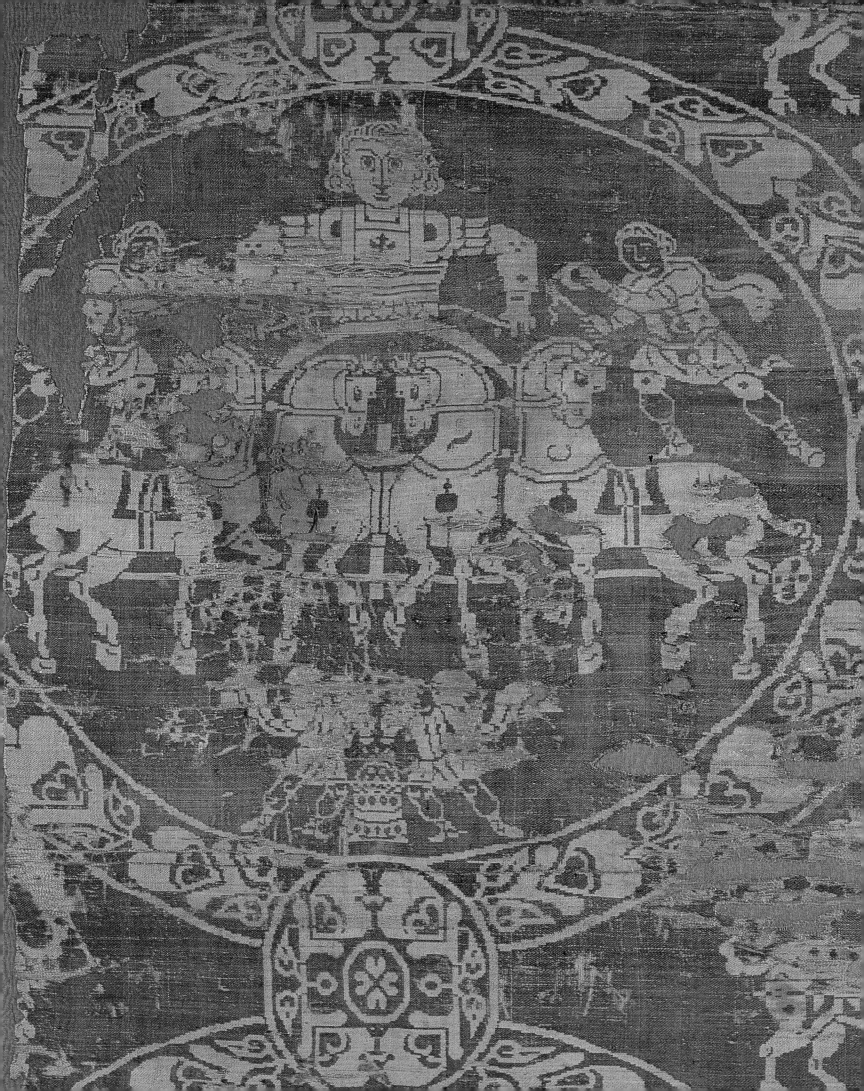

single example appeared in the manuscript of the works of Dionysius the Areopagite sent by the Constantinople court to the French king, Charles the Bald, in 827 and formerly kept in the Abbey of St Denis.

However, secular imperial art survived. Constantine V is known to have sent ambassadors bearing gold organs and other gifts to Pepin, Charlemagne's father. The Mozac Shroud in the Musée Historique des Tissus in Lyons, depicting a lion hunt and believed to have been donated by King Pepin to the abbey, was possibly among these gifts. The "Quadriga Shroud" covering the remains of Charlemagne at Aachen, a remnant of which is in the Musée de Cluny in Paris, also came from late 8th-century Constantinople workshops. These textiles, glorifying such quintessentially imperial themes as hunting and the Hippodrome games, are proof that the art of silkworking was still flourishing. The gold and silversmiths' art also continued to thrive in the capital, even if economic hardship brought decline, as witnessed by the discontinuation of the use of hallmarks. Indeed the chronicles have left us an amazed description of Theophilos' golden throne and its accompanying mechanical devices in the Palace of the Magnaura. On the other hand, it has been established that the bronze doors installed by the same Emperor in Hagia Sophia in 839 were not actually cast in the city itself: they were merely reused classical artefacts onto which silver strips representing the imperial monograms had been superimposed.

Yet not all the Empire espoused iconoclasm. Too many regions lay beyond the effective sway of State authority. At Mount Sinai and in distant monasteries icons continued to be painted. Cappadocian frescos maintained the tradition. In Italy and in Palestine, pockets of Greek culture were overtly iconophile. One of the most astonishing 9th-century manuscripts, now in Paris, the *Sacra Parallela* by St John Damascene, a staunch champion of images, should be attributed to one such source, probably in Italy, as André Grabar believed, rather than Palestine, as suggested by Kurt Weitzmann. This work, with its wealth of illustrations – more than one thousand six hundred, filling almost all the margins – is indeed a powerful iconophile profession of faith. However, the summarily executed drawing, absence of modelling, and thick contour strokes applied to a uniform gold ground all betray the vast gulf that lay

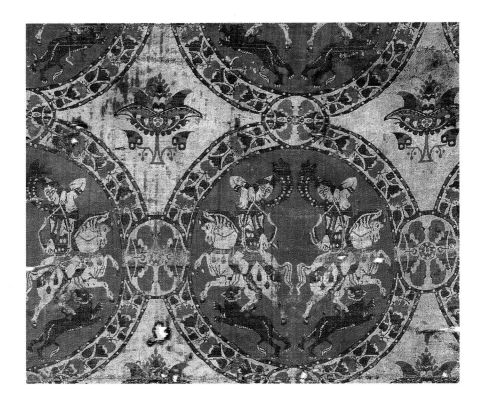

between it and its classical models. Finally, it was probably in monastic circles in Constantinople itself, at the height of persecution during the second wave of iconoclasm, that the "Khludov Psalter", also featuring numerous marginal illustrations, was written, even if it is not, as has been claimed without reasonable grounds, the work of the monk and painter Lazarus who had his hands branded by the iconoclasts.

Nevertheless, the opening years of the 9th century may have conceivably witnessed the beginnings of a revival in the imperial art of Constantinople. The Palace of Bryas, a few vestiges of which have survived, built by Theophilos on the Asiatic shore of the Bosphorus and echoing the sumptuous residences of the Omayyad Caliphs along with the pavilions he had laid out in the Grand Palace may have been the first signs of this revival, as well as attesting to a new inspiration. And when the iconoclastic controversy finally came to an end in 843, although the Empire had indeed lost more than half of its territory, foreign perils had been averted. Constantinople had not lain dormant. A salutary reorganization of political and religious power had been achieved by means of a series of reforms and gradual adaptation to new economic, military and social realities. Finally, iconoclasm, through its often bloody struggles, had enabled a veritable doctrine of images to be drawn up and an Orthodox line to be established for centuries.

3. The Byzantine Renaissance (mid-9th-late 12th century)

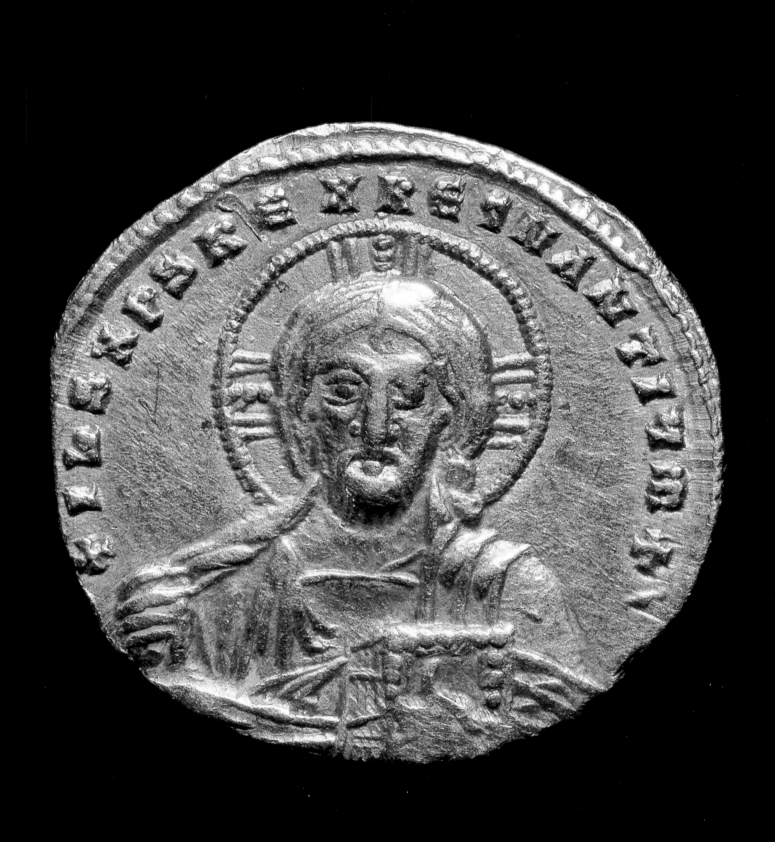

| Pages 78-79
NOMISMA OF CONSTANTINE VII
Obverse: Christ Pantokrator.
Reverse: Constantine VII
Porphyrogennetos.
945, Constantinople, gold,
diameter 1.9 cm (3/4 in.).
Paris, Bibliothèque Nationale de France,
Cabinet des Médailles.

The restoration of religious orthodoxy and the accession in 867 of Basil I, founder of the Macedonian dynasty (867-1056), inaugurated Byzantium's "second golden age". The Macedonians began by halting the Arab invasions then went on to win a succession of military victories unprecedented for three centuries. The reconquest of Crete (961) and of Antioch and Syria (969) by Nikephoros Phokas was followed by the triumphant Palestine expedition (975) of John Tzimiskes which pushed to within a few miles of Jerusalem. On the eastern front, these military successes were consolidated by the peace concluded with the Fatimids in 1001, and the capture of Edessa (1032) and of Ani in Armenia (1044). In the north, the Bulgars – powerful rivals whom conversion to Christianity by Cyril and Methodios in 864 had failed to subdue – were finally defeated in 1018 by Basil II, later known as Bulgaroktomos ("Bulgar-Slayer"). Reviving the most ancient traditions, Basil celebrated his triumph in both Constantinople and Athens. The Danube was once more the Empire's natural frontier. Farther afield, the "baptism" of Russia (989), followed by the marriage of Basil's sister, Anna, to Prince Vladimir of Kiev, sealed a long-sought political alliance. Finally, in the west, the capture of Bari (876) consecrated the effective resumption of Byzantine presence in south Italy. Never since the time of Justinian had the Empire appeared stronger nor its prestige more assured than under the reign of Basil II (976-1025).

Political and military apogee

In the capital, religious pacification, together with political and military consolidation, paved the way for the blossoming of a veritable intellectual renaissance. From 856, under the imperial aegis, a university was established at the Palace of the Magnaura. Consisting of four chairs – rhetoric or literature, geometry or mathematics, astronomy, and philosophy – it was where senior Church and civil dignitaries received their training. Classical Greek authors such as Homer (often used as a reading primer) and many others including Herodotus, Plato, Aristotle, Demosthenes, Thucydides and Plutarch were re-edited and served as models for a revived Hellenism. The work of the scribes was facilitated by the adoption of cursive rather than uncial script. These carefully composed new editions, annotated with scholarly marginalia, have handed down to us virtually everything we know about ancient Greek literature. Nor were the great early Christian writers forgotten: numerous, often lavishly illustrated editions of Basil of Caeserea, John Chrysostom and Gregory of Nazianzos were produced, while in his *Menologion*, based on erudite classical anthologies, Simeon Metaphrastes compiled the lives of the saints in the liturgical calendar. In fact, the well-spring of this hotbed of intellectual activity may well have been the iconoclastic controversy, during which the rival camps had turned to classical sources to seek vindication for their respective arguments.

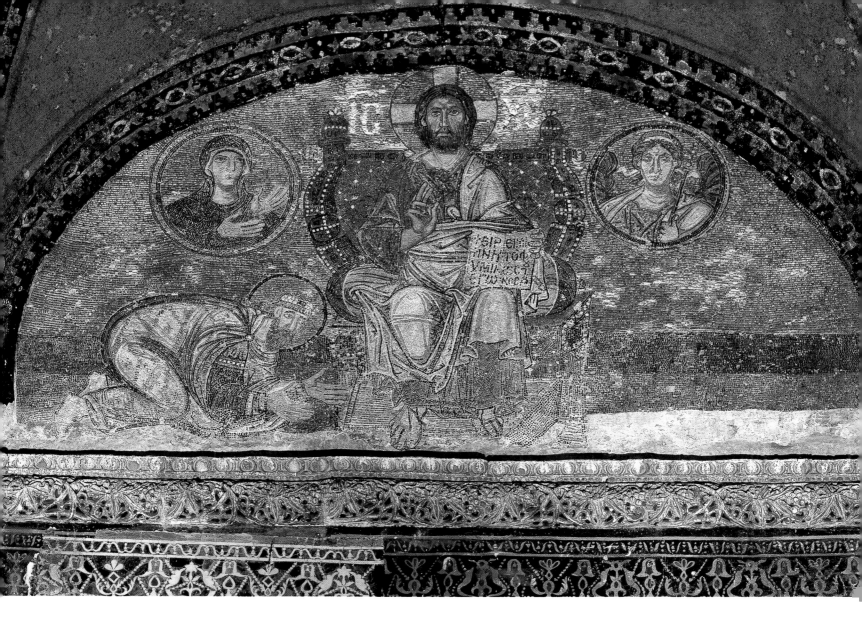

EMPEROR LEO VI
AT CHRIST'S FEET
Early 10th century, mosaic.
Istanbul, Hagia Sophia, narthex.

The Emperors played a decisive role. Despite his obscure origins, Basil I (867-886) acted as patron to the revival of law and literature. He was followed by his son Leo VI (886-912) who endeavoured to revise the legal corpus of the Justinian Code in his updated *Basilicae*. It was also during Leo's reign that the *Book of the Prefect* was written, regulating Constantinopolitan crafts. His son, Constantine VII Porphyrogennetos (913-959), long excluded from power by Romanos I Lekapenos, enjoyed ample leisure to devote himself to scholarship and the arts. Constantine wrote several political works including a *De Aministrando Imperio*, dealing with provincial administration and, above all, the famous *De Ceremoniis Aulae Byzantinae* or *Book of Ceremonies*, codifying court ritual and protocol – elements of which dated back to the Late Roman Empire – and which is an incomparable historical source for everything connected with Constantinopolitan life. The encyclopaedic spirit of the reign also manifested itself in the *Souda*, a veritable systematic compendium of knowledge, as well as in the *Geoponika* which dealt with all aspects of agriculture. These texts, like the *Book of the Prefect*, revealed an understandable preoccupation with economic matters. Even if it had not been

among the instigators of this intellectual revival, the metropolitan Church played its part, notably in the person of Patriarch Photios (856-886), one of the outstanding figures of the age, whose *Biblioteka*, a work composed in the style of the modern literary textbook, consisted of a biographical dictionary of secular and sacred authors since classical antiquity together with extracts from their writings. Around the Patriarch and leading intellectual figures, literary circles flourished at the court. Classical antiquity became the subject of scholarship and emulation, and Constantinople witnessed the blossoming of a veritable Byzantine "humanism". Artists, still surrounded in their daily lives by monuments of late antiquity which, moreover, the Macedonian dynasty endeavoured to restore, also turned to classical models. Classical statuary continued to embellish the fora and streets of the city. The imperial palaces, church treasuries, and libraries still housed collections of manuscripts, gold and siverplate, ivories and cameos dating back to the foundation of Constantinople: all had not been lost during the times of upheaval, and the storehouse of riches had swollen as the imperial domain gradually shrunk to the capital itself. Artists had at their disposal a formal, thematic and technical repertory which they could, if need be, bring back to life.

But did this renaissance spread beyond Constantinople itself? Apparently not. Until the mid-11th century, pockets of revival existed elsewhere, but only in places of imperial foundation where an essentially Constantinopolitan art already flourished. A few provincial cities – sparse urban oases in an otherwise overwhelmingly rural Empire – were indeed centres of intellectual activity but played little part in the remarkable and durable regeneration which occurred in the capital in the aftermath of iconoclasm.

The impetus continued into the 11th century. The teaching of law was entrusted to John Xiphilinus, the future Patriarch, and John Mauropous – also an acknowledged liturgist and poet – and under Constantine IX a revised syllabus was introduced at the Monastery of the Manganes. Leading figures of State were themselves often scholars, as in the case of Michael Psellos, known as the "consul of philosophers". Psellos turned his enquiring mind to history, theology, philosophy, alchemy and law, and in his books and correspondence – which have come down to us – contributed to the development of an elaborate neo-Platonic line of thought. The Empire, however, was changing. Basil II was succeeded by his weak brother, Constantine VIII who, on his death (1028), left only two daughters. Zoe, the elder, whose tempestuous love life and passion for unguents and perfumes have gone down in history, shared the imperial throne in turn with three successive husbands, then reigned conjointly with her utterly dissimilar sister, the credulous, devout and authoritarian Theodora. After years of alternate or joint rule by the two ageing siblings, at the whim of the court and Patriarch, the dynasty came to an end in 1056 on the death of Theodora. Psellos has sketched out for posterity a bleak portrait gallery of their lacklustre successors, catapulted

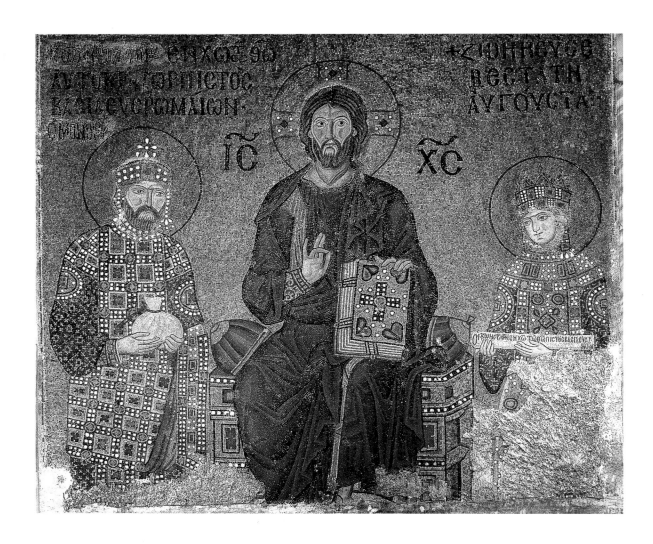

**CHRIST BETWEEN
CONSTANTINE IX MONOMACHOS
AND EMPRESS ZOE**

Mid-11th century, mosaic.
Istanbul, Hagia Sophia, south gallery.

to power by the army and constantly undermined by plots and intrigues. More ominous, however, was the renewed crisis in foreign affairs. In 1054, the breach between the Patriarchate of Constantinople and the See of Rome, latent ever since the iconoclastic controversy, was finally confirmed. The Orthodox schism became official, creating an even greater gulf between Byzantium and the West. In the east, the Seljuk Turks were on the march, and in 1071 they inflicted a crushing defeat on the Byzantine armies at the battle of Manzikert, near Lake Van; Cappadocia and Anatolia were lost and the gateway to all Asia Minor stood wide open to the Turkish advance. That same year, the Normans captured Bari; the Byzantine presence in south Italy was definitively over. The arrival in power of the Komnenos dynasty (1081-1185) put an end to this string of disasters. Alexios I (1081-1118) and John II (1118-1143) entered into alliances with Venice and Germany in order to repel the Norman threat, and defeated the Serbs and Hungarians. They skilfully exploited the turmoil created in the east by the First Crusade (1096-1099) and European settlement in the Latin States of Palestine and Syria, recovering some of the coastal regions in Anatolia and Cilicia. Despite often antagonistic relationships with the Latin West, particularly

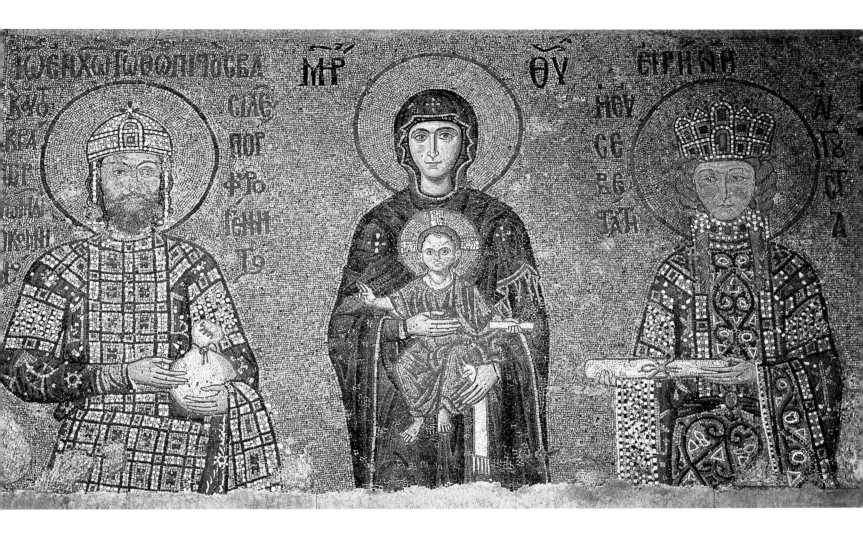

during the Second and Third Crusades (respectively 1147-1149 and 1189-1192), they thus ensured renewed and century-long stability to Byzantium. But they were powerless to check the gradual stranglehold of Westerners – particularly merchants from Venice and Amalfi – on the imperial economy. Notwithstanding their differences, Western chivalrous models exercised a genuine influence under Manuel I (1143-1180) who was sometimes accused of being a "Latinophile". The case remains, however, that the Byzantine renaissance was dazzlingly pursued under the Komneni. Figures like the grammarian Tzetzes or Archbishop Eustathios of Thessaloníki, the "master rhetor" of Hagia Sophia, carried on the scholarly work of their predecessors, studying Homer, classical Greek drama, and Pindar. Literature flourished. Among the most outstanding intellectuals, Anna Komnena, daughter of Alexios I, devoted herself, after the failure of her political ambitions and those of her husband, Nikephoros Bryennos, himself a historian, to the history of her father's reign in the *Alexiad*, taking Thucydides and Polybius as her models. The growing power of the aristocracy, both in Constantinople and in the provinces, led to the emergence of courtly poetry and prose "romances" composed with an aristocratic readership in mind. At the same time, the

VIRGIN AND CHILD BETWEEN JOHN II KOMNENOS AND EMPRESS IRENE
C. 1130, mosaic.
Istanbul, Hagia Sophia, south gallery.

MONASTERY OF CHRIST PANTOKRATOR
(ZEYREK KILISE CAMII), SOUTH CHURCH
First half of the 12th century.
Under the Ottomans, the original
four red marble columns
were replaced by four piers.
Istanbul, Turquey.

revival spread beyond the capital. The Empire witnessed an urban regeneration; cities like Ephesus, Nicaea and Corinth enjoyed relative prosperity and could thus open up to the new Constantinopolitan spirit. This was also the case with Thessaloníki and Athens, where Michael Koniates, disciple of Eustathios of Thessaloníki, elected archbishop in 1182, composed an elegy about the city, and drew up a register of its antiquities. It was also during the 12th century that the influence of Byzantine art attained its apogee, perceptible not only in Sicily and Italy but equally throughout the rest of Europe, the Slav countries, Armenia and Russia.

The Fourth Crusade was brutally to curtail these glorious centuries of Byzantine history. The Crusaders' army assembled in Venice, originally intending to attack the Ayyubids – who had reconquered Jerusalem in 1187 and expelled the Latins from the Holy Land – from the rear, via Egypt. Lacking sufficient funds, they were diverted by their Venetian creditors to Constantinople which was stormed on 13 April 1204 and put to the sack for three consecutive days. Baldwin, Count of Flanders and Hainaut, was proclaimed Emperor and crowned in Hagia Sophia. A Venetian, Tommaso Morosini, was elected Patriarch by the Crusaders who shared out the spoils of the Empire.

An architectural revival

From the mid-9th century, architecture showed every sign of a revival – expressed by the frequent use of the adjective "new" *(neos, kainos)* applied to all sorts of edifices – the continued effects of which were, over more than three centuries, to produce a vast range of remarkable buildings. Yet the architecture of the middle Byzantine period as it stands today in surviving monuments is essentially religious. In general, this no doubt roughly corresponds to the historical reality. Public building projects scarcely involved more than routine, indispensable repair works and no attempt was made to revive the civic architectural traditions of classical antiquity. In Constantinople, the urban infrastructure of public roads and streets, cisterns, ramparts and city gates inherited from the Justinian age was regularly maintained, but real architectural activity was concentrated elsewhere, on tangible symbols of imperial power – churches, imperial palaces and the Hippodrome. Basil I alone restored more than thirty churches and built eight within the precincts of the

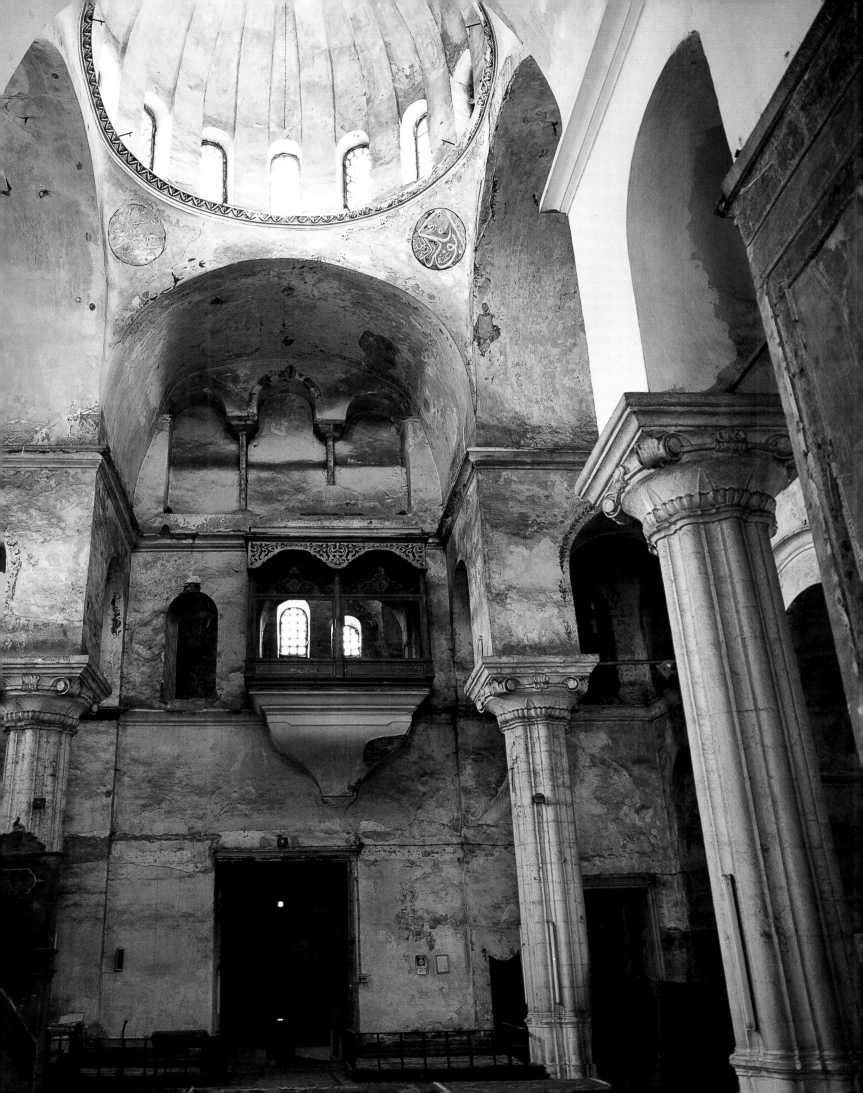

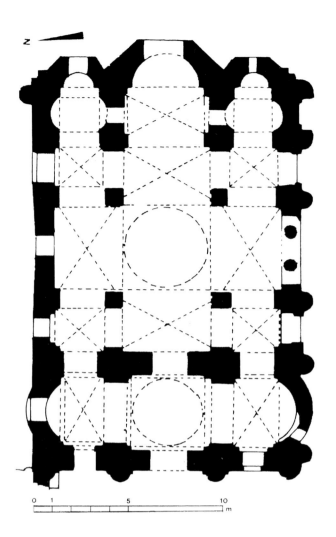

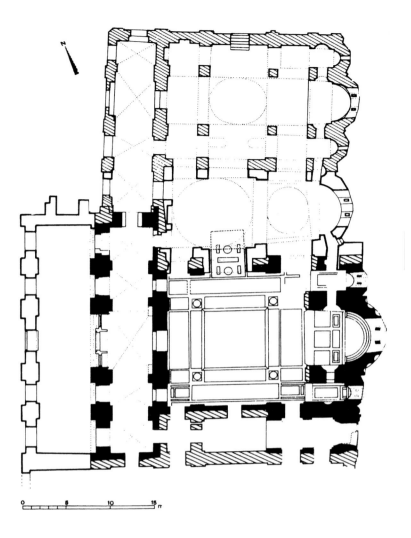

CHURCH OF THE MYRELAION (BODRUM CAMII)
Plan of the upper church.
First half of the 10th century.
Istanbul, Turquey.

MONASTERY OF CHRIST PANTOKRATOR
Plan of the three churches.
Istanbul, Turquey.

Great Palace, where he had also installed a "new" reception hall, the *Kainourgion*, embellished with marble and onyx columns and mosaics. Constantine VII restored the state rooms of the *Chrysotriclinium* in the Palace with facings of gold and silver; on the *spina* in the Hippodrome, he enhanced a stone obelisk with bronze decorative plaques, as the surviving inscription attests. And both these Emperors were emulated by their successors. The Komneni, however, neglected the Grand Palace and preferred to live in the north-west of the city at the Blachernai Palace, which they installed in lavish style and had converted into a fortress, no vestige of which has survived. In the provinces, public building work was confined to maintenance. In Thessaloníki, the mighty ramparts were regularly repaired, as is attested by inscriptions. Elsewhere, it was above all the *kastra* – erected in earlier times in response to the urgent reality of daily protection – which were carefully maintained. It would appear, finally, that civil architecture, about which practically nothing is known, experienced no major developments.

Under the Macedonians and Komneni therefore, new architecture focused mainly on the building of churches and monasteries. These, unlike their counterparts in the early Byzantine period however, were no

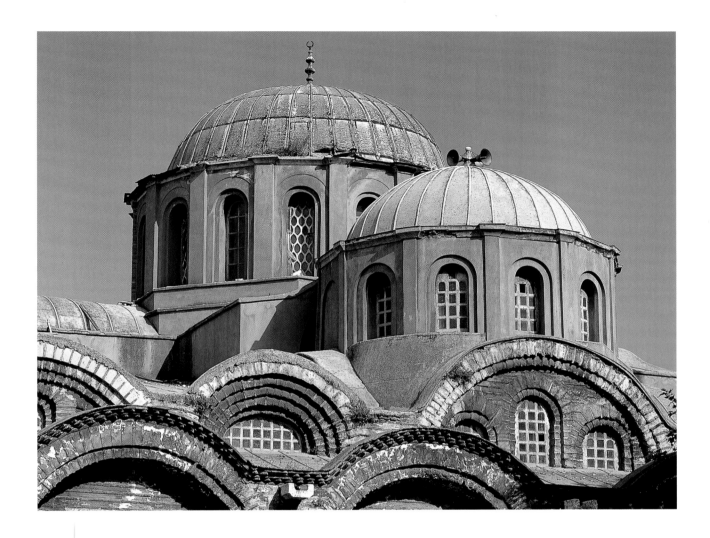

MONASTERY OF CHRIST PANTOKRATOR
Domes of the south
and middle churches,
seen from the east.
Istanbul, Turquey.

longer vast edifices; instead, the churches were almost always small, adapted to the needs of small communities. Building techniques inherited from classical tradition – the use of brick, occasionally with alternating courses of stone or marble – were used to create a quite different result. Post-iconoclasm Byzantine churches were also characterized by the widespread adoption of a standard type, known as the "inscribed Greek cross", in which plan and elevation were laid out around a dome – the diameter of which rarely exceeded a few metres – supported by four columns or by small pillars, and placed in the centre of a regular cross forming the nave *(naos)*, itself inscribed in a square. The identical arms of the cross were roofed with transversal barrel vaulting which ingeniously buttressed the dome, while the four spaces between the arms of the cross, in the corners of the square, had either groin vaulted roofs or were surmounted by secondary domes. In addition, most churches included, on the west side, a vestibule, or narthex, often accompanied by a second outer narthex, or *exonarthex*. The narthex could also extend beyond the façade to provide access to one or two lateral corridors, or *parecclesia*, running along the side of the building. Finally, the extremely simple chevet consisted of a semi-circular, or cant-walled apse which might also be flanked by two further

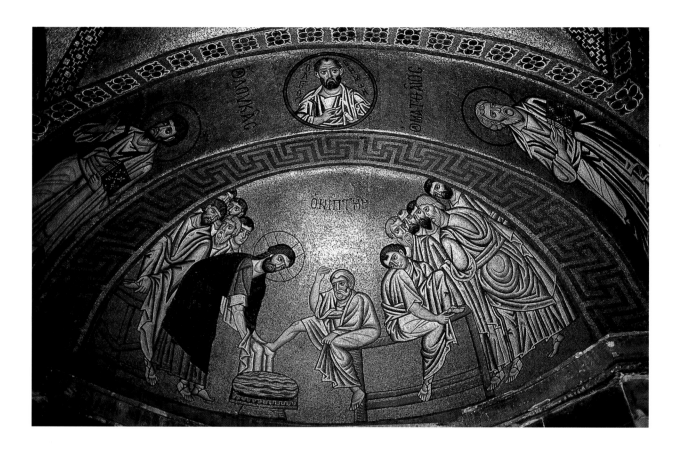

CHRIST WASHING THE APOSTLES' FEET

First half of the 11th century,
mosaic.

Phokis, St Luke (Hosios Loukas), narthex, Greece.

MONASTERY OF ST LUKE, PHOKIS

Interior view of the katholikon.
First half of the 11th century.

Hosios Loukas, Greece.

apses opening on the eastern corner spaces to form a lateral chapel on either side of the sanctuary, or *bema*.

The domed, "inscribed Greek cross" type of church did not belong to pre-iconoclastic architectural tradition, even if the origins of the dome with supporting transversal barrel vaults could be traced back to the monumental buildings of the 5th and 6th centuries. The smaller size of the new churches was designed with smaller congregations in mind, suggesting that the real origin of the type may have been monastic. The rise of monasticism, against which the iconoclasts pitted their efforts in vain, indeed constituted one of the key characteristics of medieval Byzantine spirituality. Monasteries proliferated in both cities and rural areas, invariably displaying the same features as those already present at Justinian's foundation at Mount Sinai. Within high walls, the church stood alone in the centre of a huge courtyard and was surrounded on two or more levels by monastic buildings – cells, refectory *(trapeza)*, kitchens, storerooms, cistern or well, baths, etc. – which formed a sort of miniature autonomous city. The best known examples are the Mount Athos monasteries, still in use today, and of which the most ancient, the Great Lavra, was founded in 961 by St Athanasios on one of the arid promontories of Chalcidice. They were usually inhabited by no more than a few monks who lived on the revenue from land granted by the founders and often undertook charitable work, particularly in towns where many were responsible for hospitals, orphanages, or homes for the

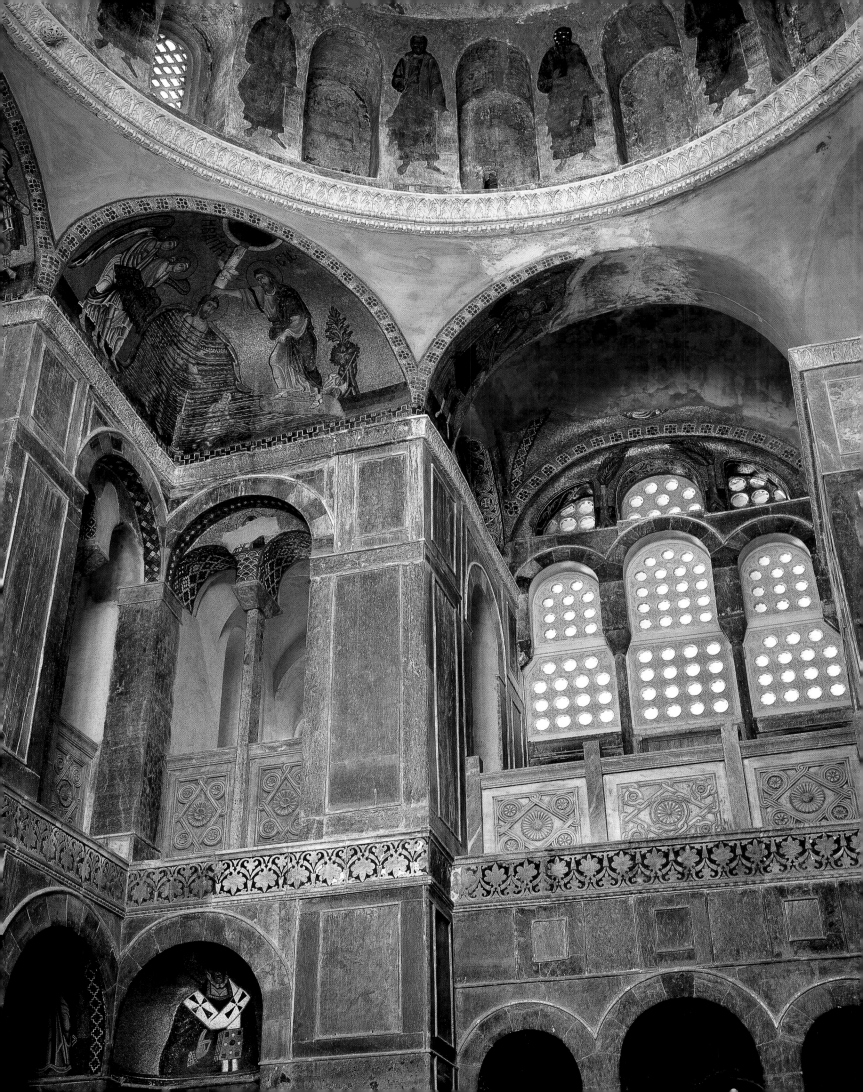

aged and needy. Dozens of such institutions existing in Constantinople alone. A number of archival documents shed light on the reality of their day-to-day life. For instance, the will of the "Great Domestic", general and *kouropalates*, Gregory Pakourianos, drawn up in 1083, contains the *typikon*, or foundation charter, of the monastery he founded at Petritzos near Bacovo in Bulgaria, where he himself and his brother were to be buried. It lists his properties and revenues, gives an inventory of the moveable goods (icons, utensils, liturgical items, books, etc.) and sets out the detailed rules governing the daily lives of the fifty-one monks.

The Nea, or "new" church, built around 880 by Basil I at the Great Palace, was one of the very first "inscribed Greek cross" edifices and is relatively familiar to us from surviving descriptions. It was a small building. The central dome stood on four marble – no doubt classical – columns, with four smaller domes at each corner of the square. It was lavishly decorated throughout: the walls and floor were lined with multi-coloured marbles, and the vaults were covered with dazzling mosaics; the chancel and altar were faced with gold, silver and precious stones; outside, the glistening domes had a remarkable covering of copper leaf. The Nea represented an ideal model which was immediately copied. In Constantinople, the north church in the Constantine Lips monastery (Fenar Isa Camii), built under Leo VI, and that of the Myrelaion (Bodrum Camii), built after 920 by Romanos I Lekapenos, are the finest examples. Exterior features such as the blind arcades of the Lips church, or the engaged pilasters articulating the elevation of the Myrelaion, attest to a genuine concern for external appearance. Inside, both churches were embellished with mosaics and marble, the only surviving vestiges of which are a few sculpted elements on the level of the cornices and windows in the apse. The Constantinopolitan model spread throughout the Empire and tended to be swiftly adopted in churches. In Greece, in the latter half of the 9th century, the church of St Andrew of Peristerai, near Thessaloníki, was still built on an old-fashioned quatrefoil plan surmounted by domes. But the Dormition at Skripou in Boeotia, dated by its inscriptions to 873-874, already displayed a transitional approach, with a central dome buttressed by four transversal barrel vaults. The church is remarkable for its reused ancient stones, notably the marble column drums turned on their edges to form an astonishing wheel decoration on the exterior walls. By the 10th century, on the other hand, the "inscribed Greek cross" plan, with its central dome standing on four columns, had become the standard type. It was found notably at the church of the Theotokos at the monastery of St Luke in Phocis (Hosios Loukas) which features an external décor of Islamic-inspired pseudo-Kufic motifs which were becoming fashionable at that time. In the early 11th century, the Panagia ton Chalkeon in Thessaloníki was built on the Constantinopolitan model but the exterior elevation, enlivened by a continuous cornice highlighting the building's two storeys, was further engaged pilasters and projecting windows. Under the Komneni,

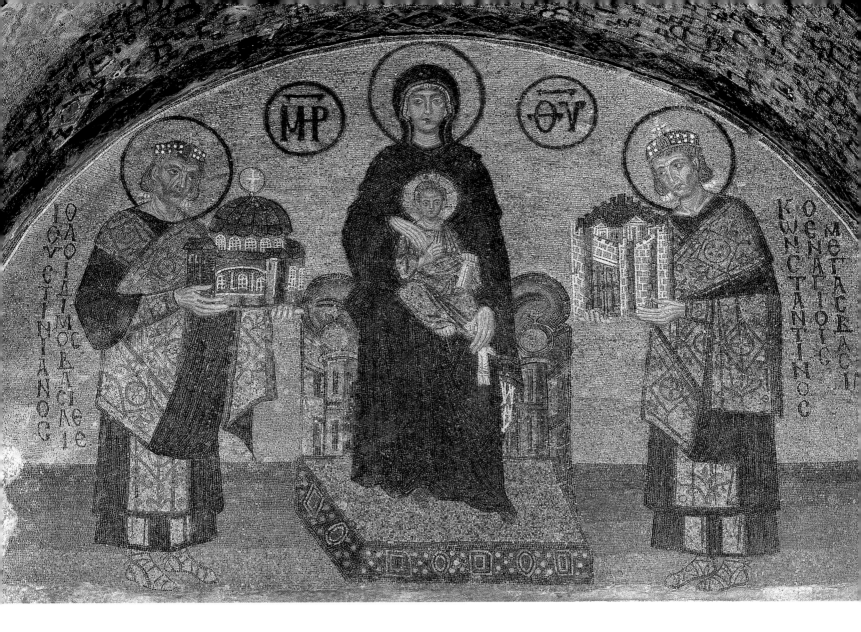

most churches continued to adopt the 10th-century type of plan. In Constantinople, this was the case with the church of Christ Pantepoptes (Eski Imaret Camii), built around 1100 by Anna Dalassena, mother of Alexios I, and with the three churches of the Christ Pantokrator monastery (Zeyrek Kilise Camii), the prestigious foundation destined to become the dynastic burial place. The south church, dedicated to Christ and built between 1118 and 1124, has a single large central dome, about twenty feet (7 metres) wide, which originally stood on four columns; around 1130, a second church, identical in structure and dedicated to the Virgin, was built and linked to the first by means of a third, twin-domed building housing the imperial sepultures, and by common narthexes. With their forcefully articulated exteriors, vestiges of a lavish marble interior décor, and *opus sectile* paving with a decoration of peopled scrolls, these churches represent the crowning achievement of Komnenian architecture.

Yet such apparent uniformity should not obscure the emergence of a number of 11th-century buildings displaying profoundly original features. One of the most interesting is the church of the Nea Moni

ENTHRONED VIRGIN AND CHILD BETWEEN CONSTANTINE AND JUSTINIAN
10th century, mosaic.
Istanbul, Hagia Sophia, south vestibule.

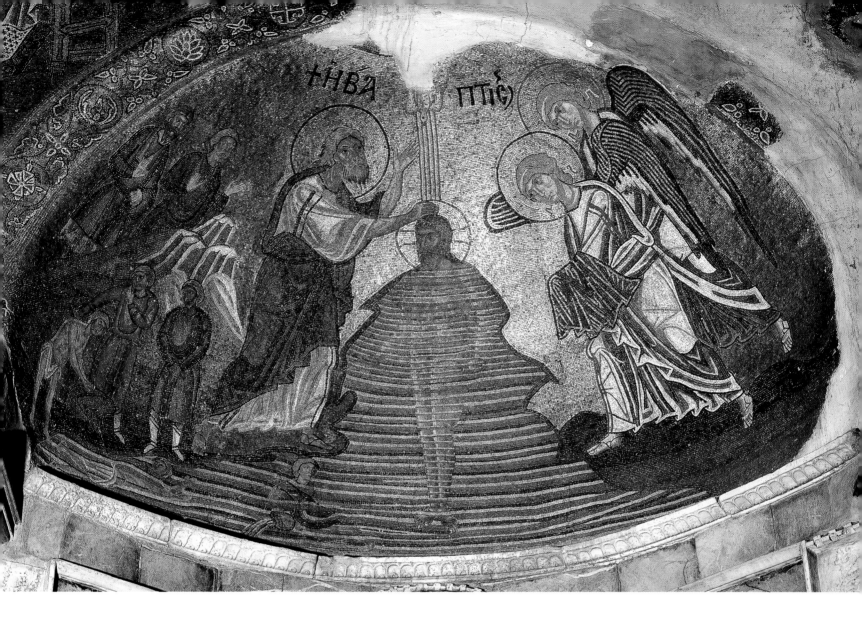

ΗΒΑ ΠΤΙC̄

THE BAPTISM OF CHRIST
Mid-11th century, mosaic.
Chios, Monastery of the Nea Moni,
south wall niche.

monastery built on the island of Chios by Constantine IX Monomachus from 1045. The respectably large dome (over 20 feet [7 metres] wide) sits directly on the walls of a square nave which has no aisles; an ingenious system of niches and corner squinches in the upper sections ensures the transition between the square and the circular base of the dome. The exterior is elegantly articulated by large blind arcades, while the three small domes on the narthex echo the projecting dome which soars above the nave on a high drum. This type spread throughout Chios and as far as Cyprus. A second building, the *katholikon* at Hosios Loukas, next to the church of the Theotokos, is also outstanding for the use of a single dome on squinches, entirely surrounded by raised groin-vaulted spaces, in turn surmounted by similarly groin-vaulted galleries. This type is found elsewhere in Greece, in Athens (Panagia Lykoudemou), and, in a simplified form without galleries, at Daphni near the ancient site of Eleusis. The "Athonite" type, characteristic of the Mount Athos churches, is also distinguished from the conventional models by a number of features probably related to a specific liturgy: a trefoil shape capped by a central dome, flanked by lateral chapels and preceded by a deep narthex and

a vast exonarthex, a type perhaps introduced at the Lavra *katholikon* in the days of St Athanasios.

The interior of the relatively small medieval Byzantine church – capped by a central dome and opening on to an apse designed on a human scale – constituted a kind of microcosm ideally suited to the official iconographic programme adopted in the aftermath of the Orthodox victory. Dominating the entire church, the bust figure of Christ Pantokrator ("All-Sovereign"), raising his hand in blessing, occupied the dome; in the vaulted apse was the standing or enthroned figure of the Virgin and Child, representing the Incarnation, accompanied in certain cases by the archangels Michael and Gabriel; beneath Mary, near the altar, the representation of the Church Fathers associated them with the celebration of the Eucharist; on the sanctuary vault, the Pentecost symbolized the descent of the Holy Ghost to the place of celebration; on the walls of the nave, the squinches of the central dome and the supporting barrel vaults, were depictions of key Gospel episodes, from the Annunciation to the Dormition of the Virgin – these were often twelve in number *(dodekaorton)*, corresponding to the twelve major feasts in the liturgical calendar; in

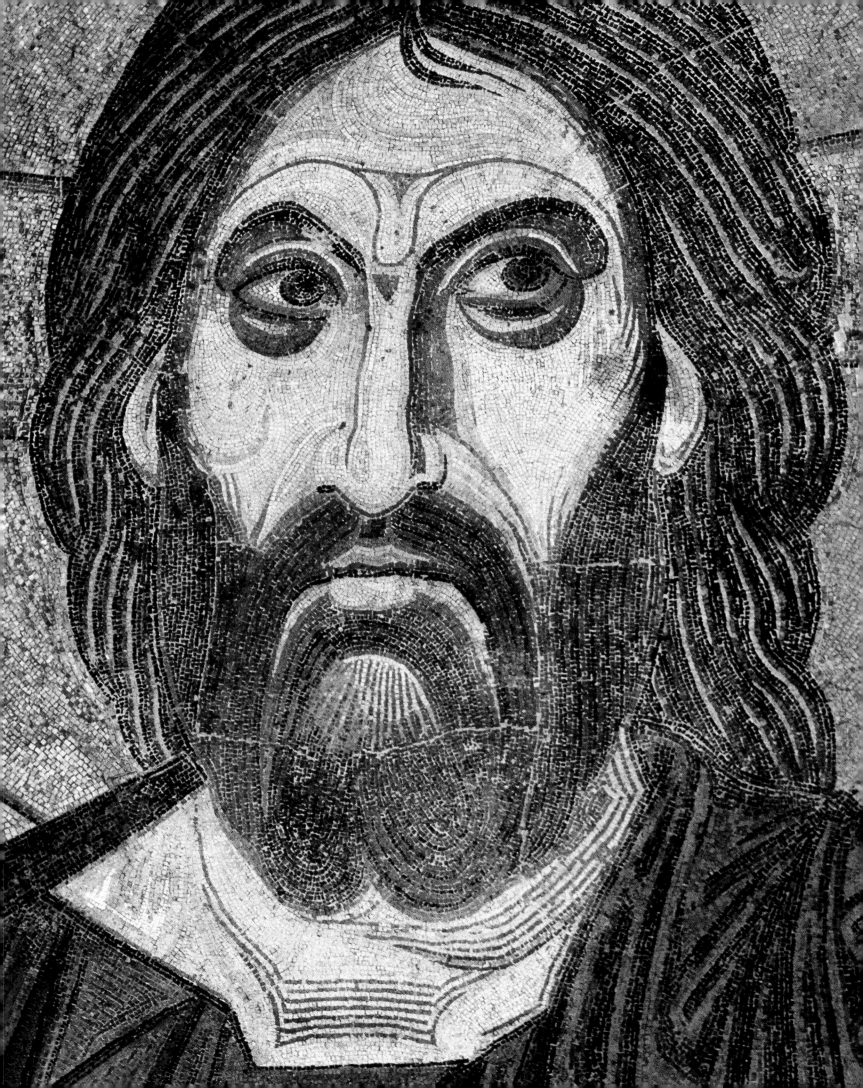

churches where the dome was supported by piers, these were embellished with portraits of the great martyrs, while the remaining spaces – secondary domes, groin-vaulted areas and narthex – were filled with full-length or medallion bust figures of the prophets, apostles and saints. This hierarchy remained standard until the late 12th century. Although allowing for several variants, between the late 10th and the late 11th century it developed fully in celebrated mosaic ensembles – Daphni, Hosios Loukas, and Nea Moni on Chios – by the finest Constantinopolitan artists. These décors are characterized by their faultless execution, noble yet restrained style, echoes of classical models, and striking contrasts between bright colours and shimmering gold backgrounds. In less richly endowed churches mosiacs were replaced by frescos, but the theological programme remained more or less unchanged. This was the case in Cyprus in the 11th and 12th centuries (St Nicolas tes Steges, Asinou, Holy Apostles at Perachorio), in 11th-century Macedonia at St Sophia of Ohrid, and at St Panteleimon of Nerezi, a church founded by a Komnenian prince in 1164, where the admirable Lamentation *(Threne)* of Christ expresses a new emotional intensity which typified the ultimate phase of Komnenian art. This increasing dramatization was heightened by the use of blue grounds and the specific subtlety of fresco painting. Even farther afield, in Cappadocia from the late 10th century, the fresco décors in the troglodytic churches carved in the rock almost invariably conformed to the norm; on any single site – for instance Göreme, Cavuçin or the Peristrema valley – a provincial, even outmoded or occasionally vernacular style was to be found alongside a purely Constantinopolitan one. Moreover, iconographic progamme and church architecture were so perfectly complementary that when the Byzantines tried to adapt the former to older buildings the attempt usually misfired. In the aftermath of the victorious Orthodox outcome to the iconoclastic controversy, a monumental Ascension of Christ – a circular composition in which Christ was surrounded by the apostles and the Virgin – was added to St Sophia of Thessaloníki, filling the entire interior of the dome, while in the apse, the iconoclasts' cross was replaced by an enthroned Virgin and Child. Although the mosaicwork is extremely beautiful, there is no relation between the theophanies, isolated from each other by vast architectural volumes which deprive them of coherence. Similarly, in Constantinople, the latter half of the 9th century witnessed an attempt to apply to Hagia Sophia the same iconographic programme being developed in other churches in the capital. But the gigantic enthroned Virgin and the two archangels in the apse seem lost in the vast space, and the figures of saints, bishops and prophets appear puny and insignificant against the immense north tympanum wall of the nave. Other than in the nave, a number of quite separate mosaic décors were also added to Hagia Sophia. The surviving examples are principally imperial votive panels. One of the most famous is above the main door of the narthex. It depicts an Emperor, probably Leo VI, prostrated at the feet of enthroned Christ, who is

CHRIST PANTOKRATOR
Details. C. 1100, mosaic.
Daphni (Greece), Monastery/Museum.

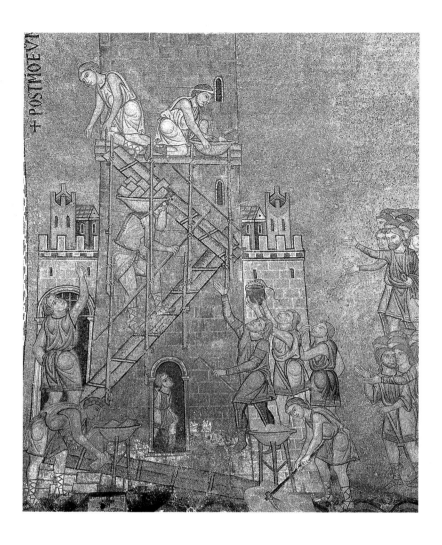

BUILDING THE TOWER OF BABEL
First half of the 13th century.
Venice, Basilica of San Marco, narthex.

BASILICA OF SAN MARCO
View of the domes in the nave,
from the west.
Late 11th/12th century.
Venice, Italy.

flanked by medallion figures of the Virgin and an archangel. Despite certain ungainly aspects in the execution, the pronounced features of the staring faces, the handling of the drapery, and the superimposed stripes of colour suggesting ground and space reveal the extent to which late 9th-century artists were still stylistically and pictorially reliant on classical models. In the south vestibule, the panel in the lunette above the door, dating from the 10th century, provided a reminder that Constantinople was under the protection of the Virgin, shown enthroned in the centre, giving her blessing with the Infant Jesus on her knee. It also glorified Constantine and Justinian, portrayed on either side of the Virgin to whom the former had dedicated the City, and the latter Hagia Sophia, the most prestigious monument of his reign. These were commemorative, and at the same time hagiographic portraits of the two greatest Byzantine historical figures, of whom the Macedonian Emperors claimed to be the heirs. With their delicately blended tones of variegated colour, and the technical perfection with which the stone and glass tesserae progressively diminish in size to give a more refined portrayal of the facial features, they are masterpieces of the Byzantine renaissance. Other votive mosaics have also been conserved in the galleries. One of these, in the north gallery,

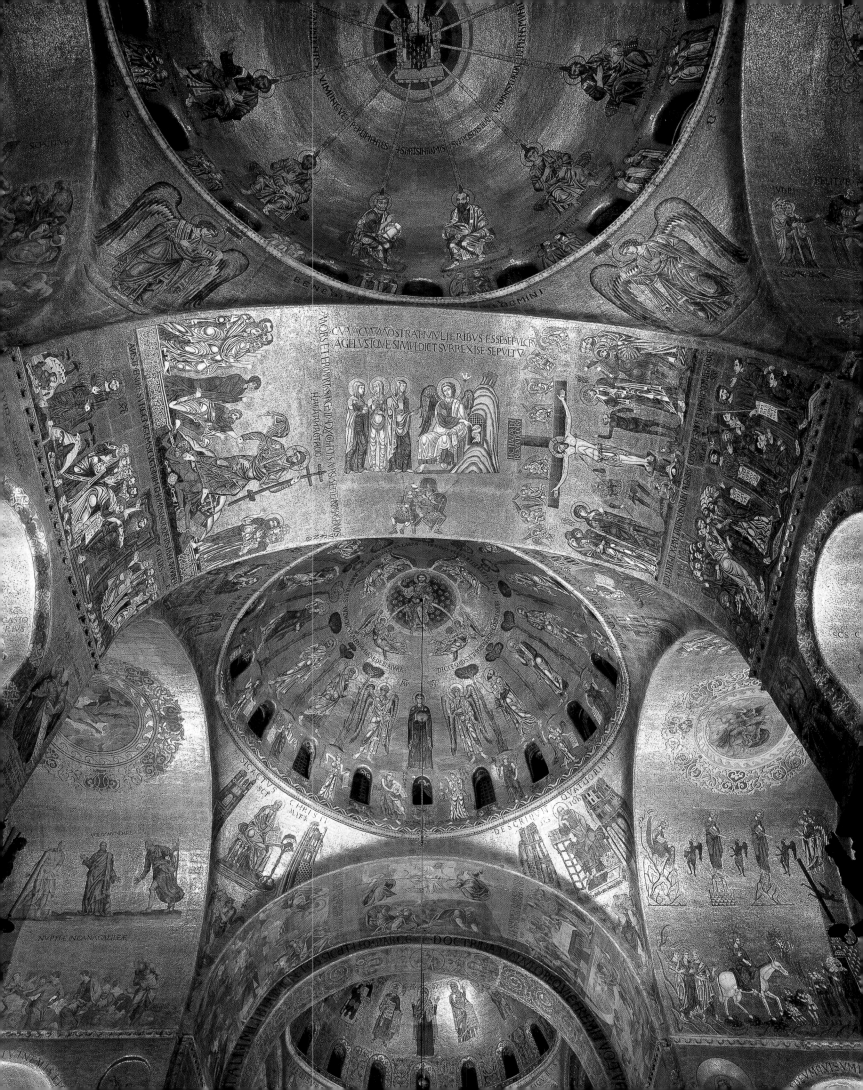

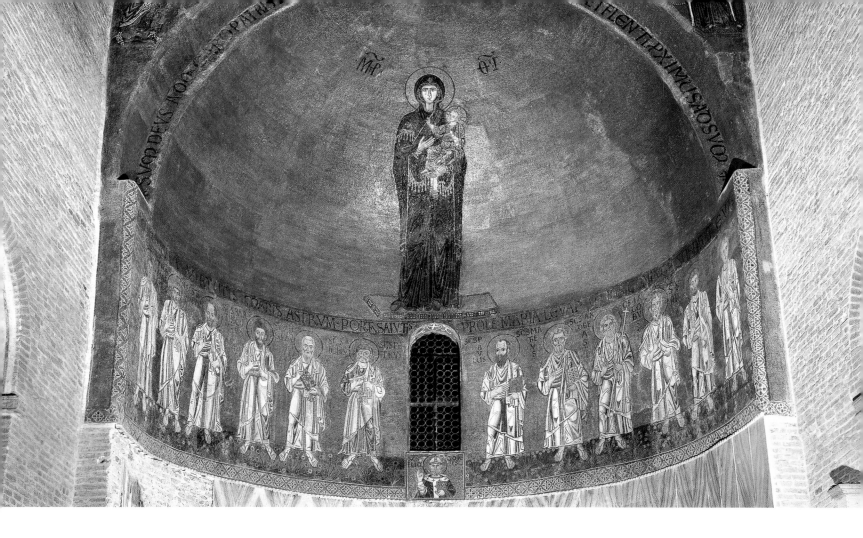

VIRGIN AND CHILD

12th century, mosaic.

Torcello, Santa Maria Assunta, apse.

offers a fine full-length portrait of Emperor Alexander (912-913), surrounded by his identifying monograms inscribed in circles which seem to hover around him. Unquestionably, however, the two most famous are those on the east wall of the south gallery, not far from the choir. The first one depicts Empress Zoe and her third husband, Constantine IX Monomachos, offering Christ a silver purse and a parchment scroll, no doubt symbolizing some privilege or donation granted by the sovereigns to the Great Church. Traces of a curious alteration can be seen on the faces. In fact, the mosaic originally portrayed Zoe and one of her first two husbands; between 1042 and 1050 it was altered to make way for the third husband, whose features and name replaced those of his predecessor. And in a remarkable display of attention to overall formal unity, alterations were made to the faces of Zoe and Christ at the same time. The intensely alive faces, moreover, seem to be inscribed like cartouches in the midst of a hieratic, deliberately austere and impassive scene. The second panel, executed around 1130, employs the same iconographic approach. John II Komnenos and his wife Irene, flanking the Virgin and Child, together with their son Alexios portrayed on the partition wall, also have conspicuously lively features which contrast with their ponderous ceremonial costumes, laden with precious stones and pearls, while the Virgin, treated with a veritable visual density, echoes the classical beauty of antique depictions.

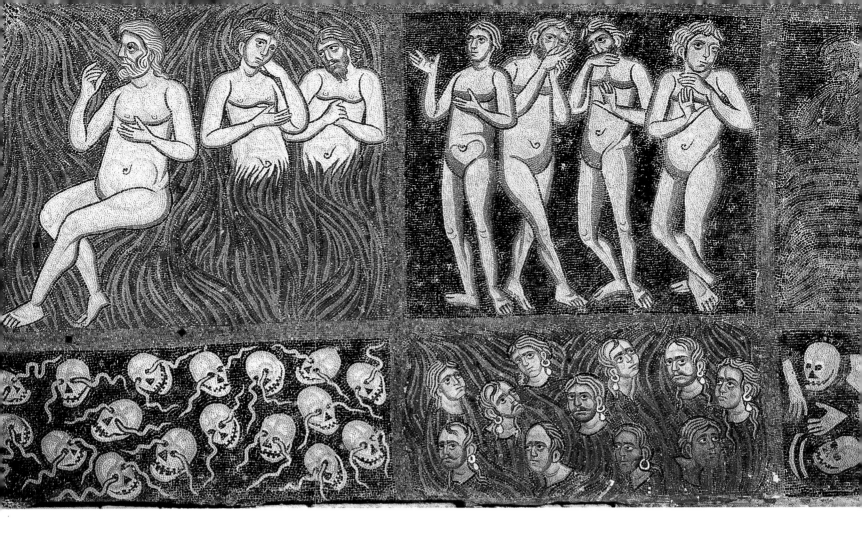

THE LAST JUDGEMENT
Detail. Late 11th/12th century, mosaic.
Torcello, Santa Maria Assunta, interior wall of the west façade

The art of Constantinople spread beyond the frontiers. In the 11th and 12th centuries, the Balkans, Serbia, Bulgaria and Moravia, together with the Christian kingdoms of the Caucasus, adopted its style and the iconographic programme of its churches. In Russia, converted in the 10th century, the inscribed cross plan was used at St Sophia of Kiev – begun in 1037, and where it was majestically deployed in five naves capped by thirteen domes –, at the cathedral of the Saviour at Cernigov, at St Sophia of Novgorod, and at the Dormition at Vladimir. It was to remain the dominant type, constantly reinterpreted until the 15th century. In the 11th century, mosaic artists from Constantinople worked on the partially conserved interior décor of St Sophia in Kiev using tesserae shipped from the shores of the Bosphorus. Greek painters travelled throughout the Russian steppes, bringing the lessons of Byzantine art to Novgorod, Pskov, and Vladimir. Greeks worked in Italy, at Monte Cassino where they were commissioned by Abbot Didier (1058-1087) to decorate the abbey-church, in Venice and in Sicily. Up until the 13th century the basilica of San Marco in Venice, begun around 1063, boasted an admirable mosaic décor. The oldest of these mosaics, in the main porch (Apostles), the choir (prophets), and the nave, are in part the work of such Greek artists. Both the plan and elevation of the building are also Byzantine, a virtually unique example in Western art. They are based on Justinian's church of the Holy Apostles, intentionally adopting a classical

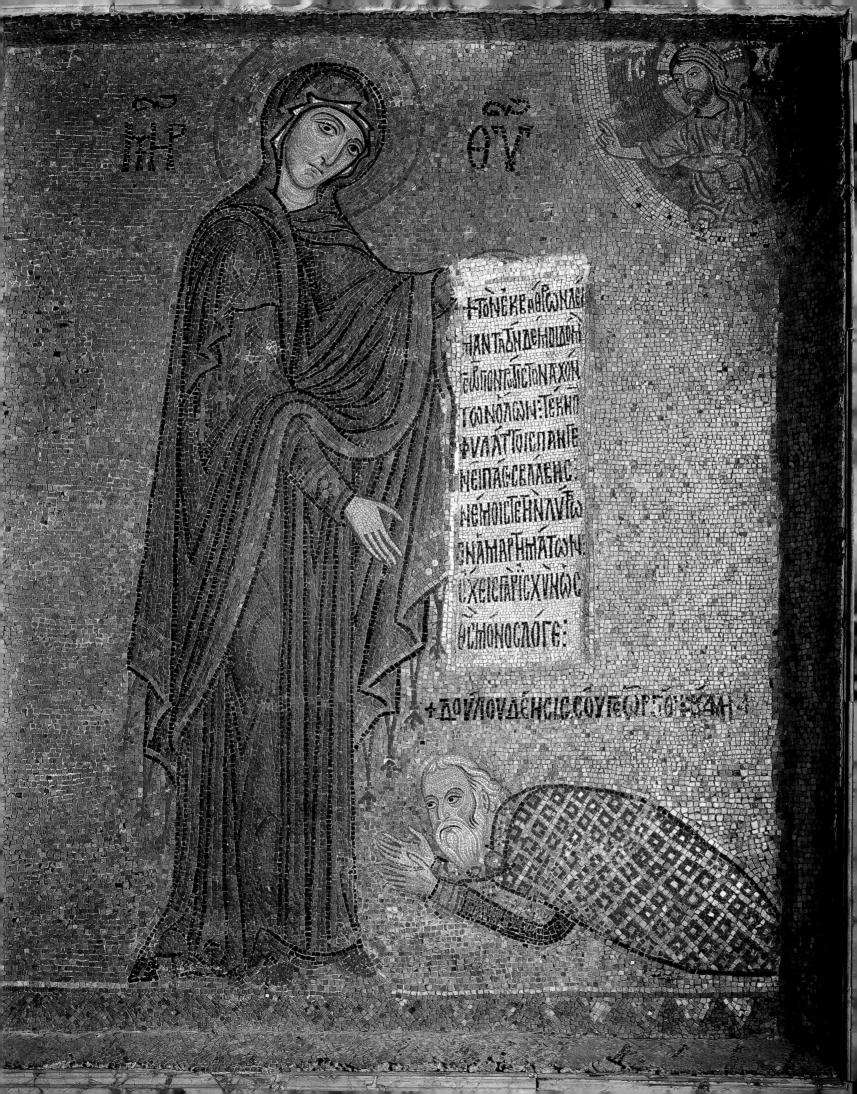

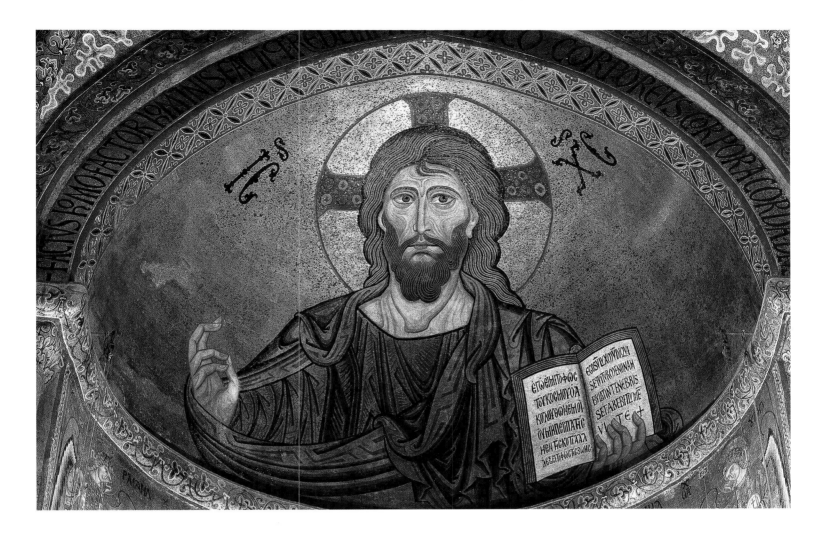

approach no longer fashionable in Constantinople in order to house the remains of the Apostle St Mark. In late 11th-century Torcello, the majestic Virgin in the apse, depicted against a gold background, was created by Greek artists who also began a monumental Last Judgement on the interior wall of the façade. It is one of the most comprehensive and earliest known versions of this theme, completed in the 12th century by the pupils the Greeks had trained. In 12th-century Sicily, during the reign of Roger II, Byzantine art blossomed in the sumptuous mosaic décors superimposed on Latin-style churches with *muqarnas*, painted timber ceilings derived from Islamic art. Constantinople mosaic artists worked in Palermo, at the Palatine chapel consecrated in 1140, at the Martorana, built between 1143 and 1151 by Admiral George of Antioch, and also at the basilica of Cefalù, founded in 1131 by King Roger II. The pictures of the Church Fathers and the scenes from the life of Christ in the Palatine chapel, the large Christ in the apse at Cefalù, and the panels portraying the founders of the Martorana – Roger II crowned by Christ and George of Antioch prostrated at the Virgin's feet – are all masterpieces of Komnenian art, of which only all too rare examples are to be found in Constantinople itself today.

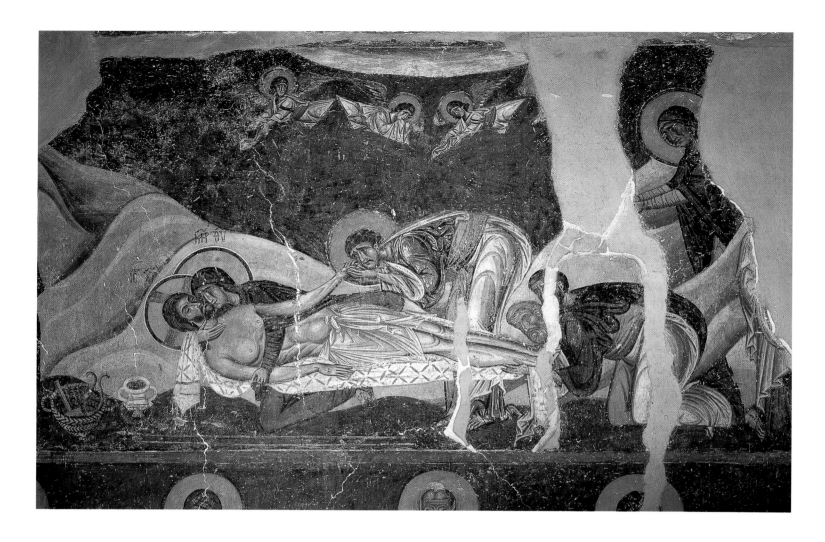

THRENOS (LAMENTATION OF CHRIST)
1164, wall painting.
Nerezi (Macedonia),
St Panteleimon, north wall.

As the Norman Kings of Sicily were well aware, the supreme beauty of Byzantine churches lay in their monumental décor. This consisted almost entirely of mosaics and frescos, together with the more mellowed lustre of polychrome marble used to pave the floors and face the walls right to the upper areas of the building. Plaques of varnished ceramic, less costly than marble, were also occasionally used as wall facing. Examples have been discovered in Constantinople in the Constantine Lips church featuring a polychrome décor of stylized vegetation derived from classical or Islamic art (Archaeological Museum, Istanbul), as well as in other sites in the capital (probably the case of the plaques now in the Louvre and the Walters Art Gallery in Baltimore). Some are distinguished by their religious iconography depicting Christ, the Virgin, and saints, or by their formal imitation of architectural elements such as toruses, cornices, arches or colonnettes. It has been suggested that the latter are vestiges of iconostasis decoration. The iconostasis, which came into widespread use in the 11th century, indeed constitutes one of the most remarkable features in the interior layout of the medieval Byzantine church. It is the result of a gradual transformation of the chancel screen of early churches into a screen separating the sanctuary from the nave *(templon)*. In the shape

of a colonnaded portico surmounted by an architrave, provided either with a raised base or a parapet, and pierced by a central door, the iconostasis was naturally the ideal place to display icons. The Virgin and John the Baptist praying (*deesis*) were placed on either side of the door; where necessary, evangelists and saints were placed in the spaces between the other columns, while the cycle of the twelve feasts of the liturgical calendar might appear perched high up on the architrave. In this way, architectural-type frames designed in marble and wood and often faced in gold or silver were filled with icons – painted on wood, or executed in mosaic, precious metal, or even ceramic; a few rare vestiges of such interiors have survived, such as the marble example from St Panteleimon in Nerezi, or that of the *Katholikon* at Hosios Loukas, both of which are incomplete and no longer have their icons.

Given this context, sculpture played a relatively minor role in monumental décor. Inside buildings, it helped to enhance the lavish effect but was confined in the main to the capitals, cornices, lintels, slabs, columns and architraves of the iconostasis, ambo or *ciboria*, and endlessly reiterated the same themes derived from the repertories of classical antiquity or the oriental arts: palmettes, imbrications, rosettes, stylized foliage, foliated

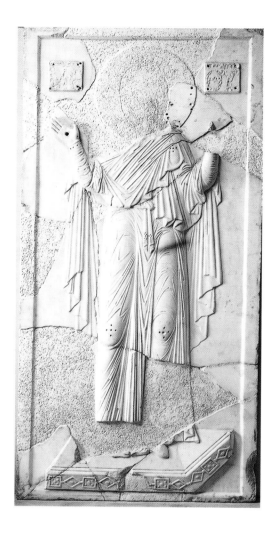

VIRGIN ORANS
From the Monastery
of the Manganes.
11th or 12th century, marble,
height 200 cm (78 3/4 in.).
Istanbul, Archaeological Museum.

scrolls – occasionally with birds or animals – as well as crosses, peacocks, eagles, griffins or *simurghs* – mythological creatures which featured in Persian art. Relief carving was also often replaced by champlevé, inlaid with coloured material. Outside, sculpture, although rarer, was occasionally distinguished by the use of somewhat haphazardly arranged sculpted slabs with decorative bas-reliefs. And there was abundant reuse of old materials. The most familiar example is the Little Metropolis in Athens, the exterior walls of which are covered with reused classical inscriptions, frieze segments and reliefs. At Skripou there are column drums and also fragments of friezes and sections of entablatures. In Constantinople, the engaged capitals crowning the pilasters in the nave of the Constantine Lips church were carefully removed from late 5th-century acanthus capitals. The façade of the Great Palace which overlooked the sea was also known to have been embellished with an applied décor of trompe-l'œil doors, pediments, arches and columns, foliated friezes and lion statues, probably composed, in the 10th or in the 11th centuries, from classical spoils dating from various periods. In a similar vein, the series of reliefs depicting Hercules, Prometheus, Pegasus, Endymion and other mythological figures were reinstalled on the ramparts at the Golden Gate around the same time. Such reused materials certainly provided an inexpensive means of adding an exquisite touch to buildings but they were also no doubt perceived as "references" to a glorious past with which the Byzantines constantly sought to associate themselves. This fascination with classical antiquity, however, did not lead to a real revival of sculpture in post-iconoclastic Byzantine art. There was no sculpture in the round, and when bas-relief was used it merely served a decorative function, and was invariably rejected for the expression of major iconographic programmes which were always reserved for mosaic and fresco. Marble or stone sculpted icons were also extremely rare. Despite their technical accomplishment, examples such as the Deesis Virgin – probably originally from an iconostasis and now in Dumbarton Oaks –, the large deesis reinstalled after 1204 in the south aisle of San Marco in Venice, a Baptism of Christ in Rouen Museum, and some fifteen figures of the Virgin Orans, including the specimen in Istanbul Museum discovered at the Manganes monastery, are characterized by a totally pictorial approach in which specifically three-dimensional effects are barely explored. In addition, there are a few vestiges of inlaid marble icons such as the head and arm of a warrior saint in the Benaki Museum in Athens, or the icon of St Eudokia discovered in the Lips monastery along with other fragments and now in Istanbul Museum. But they display a closer visual affinity with painting, mosaic or the luxury arts and crafts than with sculpture proper.

The blossoming of painting

With the triumph of orthodoxy and the reinstatement of images, the art of painting was to flourish in book illustrations and icons. Several

hundred illuminated manuscripts produced between the 9th and the 12th century have survived. These alone allow us to grasp the sheer scale of the Byzantine renaissance in the field of painting, to apprehend its veritable essence, and to trace, beneath a misleading outward uniformity, its gradual evolution over more than three centuries.

Unfortunately, most book paintings were extremely fragile, owing to the technique involved – one which Jean Porcher has qualified as "appalling". The painters were primarily concerned with producing a perfect result and paid scant attention to the intrinsic qualities of the means employed. In order to make colours shimmer more intensely, they were either applied on an extremely thin neutral preparatory coat to which they had difficulty adhering, or, on the contrary, were painted onto a thick one which tended to peel off. Very few manuscripts were explicitly dated and no more than a handful include a colophon giving an artist's name, or mentioning where the work was executed. Parchment was the unique support; paper was only introduced at a later date. Most of the manuscripts were *codices*, although the scroll, inherited from ancient times, was still employed, particularly in the traditional form of the liturgical scroll which the celebrant would unroll vertically in front of himself as he read.

A variety of formats existed. In relation to the text, the illustration might cover the whole page, or form a framed picture occupying only part of it. It was commonly used to decorate margins, and occasionally slipped almost imperceptibly into the lettrines – although never a match for the historiated initial letters of Western illuminated manuscripts. Finally, purely ornamental manuscripts also existed; initial letters with a plant or animal decoration were employed in Byzantine manuscripts, although sparingly. The most extraordinary type of illustration – and one which became a Byzantine pictorial speciality – is certainly represented by the large compositions which opened many manuscripts and were inscribed within an elegant "π"-shaped portico known as a *Pylè*.

Most texts were religious or, like the psalter, the painter's favourite medium, served a liturgical purpose. Two types of psalters coexisted. The first, the so-called "monastic" or "marginally illustrated" type adopted a small format and its margins might sometimes teem with a hundred or more little images; it probably appeared during the iconoclastic controversy and served, in iconophile circles, to disseminate images; the famous "Khludov Psalter", along with the psalter illustrated by Theodore at the request of the abbot of the Stoudios monastery in 1066, and now in London, are the two most perfect examples. The second, the so-called "aristocratic" type, intended for an imperial or princely clientele, and of which the "Paris Psalter" (Bibliothèque Nationale de France, Gr. 139) – perhaps executed for Constantine VII – is justifiably the most famous specimen, was distinctly larger in size and had fewer – but in this case full-page – illustrations glorifying David, Solomon and other biblical Kings. Excepting the Octateuch, or first eight books of the Bible, painters were less inspired by other Old Testament texts. On the other hand, they were seemingly captivated by the glosses which accompanied each biblical verse and would sprinkle these extracts from patristic commentaries with their little pictures. In the New Testament, pride of place went to the Evangelists preaching the Gospel, scenes from the life of Christ, and tables of concordance. The latter often took the form of a sumptuous portico surmounted by a pediment filled with polychrome floral ornamentation, and above which were sometimes included face-to-face animals, or heavenly gardens with fountains, flowers and exotic beasts. Others portrayed the Fathers of the Church, in particular John Chrysostom and Gregory of Nazianzos, whose homilies were collected in anthologies. The venerable copy of Gregory of Nazianzos now in Paris (Gr. 510), painted for Basil I, is, moreover, the first undisputed masterpiece of the Macedonian renaissance. Finally, although illustrated lives of individual saints were occasionally produced, these were much less common than Menologia in which episodes from the lives, martyrdom, or cult of relics were either depicted on one or two pages for each month, or spread throughout the text with illustrations accompanying the page for each day. New editions of classical authors also fostered the development of secular painting. Medical and pharmacological works such as Nikander's

ICON OF ST EUDOKIA
From the Constantine Lips Monastery.
10th century, inlaid marble.
67 × 28 cm (26 3/8 × 11 in.).
Istanbul, Archaeological Museum.

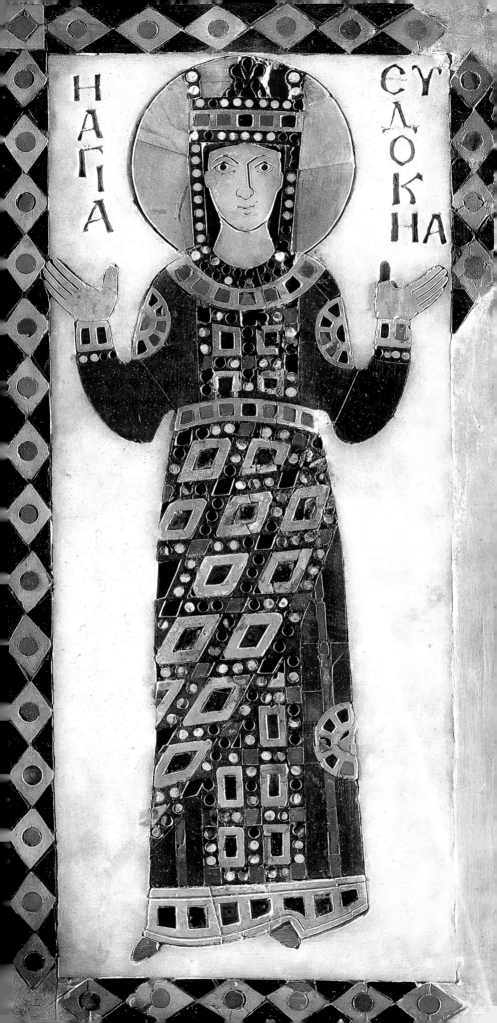

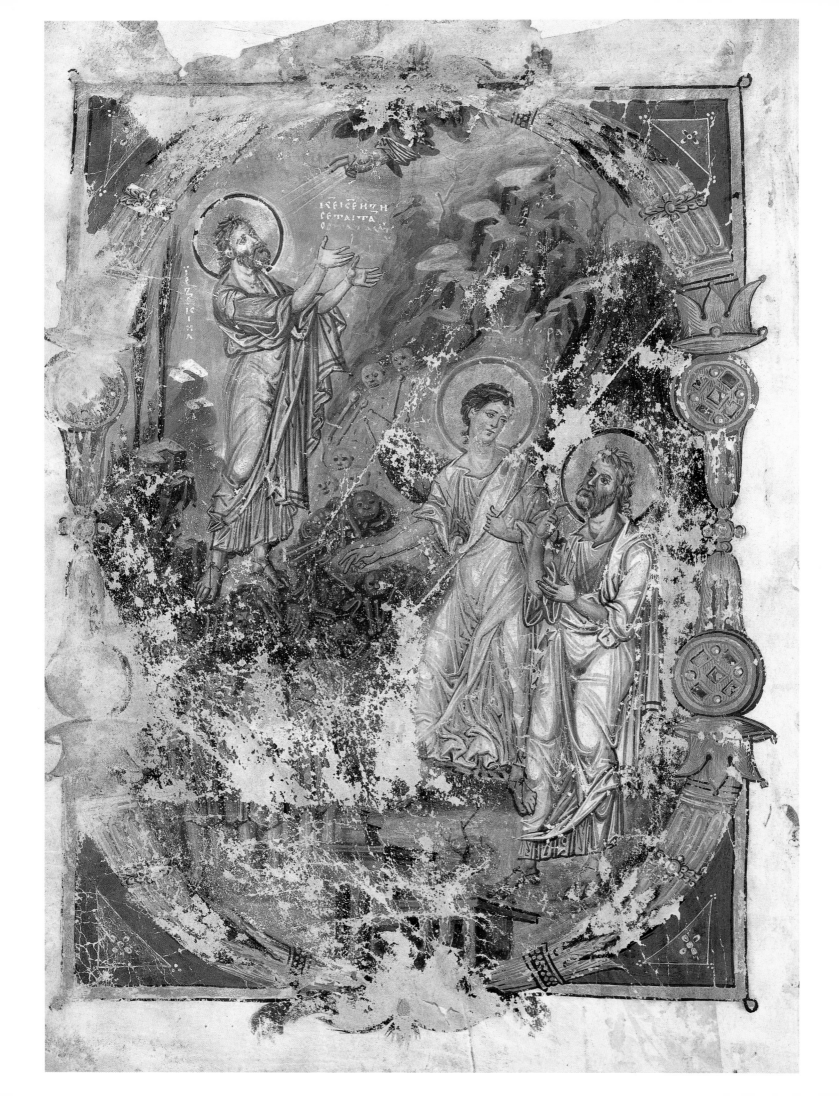

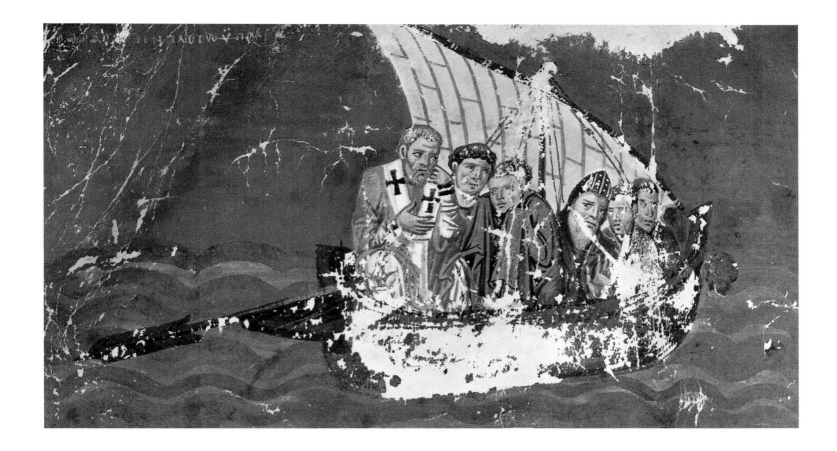

dissertation on snakebites, Dioskorides, or cynegetic treatises – particularly the one attributed to Oppian – had always been illustrated. Naturally, these provided sources of inspiration for the painters who worked on luxury editions such as the Paris Nikander (Suppl. Gr. 247), the Oppian in the Biblioteca Marciana in Venice, or the Dioskorides in the Pierpont Morgan Library, New York. New 11th-century editions of a number of treatises on military tactics and siege techniques, now divided between collections in Rome and Paris (Gr. 2442), have bequeathed to us a series of fine, often detailed colour drawings of siege engines. Despite being beautifully executed, these drawings are not however strictly speaking the creation of Byzantine painters. Historical works, some of which are known to have been illustrated, probably displayed more originality, but only an approximate idea is to be gleaned from the sole surviving example, the Skylitzes chronicle in Madrid, produced in a Hellenized milieu in south Italy in the latter half of the 12th century. Painting, it must be acknowledged, was essentially religious in inspiration. The few known inventories of libraries – admittedly monastic – are revealing in this respect. In 1200, the library of Patmos monastery possessed almost three hundred books. Although some two hundred of the texts in the collection were liturgical, among others were included copies of a chronicle of Nikephoros, a Skylitzes, a Flavius Josephus – an edifying work then in vogue – and a Barlaam and Joasaph. The contents

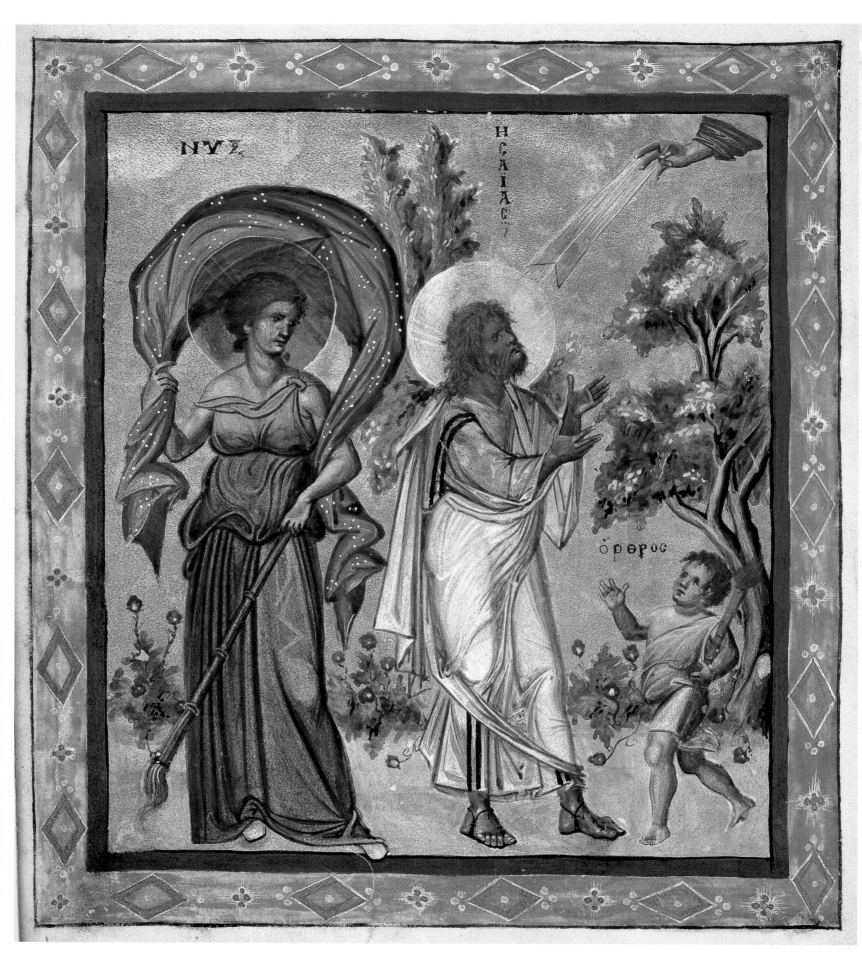

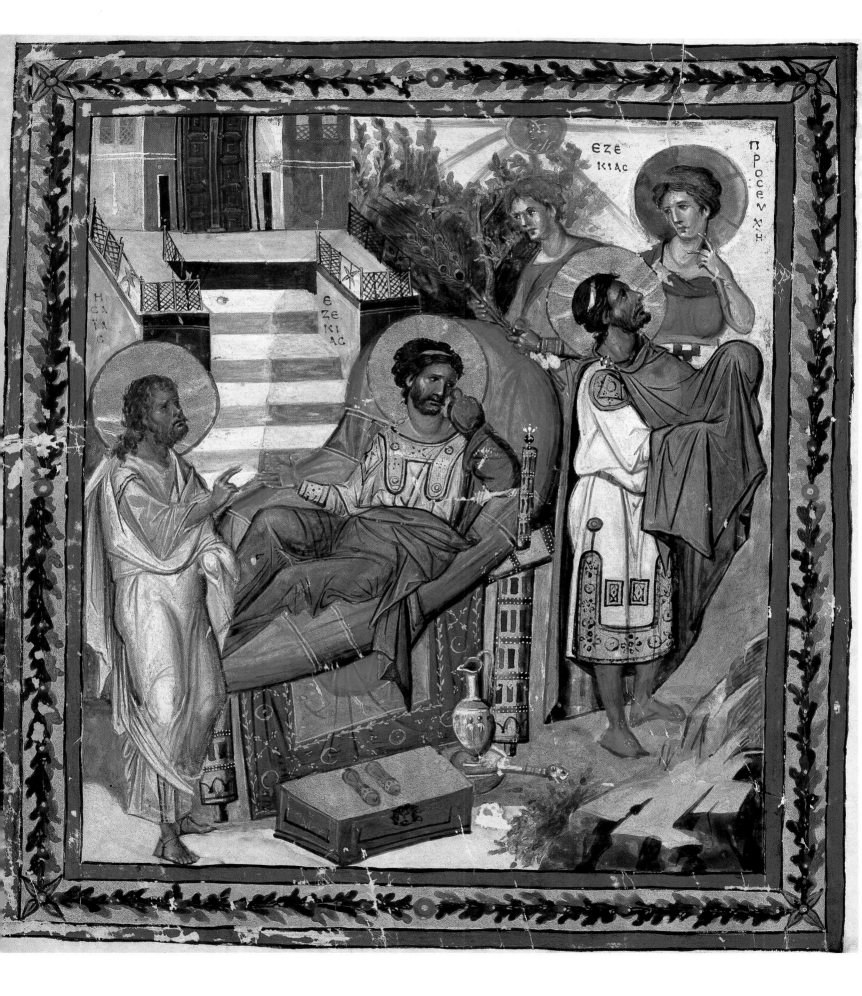

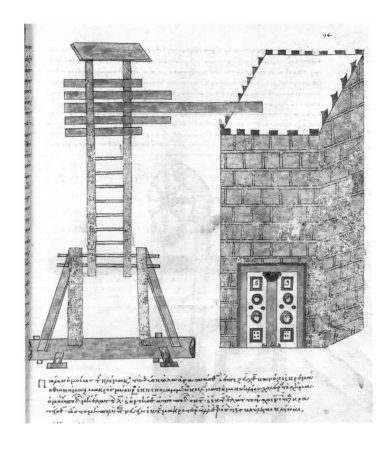

of the imperial libraries probably differed, but the relative proportions found in the Patmos inventory are nevertheless significant. Despite this, secular art was definitely present, to be found even in the most solemn manuscripts. The margins of sacred texts abound with illustrations of hunting, birds perched by fountains of clear gushing water, and scenes from daily life. The religious paintings in the magnificent copy of Gregory of Nazianzos in Paris (Gr. 550) are accompanied by extremely delicately executed yet – given the context – somewhat incongruous, everyday depictions of fruit picking, people playing on swings, and even a performing bear; another Nazianzos (Gr. 533) features vignettes – a shepherd, a herdsman, a bird hunter, a fisherman, peasants working in the fields, and busy bees –intended to illustrate the reawakening of nature in Spring, a theme evoked by Gregory in a homily for the first Sunday after Easter; glosses on the Book of Job include illustrated versions of the patriarch's commentaries on the stars, constellations, man, and the animals of creation. Classical sources, secular inspiration and Christian tradition were skilfully combined. But the arts of the Orient, particularly those of Islam, also provided an inexhaustible thematic repertory. Artists filled their *pylè* with brightly coloured, stylized floral compositions, and introduced ornamental foliated scrolls, flowing arabesques, and exotic or fabulous bestiaries which even included the phoenix – an import from China along with Far-Eastern silks, probably via the intermediary of copies made by Persian scribes.

**TREATISE ON MILITARY TACTICS
AND SIEGE TECHNIQUES**
11th century, Constantinople,
paint on parchment.
Greek Manuscript 2442, fol. 94,
34 × 26.5 cm (13 3/8 × 10 3/8 in.).
Paris, Bibliothèque Nationale de France.

THE FOUR GOSPELS: CANON TABLES
11th century, Constantinople,
paint on parchment.
Greek Manuscript 64, fol. 3,
19 × 14 cm (7 1/2 × 5 1/2 in.).
Paris, Bibliothèque Nationale de France.

| Page 115
**"PARIS PSALTER":
THE ILLNESS OF KING HEZEKIAH**
10th century, Constantinople,
paint on parchment.
Greek Manuscript 139, fol. 446 v,
34 × 26.5 cm (13 3/8 × 10 3/8 in.).
Paris, Bibliothèque Nationale de France.

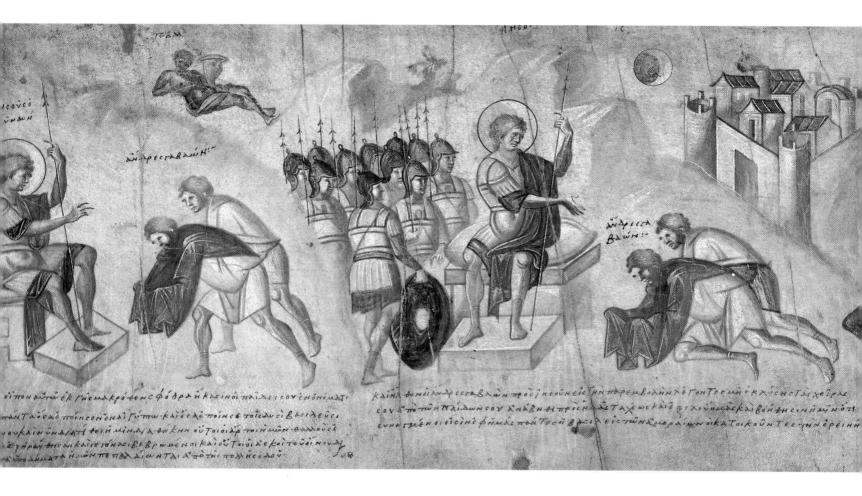

THE JOSHUA ROLL
10th century, Constantinople,
paint on parchment.
Greek Palat. Manuscript 431, fol. 12,
31.5 × 75 cm (12 3/8 × 29 1/2 in.).
Vatican City,
Biblioteca Apostolica Vaticana.

| Pages 118-119
NIKANDER, *THERIACA*
10th century, Constantinople,
paint on parchment.
Supp. Greek Manuscript 247,
fols. 47 v and 48,
16 × 12.5 cm (6 1/8 × 4 7/8 in.),
detail.
| Paris, Bibliothèque Nationale de France.

Painters worked exclusively for the court, the Church, or princes, and the Palace no doubt had its own workshop. Although he did not himself practice painting, Constantine VII is said to have shown a keen interest in artistic activity. A team of seven painters worked together, probably at the behest of the Emperor, on the hundreds of images in Basil II's Menologion which belongs to the Vatican collections. In the 12th century, Isaac Komnenos, son of Alexios I, contributed to the Seraglio Octateuch, now in Topkapi Museum. Copyists and illuminators were employed by the Patriarchate, as well as by great Constantinopolitan monasteries such as the Stoudios monastery where the Theodore Psalter, now in London, was perhaps produced. A distinction was apparently drawn between the craft of copyist and that of painter since, in a remarkable evangeliary in Melbourne and executed around 1100 in a Constantinople monastery, the monk Theophanos, who included a self-portrait in which he depicts himself offering his book to the Virgin, proudly mentions that he is both scribe and illuminator. With the exception of peripheral regions such as Georgia, Armenia and south Italy, characterized by well-defined local features, practically nothing, however, is known about the possible activity of painters in provincial monasteries; and it is only in the 12th century that the veil of obscurity is slightly

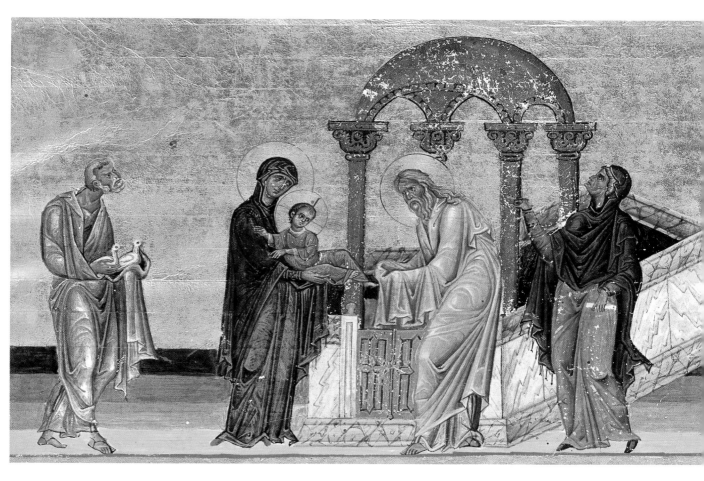

MENOLOGION OF BASIL II:
THE PRESENTATION AT THE TEMPLE
Early 11th century, Constantinople,
paint on parchment.
Greek Manuscript 1613, fol. 365,
36.4 × 28.4 cm (14 3/8 × 11 1/8 in.).
Vatican City,
Biblioteca Apostolica Vaticana.

lifted on those few outlying centres which – like Cyprus perhaps – were beginning to assert themselves. Under the Macedonians and the Komneni, Byzantine and Constantinopolitan paintings are virtually synonymous. The earliest signs of the Byzantine renaissance emerged in the "Khludov Psalter", a manuscript dating from the turning point of the iconoclastic controversy. This psalter's two hundred and nine paintings reveal a remarkable familiarity with antique models which it draws upon indiscriminately. The closing image – a depiction of David as a Christianized Orpheus – displays once more the rapid execution and illusionistic techniques of Hellenistic painting. Elsewhere, marginal paintings include a St Peter of the Denial who echoes the vibrancy, flexibility and suggestive shading of Alexandrian art; birds which seem to have flown straight out of some illustrated classical treatise on natural history; and martyred saints whose frontal presentation and bodily proportions recall the mosaic art of Ravenna. A few years later, the paintings which feature in the *Cosmography* in the Vatican copy of the Cosmas Indicopleustes adopted a similar approach, but were incorporated into the text and locked within autonomous frames, like the antique bas-reliefs from which their figures borrowed rhythmical solemnity and classical gesture. The masterpiece of the late 9th-century, the famous Paris Gregory of Nazianzos (Gr. 510),

ΤΟΥ ΑΥ ΤΟΥ · ΕΙΣ ΓΡΗΓΟΡΙΟΝ ΤΟΝ ΑΔΕ ΒΑΣΙ

ί λου τος φου. ου κε ςτ μ Δμ τα λ λει·

λ αυ μα τω μ ον των ου αδυ·

ίου Δε τι ο φαυ θμος της Κ αχχο

μ ησα μτου. ~ φιλος πω φου. ο κε

δον κρ αται Λι · Κ αι θ χιρω με

μ ομ Βασι λειου · φι λος πι φος

ω δε χ ενιο ν Κ αι Λι λθον

τι μ μον πο λ υ μ ·

executed for Basil I between 879 and 883, again juxtaposes various sources of inspiration, in particular the series of narrative scenes of Church history in which lively figures are depicted against a uniform blue background. In marked contrast, the painter who illustrated the page on Ezekiel succeeds in unifying his sources in an admirable composition which blends classicizing Hellenism and Byzantine spirituality. Ezekiel, symbol of Israel's despair and faith in Jehovah, appears twice: first of all conducted by the angel into the Valley of Dry Bones, then praying to God to resurrect the dead. The casual virtuosity of the ascending composition, the confident brushwork, the almost impressionist technique with which subtle gradations of pink, blue, brown and green are employed, with no hint of contour, to depict the sky and rocky terrain, the exquisitely supreme angel, and the utterly classical nobility of the drapes, offer an effortless demonstration of the perfection which Byzantine painting, drawing on the lessons of classical antiquity, had achieved within a few years. An achievement which was sustained into the first half of the 10th century. This classical revival, initiated by the Gregory of Nazianzos Ezekiel, reached its pinnacle in the magnificent "Paris Psalter". At least five painters, of varying talent, worked on the fourteen full-page illustrations which include scenes depicting David playing his harp, or accompanied by personifications of Melody and of the nymph Echo, Isaiah praying, as well as allegories of Night and Dawn which respectively assume the features of a woman with a star-spangled veil and a young boy

PSALTER OF BASIL II:
SCENES FROM THE LIFE OF DAVID
Early 11th century, Constantinople,
paint on parchment.
Greek Manuscript 17, fol. 3 r,
30.2 × 24.4 cm (11 7/8 × 9 5/8 in.),
detail.
Venice, Biblioteca Marciana.

HOMILIES OF GREGORY OF NAZIANZOS
12th century, Constantinople,
paint on parchment.
Greek Manuscript 550, fol. 204,
27 × 19.5 cm (10 5/8 × 7 5/8 in.).
Paris, Bibliothèque Nationale de France.

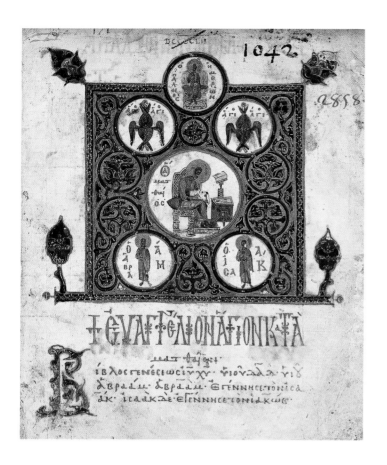

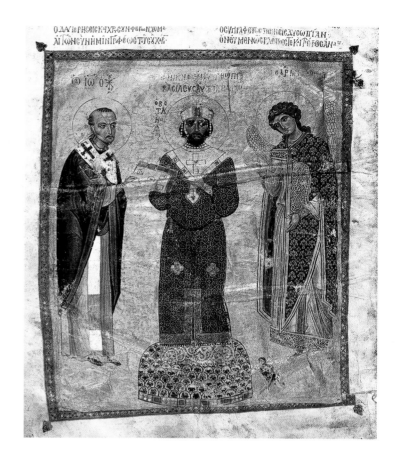

bearing a lighted torch, and the ailing King Hezekiah offering thanks for his subsequent recovery. The Bible of Queen Christina, now in Rome, offers yet another, albeit more rigid example of a similar type. The underlying classical inspiration in such masterpieces is even more forcefully expressed in the Vatican Library copy of the Joshua Roll, a manuscript which is so "classical" that for a long time classical scholars themselves were deceived. The Paris Nikander (Suppl. Gr. 247), like the Joshua Roll, has no background, but faithfully imitates the illusionist style that had flourished in the botanical plates of the Vienna Dioskorides.

Signs of change appeared in the late 10th century: ethereal gold backgrounds became more common, proportions were elongated, a wider range of movements was sought, and facial features became more severe. The "aristocratic"-type Psalter of Basil II, in the Biblioteca Marciana in Venice, partially adopted this new aesthetic approach, as did the famous Vatican Menologion. The artists responsible for the four hundred and thirty illustrations on gold backgrounds in the latter work amassed realistic details, yet never forgot the formal lessons of their predecessors, and this is perceptible in the virtuoso ease with which they suggest architectural backgrounds and landscapes. Such tendencies became more pronounced in the course of the 11th century and led ultimately to the development of a new style – more hieratic and displaying ascetic

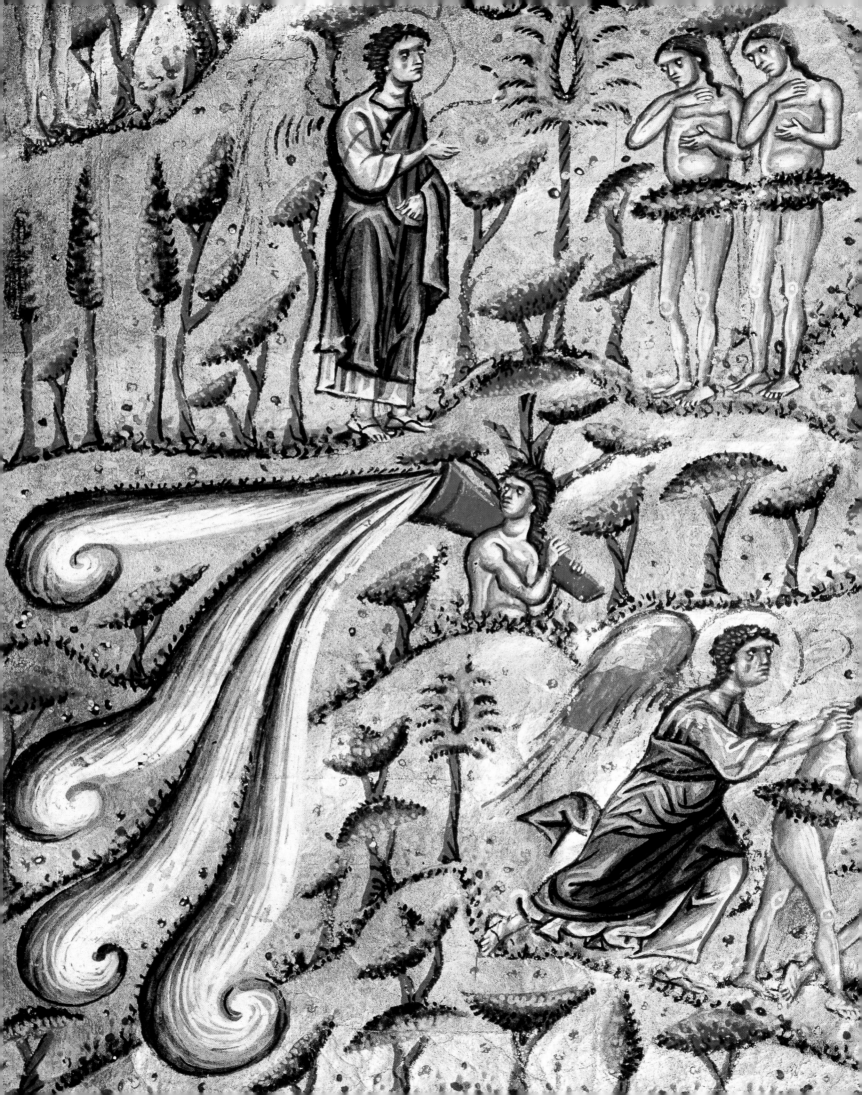

overtones – which has been immortalized in the portrait of Nikephoros Botaneiates flanked by St John Chrysostom and the archangel Michael in the famous Paris manuscript of the Homilies of John Chrysostom (Coislin 79). At the same time, the pursuit of elegance resulted in a precious, refined art which delighted in exuberant ornamentation and teemed with minute figurines, delicate silhouettes highlighted by gold strokes, and filling the frontispiece medallions or appearing in the margins, as in the Theodore Psalter. Meanwhile, Islamic-inspired ornamental compositions became common, as shown by a group of fine manuscripts, the most charming of which is the Paris Gospels (Gr. 64). In the 12th century, the majority of painters were still exploring this decorative vein and introducing, where necessary, an ascetic note. The imaginative illustrator of one copy of Gregory of Nazianzos, now in Paris (Gr. 550), placed a series of miniatures inside a spectacularly ornate assortment of different frames, produced extremely rigorously executed full-page paintings, increased the number of ornamental lettrines, and filled his margins with secular images, often seemingly intended to do no more than divert the reader. Yet the classical inspiration was never forgotten. It resurfaced in the Seraglio Octateuch which, like the Joshua Roll, was executed in an energetic, almost disturbing style – a portent of developments to come at the end of the century. But even before the mid-century, a pioneering figure emerged – the master who illustrated the Paris Kokkinobaphos (Gr. 1208). Instead of adopting a traditional approach, this painter introduced a sensitive idiom, an entirely new imagery with visionary overtones, to interpret the poetic digressions of the six *Homilies on the Life of the Virgin*, written by the monk James of Kokkinobaphos. Symbolic and typological images leap from his brush. His vision of Paradise is that of a gilded, horizonless space – valleys full of strangely-shaped colourful trees, where the blue and white waters of the Four Rivers flow like spiralling scrolls from a genie's vase. His Ascension glides gracefully into a frontispiece, the *pylè* of which is transformed into a gold and marble church crowned with domes; within the intimacy of the church, the ancient mystery is enacted: Mary holds out her arms to the vulnerable infant Jesus. Contrasting colours and white highlights emphasize the trembling apostles. At Nerezi, and in the icons of the late Komnenian period, this sensitivity was to waver between pathos and mannerism.

Our knowledge of icon painting on wood – unlike more fully documented manuscript painting – is extremely patchy. Only rare examples have survived. In fact, the standard modern definition of an "icon"– a painted wood panel – only refers to one category of what the Byzantines

ICON OF THE ANNUNCIATION

Late 12th century, paint on wood,
61 × 42.2 cm (24 × 16 5/8 in.).
Mount Sinai, Monastery of St Catherine.

**ICON WITH THE HEAVENLY LADDER
OF JOHN KLIMAX**

Late 12th century, paint on wood,
41.1 × 29.5 cm
(16 1/8 × 11 5/8 in.).
Mount Sinai, Monastery of St Catherine.

called "icons", that is to say all religious images. And such images used wood, ivory, marble, mosaic, fresco, precious metals and various other materials as a support. Nevertheless, icons painted on wood panels became more common in the aftermath of iconoclasm. Apart from costing much less than those made of precious materials, their proliferation – to an extent that is difficult to imagine –was due to two other factors: they were relatively quick to produce, thanks to the widespread use of the egg tempera technique; and even the humblest of churches wished to have its own devotional images. On the other hand, they were intended for the populace and had to conform to prevailing Orthodox conventions, unlike illuminated manuscripts which, destined for the privileged few, could adopt a more liberal approach. The sheer number of so-called *acheiropoietes* icons – reputed "not to be made by human hand" but to result from divine intervention – not only confirmed their reputation for sanctity but also illustrated the extent to which the art was strictly controlled by the Church: iconography had been determined for all time, authenticity depended upon exact reproduction of the model, and all innovation was suspect. This explains their overwhelmingly "Constantinopolitan" character. Thus, at Mount Sinai, from the

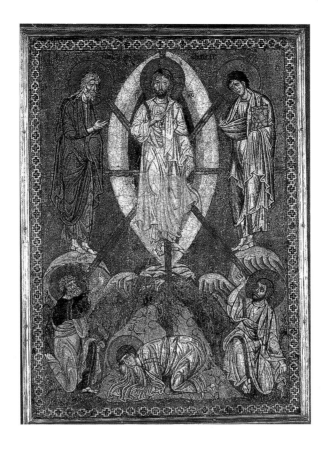

ICON OF THE TRANSFIGURATION
C. 1200, Constantinople,
mosaic transferred to slate,
52 × 35 cm (20 1/2 × 13 3/4 in.).
Paris, Musée du Louvre.

THE VLADIMIR VIRGIN
First half of the 12th century,
Constantinople, paint on wood,
104 × 69 cm (41 × 27 1/8 in.).
Moscow, Tretyakov Gallery.

10th century, the few 8th and 9th-century icons, which displayed provincial technique, made way for works executed in the officially approved metropolitan style. Virtually nothing, however, is really known about how they were actually made, and whether in Constantinople or, maybe, elsewhere.

As later, under the Palaiologos dynasty, icons must have reiterated the same standard images of Christ, the Virgin, the saints, or the twelve holy feasts, and would have been painted on single panels, diptychs, triptychs, or in a "bilateral" arrangement which usually juxtaposed the images of the Virgin and the Crucifixion. They were either permanently displayed on the iconostasis, or exhibited for public veneration on the feast day of the saint whom they commemorated. Some, like the small panel from Mount Sinai – one of the rare examples that can nowadays be attributed to the Macedonian era – in which King Abgar is depicted holding the Mandylion (or "Holy Towel") of Edessa which was transferred to Constantinople in 944, displayed definite originality. During the 11th century and under the Komneni, monastic spirituality introduced a number of innovations. Also conserved at Mount Sinai is an astonishing allegorical *Heavenly Ladder* of John Klimax, depicting monks who are clambering up the rungs of the ladder towards salvation, while others plunge into the void, dragged down by demons. And the same monastery houses a diptych which portrays all the assembled saints of the Menologion in two superimposed rows of tiny figures. In the early 12th century,

influenced by the Good Friday liturgy, a Christ of Sorrows appears on an icon from Kastoria, in north-west Greece. The so-called "compassionate" *(eleousa)* Virgin and Child was tailored to Orthodox hymn-writing: one of the finest and most ancient specimens is the Vladimir Virgin Eleousa, now in Moscow, which was taken from Constantinople to Kiev in 1131 and in which only the faces are original. For the late 12th century, the most remarkable group of icons is at Mount Sinai. Whether they were painted locally or in Constantinople remains a matter for debate. They are characterized by gold backgrounds and burnished gold nimbi; the Crucifixion, framed by medallion portraits of saints in an austere hieratic style, and above all the Annunciation, in which the dynamic figure of the angel and the refined gestures of Mary verge on mannerism, are to be counted among the masterpieces of Byzantine painting. Mosaic icons represent a particular type, the oldest examples of which date back to the Komnenian era. They are made from minute marble, glass, gilded copper, or even occasionally gold or silver tesserae, which are affixed to a wood panel by wax glue. One of the largest and most remarkable is that of the Transfiguration, now in the Louvre, which can be attributed to Constantinople around 1200. Although the composition still displays an extremely classical harmony, the dramatically tense figures surrounding Christ already herald the expressiveness explored by 13th-century art. The infinitely refined technique of such icons make them as much part of the luxury arts as of painting.

Luxury arts and crafts: imperial prestige

As in the age of Justinian, luxury was indispensable to religious and imperial glorification; it ensured imperial prestige and was imperatively flaunted, both in the capital and beyond the frontiers. The Emperors in their palaces called on glittering splendour, as attested by Greek sources – in particular the *Book of Ceremonies* with its almost obsessive descriptions of gold, silver and silk. For receptions and feasts, gold and silversmiths were commissioned to embellish the Palace with their works, and silk merchants commanded to provide precious hangings and carpets, while choice items from the imperial treasury were put on display – alongside gold chairs, tables and plate – in a monumental, five-towered cupboard, the *Pentapyrgion*. Ambassadors were dazzled by the lavish court ceremonial and marvelled at the magnificent churches and palaces of Constantinople. Liutprand of Cremona, in a famous passage in the account of his mission as ambassador for Otto I, gave a breathtaking description of Constantine VII's golden throne – guarded by large gold mechanical lions which beat their tails on the floor and roared – and of the gilded bronze tree, worthy of the *Thousand and One Nights*, with its branches full of mechanical birds, fluttering their wings and singing. Similarly, the tales of pilgrims who visited the shrines of Constantinople are full of the splendours they encountered. An incredible panoply of

THE "EAGLES" SHROUD FROM THE RELIQUARY OF ST GERMANUS OF AUXERRE

Detail. C. 1000, Constantinople, silk, 160 × 121 cm (63 × 47 5/8 in.), height of individual eagle: 75 cm (29 1/2 in.). Auxerre, Musée de l'Abbaye Saint-Germain.

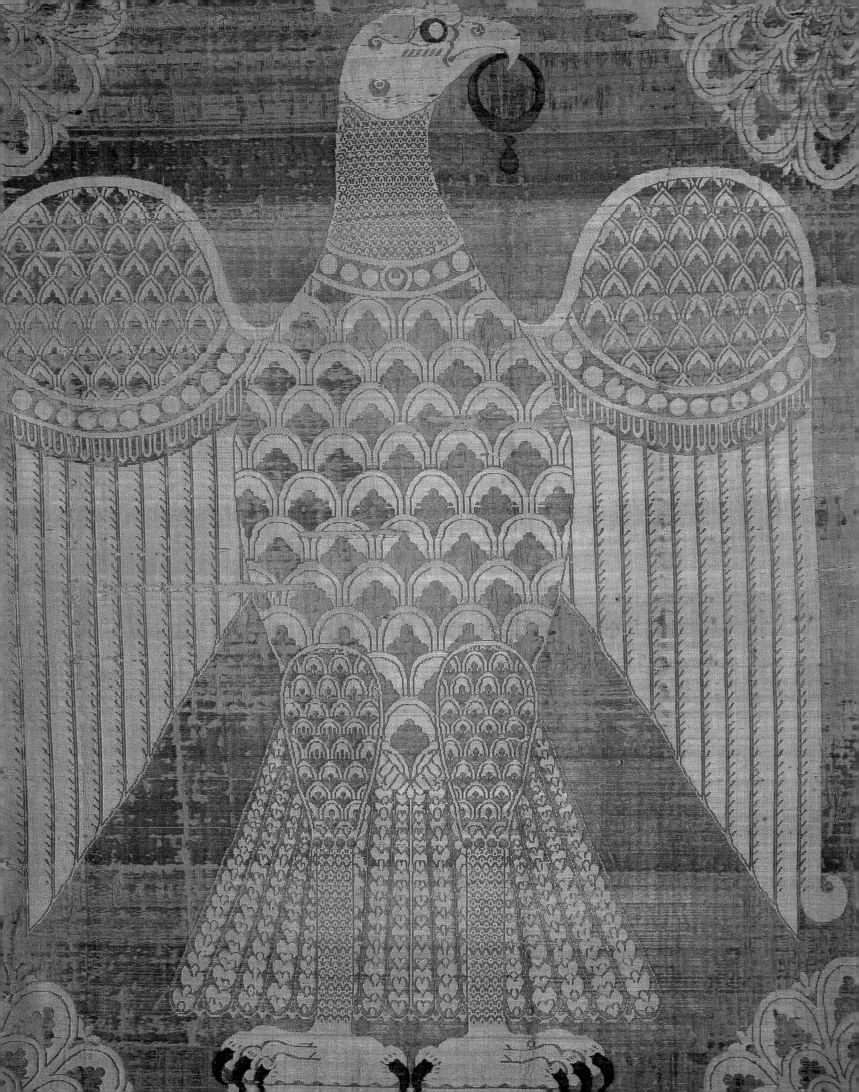

relics, reliquaries, shrines and icons covered with gold and precious stones is conjured up. There are descriptions of several remarkable works, such as the silver chariot of Hagia Sophia which is traditionally attributed to Constantine, or the gold paten – embellished with pearls and with a central gemstone sculpted in the effigy of Christ – donated to the same church by the Russian princess Olga following her conversion. Western chronicles tell of imperial embassies and an endless stream of gifts, while the *Liber pontificalis* faithfully recorded imperial liberality towards the churches of Rome, a tradition dating from the days of Constantine and Justinian and which continued up until the 11th-century Schism.

From the 9th century, imperial consolidation brought a new lease of life to the Constantinopolitan workshops. The craftsmen in the capital – gold and silversmiths, bronzeworkers, glassmakers and silkworkers – still resided in the same districts they had lived in since the time of Justinian and were still banded into guilds. The authorities sought to exercise control as strictly as they had done in the 6th century; under Leo VI, this is attested to by the *Book of the Prefect*, in which the most extensive passages dealt with the production and selling of silk. These activities were stringently regulated, as was shown by the misadventure which befell

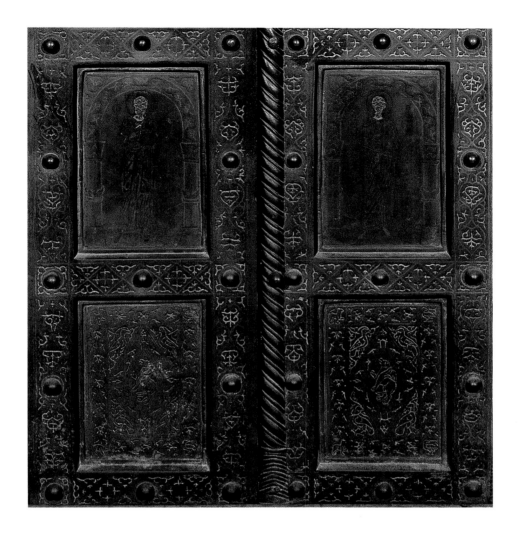

THE "ST CLEMENT"
BRONZE DOORS
Detail. C. 1100, Constantinople.
Venice, Basilica of San Marco, side entrance.

Liutprand of Cremona in 968 during his second embassy: to his extreme indignation, the Byzantine customs authorities confiscated five purple silks for which he had apparently not obtained an export licence. More-over, the term *sigilaton*, occasionally applied to silk, may have been used to designate any officially stamped item which could be freely exported. On the other hand, despite such attempts at regulation, the use of hall-marks for gold and silverplate was not reintroduced, and the ban on gold and silversmiths working outside the area along the *Mese* suggests that there was a good deal of clandestine activity. By the mid-11th century however, merchants from Venice and Amalfi established themselves in the capital and their growing stranglehold on its economy, gradually officialized by the granting of imperial privileges, made protectionism obsolete. Soon veritable Western entrepreneurs appeared on the scene, exploiting the traditional Constantinople industries for their own profit. Among the earliest were Pantaleone and his son Mauro, members of a powerful Amalfi family established not only in Constantinople but also in Syria, Antioch and Jerusalem. Around 1060, they were the major exporters to Italy – notably to Amalfi, Monte Cassino, and Rome (San Paolo fuori le Mura) – of monumental bronze doors inlaid with silver.

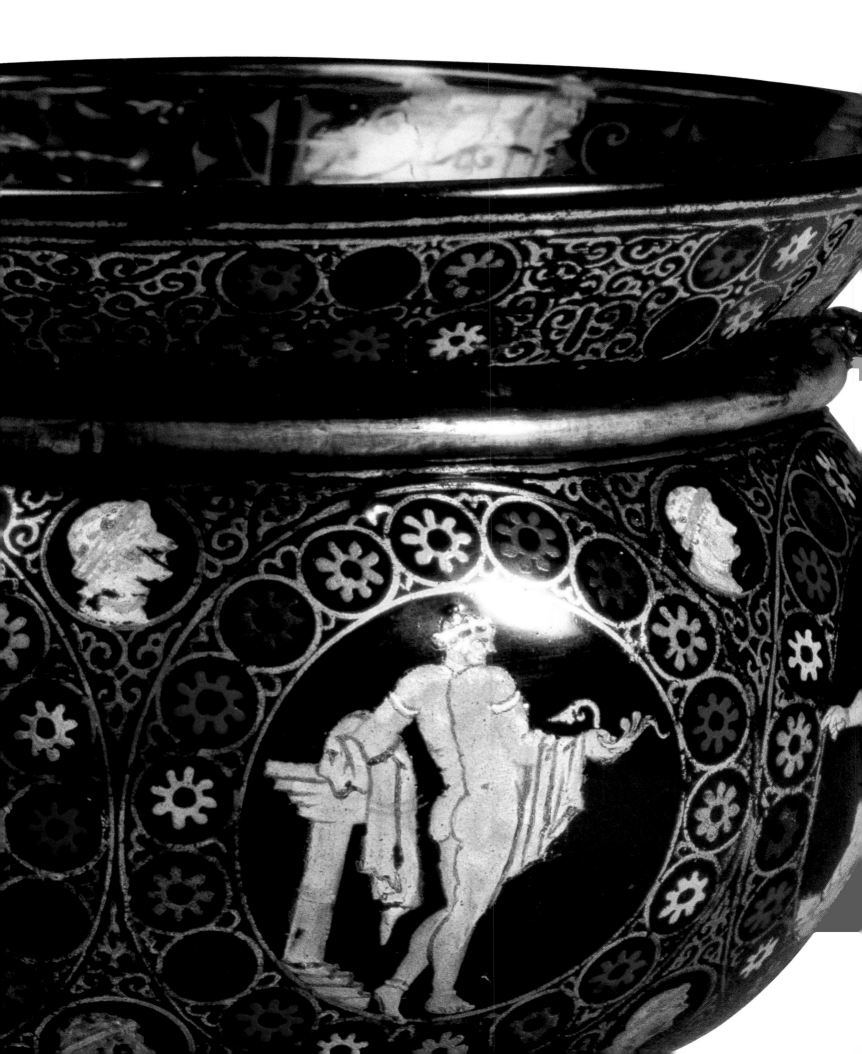

PURPLE GLASS VASE
WITH MYTHOLOGICAL DECORATION
Detail. 10th century,
Constantinople, painted glass,
height 17 cm (6 3/4 in.);
width including handles 33 cm (13 in.).
Venice, Procuratoria di San Marco.

These were made in easily transportable kit form and the family even apparently controlled production in Constantinople itself.

To an even greater extent than under Justinian, the capital became the focal centre for the production of luxury goods. The principal clients – the Emperor, the court and the leading Church dignitaries – all resided there. Above all, during the turmoil of the 7th and 8th centuries, Constantinople alone had managed to maintain the grand traditions. Some former centres, such as Syria or Egypt, were irretrievably lost, in others production had ground to a halt. Although some provincial economic activity still went on, it was essentially geared to producing basic necessities rather than luxuries. The celebrated fabrics which the noble Danilis brought from the Peloponnese as gifts for Basil I, with whom she had long entertained friendly relations, were, with the exception of the foreign-made items among them, mere linens or woollens. And the carpets which, on returning home, she had specially woven for the church of the Nea were probably of similar material. The relatively humble quality of provincial production under the Macedonians is confirmed by the examination of a small group of tinned bronze liturgical implements with decorative engraving, almost certainly made in the vincinity of the Taurus copper deposits. As for the remarkable "Reliquary of St Anastasios" in Aachen, which was executed in the form of a Byzantine church with a gold and niello dome for Eustathios Maleinos, the late 10th-century *strategos* (military governor) of Antioch, it was no doubt the work of a craftsman active in the latter city which had once more – albeit temporarily – come under Byzantine control. But the only possible explanation for such an astonishing artefact must lie in the enduring presence of Constantinopolitan artistic traditions in Arab-dominated Syria.

Under the Komneni, on the other hand, the provinces enjoyed a spell of relative prosperity and brilliant craftsmanship apparently developed in some centres. In 1147, Roger II of Sicily took captive a number of silk-workers in both Thebes and Athens, which suggests that the manufacture of luxury goods was no longer confined to Constantinople. Similarly, a small group of altar and processional crosses – now in Paris (Musée de Cluny), Geneva, New York and Cleveland – which were executed in gilded silver with niello decoration and all came from north-west Anatolia, no doubt originate from workshops in that region, and can be distinguished from Constantinopolitan works by a cruder style and corrupt inscriptions. It has to be acknowledged, however, that among the works attributable to provincial centres, only rare examples can match the splendour of those produced in the capital.

The glass industry "crystallized" this disparity. It not only provided the tesserae for mosaics and enamels for gold and silverplate, but also produced extremely expensive pieces. In the 10th century, their beauty and colours were praised in a well-known epigram by John the Geometer, while in the early 12th-century Latin West, the monk Theophilus admired the goblets "made by the Greeks... in purple or light-blue glass", and those "decorated with gold..., with circles, and within the circles, animals, birds, of richly variegated work". Yet for this entire period, excavations carried out at Sardis and at Corinth – where vestiges of work-

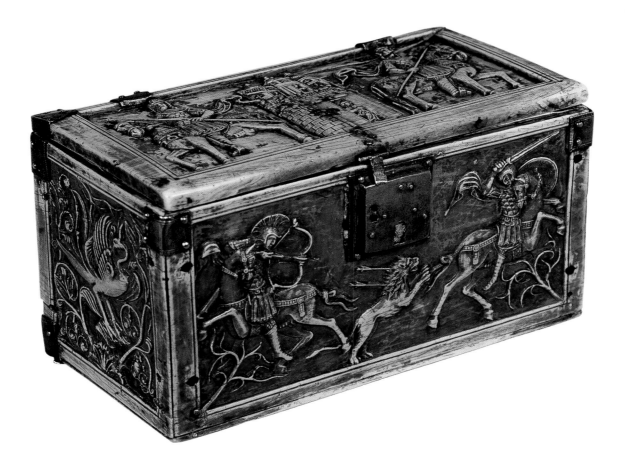

shops have been discovered –, in Cyprus or in the Balkans, have brought to light little more than ordinary jewellery, spun-glass bracelets, amulets or imitation cameos, along with blown glass bowls, bottles and goblets, which are either undecorated or merely spurred or ribbed. It is thus to the workshops in the capital alone that should be attributed a series of sumptuous blue or purple glassware pieces with enamelled decoration – like those described by Theophilus –, of which a few rare fragments have been unearthed not only at Corinth and in Cyprus but also beyond the imperial frontiers at Dvin in Armenia, Novogrudok in Russia, and as far afield as Tarquinia and Otranto in Italy. These fragments all display affinities with the one surviving intact specimen, the famous purple glass cup in the treasury of San Marco in Venice, probably itself part of plunder from the Fourth Crusade. The belly of this admirable piece features a series of large medallion portraits of Ares, Dionysos and Hercules – direct borrowings from the classical repertory; the medallions are framed by painted rosettes which are picked out against a background of gilded stylized foliated scrolls, while elegant pseudo-Kufic inscriptions run along the base and inner lip of the cup.

Byzantium indeed remained spellbound by the art of Islam. There were constant exchanges with the Arab world. Arab travellers, prisoners, and craftsmen lived in Constantinople. Up until the 11th century, the city also boasted a mosque. Court circles were familiar with Islamic art, if only

THE HARBAVILLE TRIPTYCH, FRONT:
DEESIS, APOSTLES AND SAINTS

Mid-10th century, ivory,
height 24 cm (9 1/2 in.);
length (open) 28 cm (11 in.).
Paris, Musée du Louvre,
Département des Objets d'Art.

through the gifts received from the Caliphs and – when it bore no religious message – it supplied an inexhaustible repertory to Byzantine artists. There are a few remaining 10th and 11th-century plain, transparent glass bowls, such as those in the treasury of San Marco in Venice which still have their original Byzantine mounting and a relief decoration of discs, spurs, or facets, imitating Sassanid pieces in rock crystal or those made for the Fatimids of Cairo. Stylized plant motifs and lush palmettes featured on pottery, and also on gold and silverwork or ivories, either in the form of enamelled fillets or as a decorative coating of foliated scrolls and fleurons. Textiles in particular revealed the closest affinities with Islamic art, sharing the same zoomorphic themes – lions, elephants, parrots, eagles, griffins and *simurghs* – and forceful stylization. Moreover, specific Greek terminology relating to fabrics borrowed heavily from Arabic, and vice-versa. The commonest techniques – samite up to the 11th century, then lampas – were identical in both civilizations. Under the Macedonians, some of the sumptuous multicoloured silks produced by the imperial workshops even bore inscriptions which were modelled on the Koranic invocations to be seen on contemporary Islamic fabrics, for instance the "Lions Passant" silk in Cologne Diocesan Museum which

THE HARBAVILLE TRIPTYCH, BACK:
CHRIST'S TRIUMPHAL CROSS ABOVE
A PARADISIACAL GARDEN
(CENTRE PANEL) AND SAINTS (WINGS)
Mid-10th century, ivory,
height 24 cm (9 1/2 in.);
length (open) 28 cm (11 in.).
Paris, Musée du Louvre,
Département des Objets d'Art.

is decorated with large yellow lions on a purple background, and bears the names of Basil II and Constantine VIII (and therefore dates from before 1025). Another silk, placed in the year 1000 in Charlemagne's tomb in Aachen and decorated with elephants framed in monumental medallions, bears the names of two imperial officials and that of the Zeuxippe workshop located in the vicinity of the imperial Palace. One of the finest, however, is perhaps the silk used, around 1000, as a shroud to wrap the remains of St Germanus of Auxerre. Large yellow eagles with spread wings and powerful talons are set against a purple background dotted with large rosettes, and each bird clasps in its beak a ring from which hangs a pearl. During the 11th century, both in Byzantium and in Islamic countries, the lampas technique became prevalent. It is characterized by monochrome, "incised" silks – so called because the decorative pattern seems to be carved into the background as if in relief. Fabrics became more shimmering, and motifs smaller and more intricate. Although oriental themes, face-to-face animals and pseudo-Kufic inscriptions remained fashionable until the 12th century, they did not, however, exclude religious images – which are occasionally mentioned from the 9th century in the *Liber pontificalis* – or the more traditional

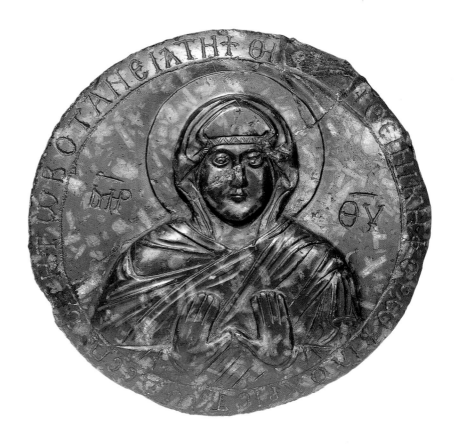

representations of imperial propaganda, as illustrated by a single surviving example – the silk tapestry from the treasury of Bamberg Cathedral depicting the triumph of Basil II which was celebrated in 1018 in Athens and in Constantinople. The equestrian figure of the Emperor, flanked by two allegorical female figures presenting him with a crown and helmet, looks exactly like some triumphant victor from classical antiquity. The luxury arts and crafts were indeed largely dependent upon classical models. Little importance, however, was attached to the models themselves, providing that their transcription gave the impression of a certain continuity with the past. Yet this prestigious past, which artists and their clients sought so much to revive, was basically identified with the Empire of Constantine and Justinian, an Empire which was both Roman and Greek, and above all Christian. Accordingly, they only borrowed from classical art those elements which were compatible with Christian doctrine and pictorial orthodoxy – strictly codified in the aftermath of the iconoclastic controversy – and chose to transpose into religious art only those formal and stylistic features which could be used to perfect it.

This did not mean that the pagan art of classical antiquity was simply spurned. Even in the 10th century, it was to re-emerge in a number of secular works which, like the fantasies of the manuscript illustrators, were destined for a privileged intellectual few. Figures from classical mythology appear for instance on the purple glass cup in Venice. The lid of the silver inkpot belonging to the calligrapher Leo, belonging to the treasury of

Padua cathedral, features a Gorgon's head, while the decoration on the pot itself depicts Apollo and entwined Pythian snakes. A cohort of classical gods and heroes also appears on an admirable series of ivory caskets, depicted inside little sculpted relief panels, framed by bands of rosettes. The finest of these, such as the Veroli casket, now in London, have portraits of Aphrodite, Hercules, or Bellerophon, or scenes such as the rape of Europa and the sacrifice of Iphigenia, mingled with centaur musicians, nereids riding sea monsters, or maenads dancing in Dionysian processions. The mythological figures on all the caskets are curiously portrayed as chubby *putti*; the nonchalant attitudes and gestures are a striking parody of the classical models from which they are derived. These eclectic friezes, juxtaposed in an apparently haphazard way, offer a charming, and often erotic, pot-pourri of classical literature. This ironic interpretation of classical antiquity is taken even further in scenes where the *putti* play with the lions and stags confronting circus gladiators or, as in certain pagan sarcophagi, are shown diving bare-bottomed into a basket.

The return to classical tradition explains the re-emergence of techniques that had been abandoned during the centuries of turmoil. The craftsmen of the Macedonian renaissance could not remain indifferent to the art of glyptics, which had flourished in classical antiquity. As in architecture, their admiration was revealed in reused materials. The "Grand camée de France" – the most famous, largest and finest of classical cameos, now in the Cabinet des Médailles in Paris, and which depicts the triumph of Germanicus – was mounted in Constantinople in a silver reliquary panel – destroyed in 1804 –, although it is impossible to discern the exact Christian significance which the Byzantines attached to an image which, in the 17th century, was believed to represent Joseph's triumph in Egypt. The treasury of San Marco in Venice still possesses classical rock crystal goblets and sardonyx vases from the age of Augustus which were mounted in gold and silver and converted to liturgical use. These include, among other pieces, a crystal lamp with a decoration of marine fauna, the agate chalice of the Logothetes Sisinnios, a twin-handled sardonyx chalice, and a lobed sardonyx chalice inscribed with the name of Romanos II. Reuse soon led to imitation. From the 10th century, magnificent sardonyx chalices such as the so-called "Chalice of the Patriarchs", and serpentine and alabaster patens, most of which are also now in Venice, were matching their models in quality of workmanship. As in classical times, a vast number of jasper, sardonyx, and more rarely sapphire, amethyst and lapis lazuli cameos were carved in Constantinople between the 9th and 12th centuries. Although only two specimens, now in the Victoria and Albert Museum in London, are dated – Leo VI's jasper cameo with Christ Blessing, and a serpentine cameo with the Virgin Orans and an inscription invoking the protection of the Emperor Nikephoros Botaneiates –, they all reveal the invariably refined craftsmanship of the Byzantine lapidaries and the profound influence of classical models on their nascent style. And yet, despite such references,

ICON OF THE ARCHANGEL GABRIEL
Late 11th-early 12th century, Constantinople, steatite enhanced with gold, gilded wood frame, height 16.4 cm (6 1/2 in.).
Fiesole, Museo Bandini.

RELIQUARY OF THE TRUE CROSS, OPEN
Mid-10th century, Constantinople, gold, silver gilt, cloisonné enamel on gold, pearls and precious stones, height 48 cm (18 7/8 in.).
Limburg an der Lahn, Cathedral Treasury.

Brought to Germany from Constantinople by the knight Ulrich von Ulmen after the Fourth Crusade. The cross, which bears an inscription on the back in the names of Constantine VII and his son Romanos II, was made between 945 and 959. The reliquary, with its separate compartments, is inscribed with the name of Proedrus Basil, the bastard son of Romanos I, and was made between 968 and 985.

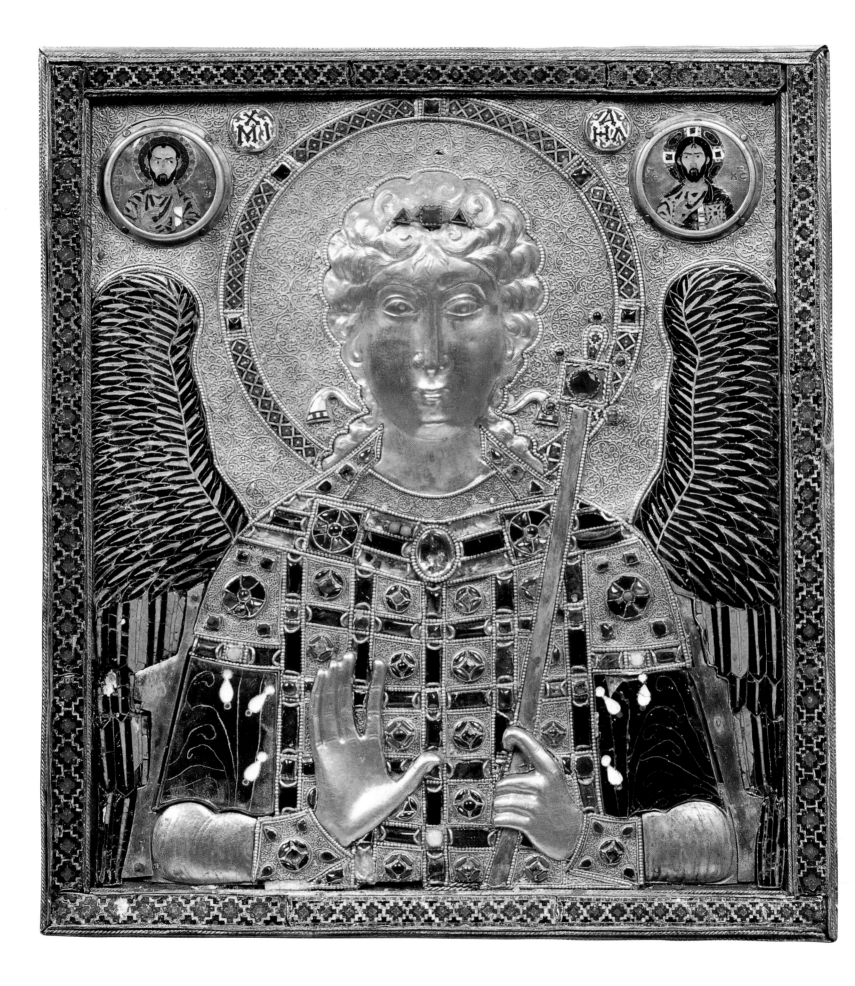

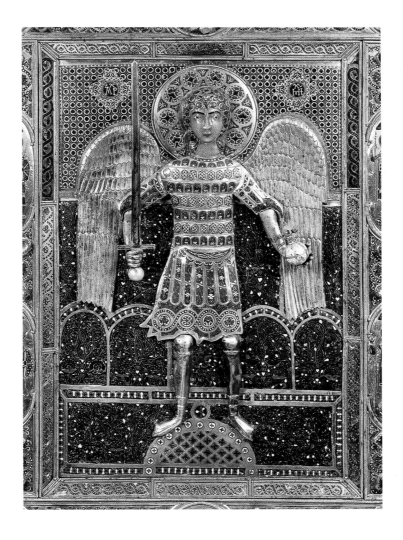

the iconography remained exclusively Christian, rejecting the pagan or dynastic themes depicted in the glyptic examples of antiquity.

In the 10th century, ivory sculpture, a favoured late classical technique, also underwent an abrupt revival – or at least one that, for instance, the tip of a sceptre executed for Leo V or Leo VI (Berlin State Museums) in the previous century, with its compact forms barely enlivened by a heightened graphic style and ornamental treatment, could not be considered a harbinger. Indeed, the spectacular blossoming of Byzantine ivory sculpture only began under the reign of Constantine VII. Several pieces are directly related to his imperial patronage. One plaque, now in Moscow, represents the Emperor being crowned by Christ. A triptych with the *deesis* and saints in the Palazzo Venezia in Rome bears inscriptions referring to him. Both these ivories come from the same workshop, the creations of which have been collectively categorized as the "Romanos group", named after the famous plaque in the Cabinet des Médailles in Paris which depicts Christ crowning the young Romanos II – son of Constantine VII, co-Emperor with his father from 945 – and his first wife, Eudokia, who died in 949. The Romanos group ivories are

ICON WITH FULL-LENGTH PORTRAIT OF ST MICHAEL
Detail of the central panel. Late 11th or early 12th century, Constantinople, gold, silver gilt, cloisonné enamel on gold, height 46 cm (18 1/8 in.).
Venice, Procuratoria di San Marco.

ICON WITH BUST PORTRAIT OF ST MICHAEL
Detail of the central panel. 10th century, Constantinople, gold, silver gilt, cloisonné enamel on gold, precious stones, height 44 cm (17 3/8 in.).
Venice, Procuratoria di San Marco.

among the supreme achievements of the Macedonian renaissance. They are characterized not only by their extreme formal elegance, simple compositions, harmonious proportions, dignified draperies, and noble features, but also by an accomplished deep carving technique used to create a virtuoso representation of the great models of classical antiquity in high relief. The group also includes other masterpieces such as the sublime Virgin and Child in the Museum Catharijne convent in Utrecht, and the remarkable "Harbaville Triptych" in the Louvre. The central panel of the latter ivory depicts the *deesis* and saints, while on the back the victorious Cross of Christ towers in a starry sky over a paradisiacal garden where birds, lions and rabbits live peacefully together. A second group, based around the reliefs in the reliquary of the True Cross in Cortona, should also be related to imperial circles since the reliquary itself bears an inscription in the name of Emperor Nikephoros II Phokas (963-969). In these ivories, however, the almost ethereal nobility of the "Romanos group" gives way to a more monumental and denser visual effect, readily apparent for instance in the twin plaques in the Louvre depicting the Crucifixion and Christ's Mission to the Apostles. These were probably based on different models, and the broad faces with their heavy eyelids and full lips seem to echo certain features of 6th-century ivories.

The ivories belonging to the so-called "pictorial group" – the most classicizing group of all – drew on yet other sources. Features such as the lively scenes and brisk narrative style, figures with lithe, dancing silhouettes and draperies which hug the body and heighten the sense of movement, the chubby faces and curly hair – seen for instance on the plaque depicting the Dormition of the Virgin, incorporated, around 1000, onto the book cover of Otto III's copy of the Gospels (now in Munich) – are in fact directly derived from Hellenistic art. Explicit references were quite common: a classically inspired *spinario* appears in the bottom foreground of a panel depicting Christ's Entry into Jerusalem (Berlin State Museums), while in the tiny Nativity triptych in the Louvre, one of the Apostles in the Ascension scene is depicted as a classical orator. Further confirmation of the close links between this last group and the art of classical antiquity is the fact that it includes the finest caskets with mythological ornamentation. The most famous of these, the Veroli casket, comes from the same workshop as the Louvre Nativity triptych.

Not all Byzantine ivories fall into such neat categories. The complexity of Constantinopolitan production is notably illustrated by the casket stained with a purple pigment in the treasury of Troyes Cathedral, executed in the late 10th or early 11th century; the classical themes of imperial iconography (triumphal victory parade, lion and boar hunting) are depicted in a vigorous style not really encountered in other ivories. Yet despite recent attempts to extend the duration of production up to the 12th century, it has to be acknowledged that the golden age of ivory carving was as short-lived as it was resplendent and, given a few exceptions, barely seems to have gone beyond the first half of the 11th century; at which

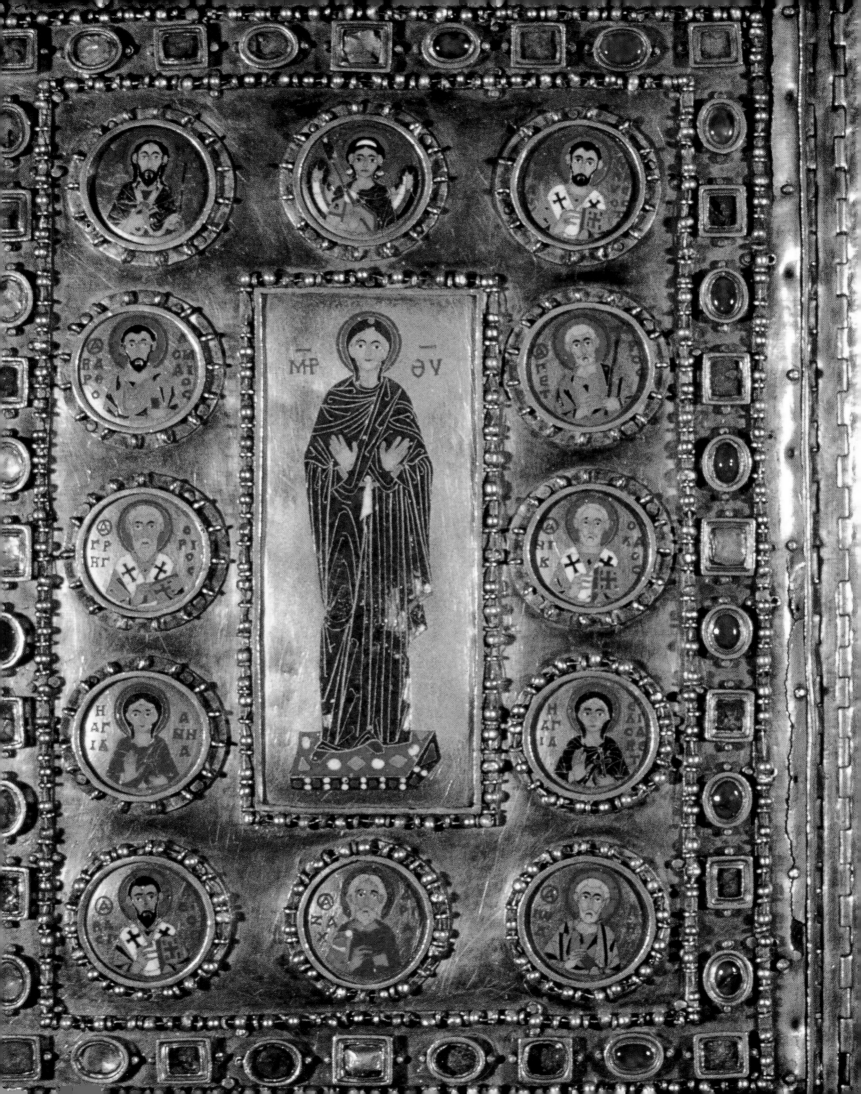

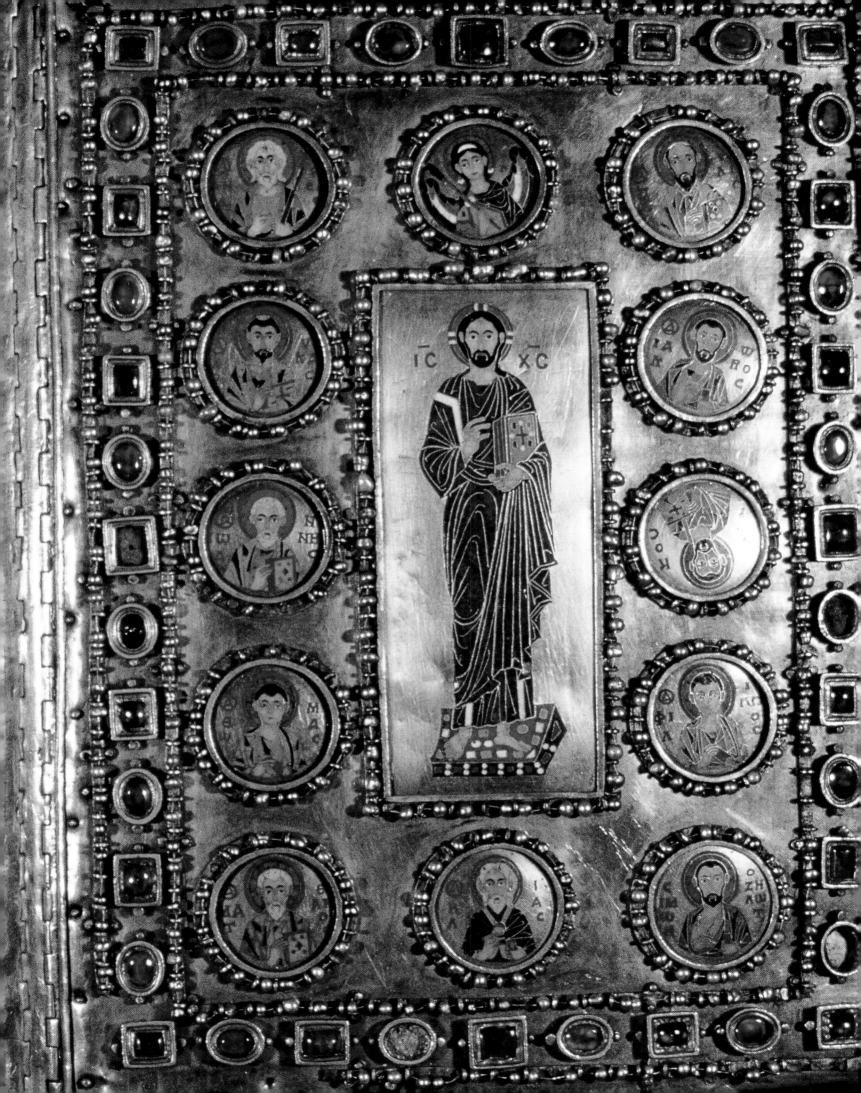

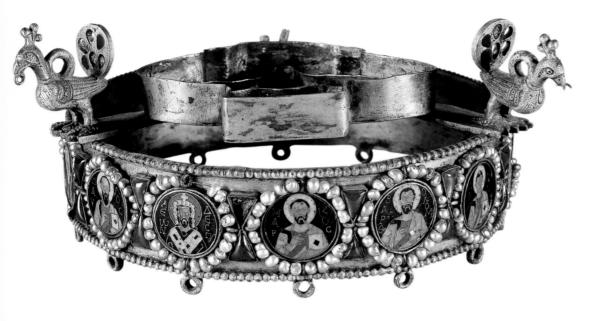

EMPEROR LEO VI'S VOTIVE CROWN

886-912, Constantinople, gold, cloisonné enamel on gold, and pearls, height 3.5 cm (1 3/8 in.); diameter 13 cm (5 1/8 in.).

Venice, Procuratoria di San Marco.

ST STEPHEN OF HUNGARY'S CROWN

1074-1077, Constantinople, subsequent conversion into a closed crown, gold, silver gilt, cloisonné enamel on gold, diameter 20.9 cm (8 1/4 in.).

Budapest, Hungarian National Museum.

point, no doubt, increasingly rare ivory was replaced by steatite, a soft greyish-green stone which was easily worked and cut into thin plaques. Furthermore, from the late 10th century even the earliest steatite carvings copy the ivories in their style. This is the case for the *Hetoimasia* in the Louvre, an icon of St Nicholas at Mount Sinai with painted highlights, or again for the archangel in Fiesole, all of which almost reproduce the nobility of the "Romanos group" carvings.

In contrast, precious metalworking continued to flourish for more than three centuries. The monumental works which embellished churches and palaces and were described in contemporary texts have vanished without trace. Among those pieces that have come down to us, religious gold and silverplate naturally predominates. Nowadays there are virtually no surviving counterparts to the Padua inkpot with its mythological décor, or to the seven enamel plaques of the crown of Constantine Monomachos (Budapest) on which appear, in a stylized oriental garden, the Emperor, his wife Zoe, and her sister Theodora, accompanied by personifications of Truth and Humility. Secular art is also represented by pieces of jewellery, all stylistically derived from the closing period of late antiquity: bracelets, like the gold and enamel pair with floral and bird motifs discovered in Thessaloníki in 1956; gold, silver and bronze rings; earrings, the most sumptuous of which were embellished with large pearls, enamels and granulation. Yet the almost invariable invocations to Christ or to the Virgin found on rings confirm an omnipresent religious ethos; the one surviving complete necklace, discovered at Preslav, combines the thrice-repeated image of the Virgin Orans with floral and

| Pages 152-153
BOOKBINDING WITH CHRIST BLESSING AND VIRGIN ORANS

Late 10th-early 11th century, Constantinople, silver gilt on wood, cloisonné enamel on gold, pearls and precious stones, height 29 cm (11 3/8 in.).

Venice, Biblioteca Marciana.

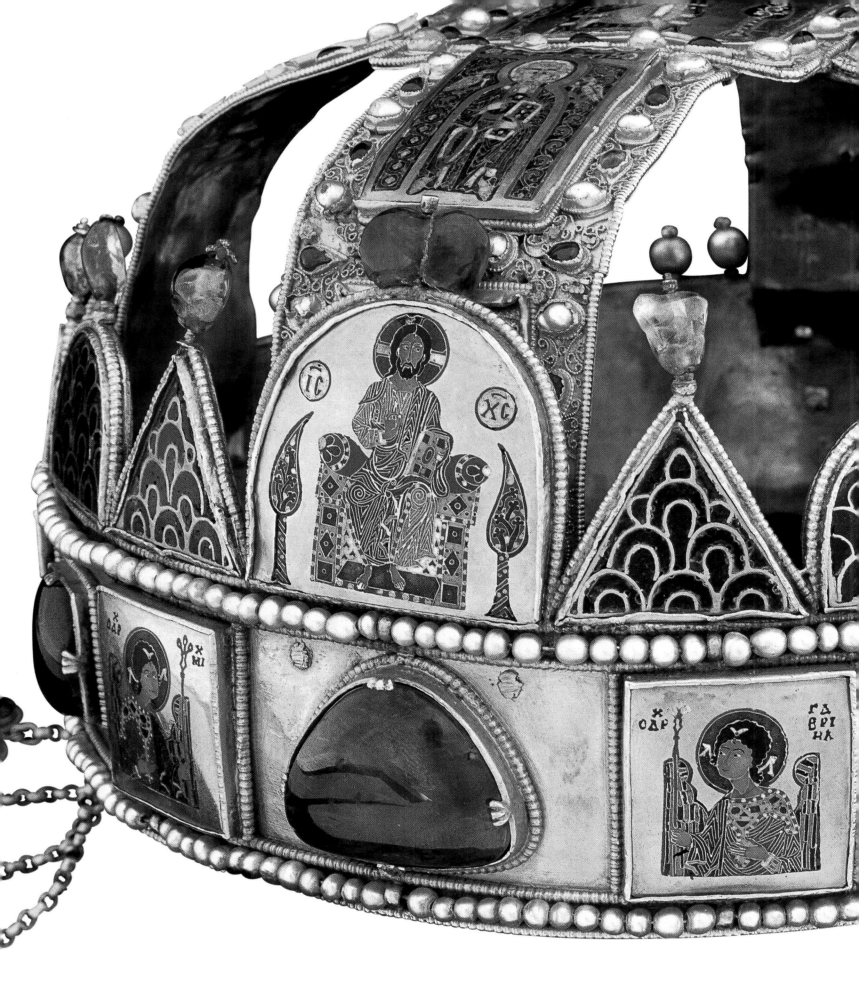

RELIQUARY OF ST DEMETRIOS
Mid-11th century, Constantinople (?),
silver gilt, height 15 cm (5 7/8 in.).
Moscow, State Historical and Cultural Museum.

**ARTOPHORION (CONTAINER
FOR THE RESERVED HOST)
KNOWN AS THE "RELIQUARY OF ANASTASIOS"**
Late 10th century, Antioch,
silver gilt with niello,
height 39.6 cm (15 5/8 in.).
Aachen, Cathedral Treasury.

bird motifs. Another type of artefact which witnessed a remarkable development was that of *enkolpia* – reliquary pendants, small receptacles, often in the shape of a cross, worn on the chest. The plainest were made of bronze or silver; the finest were in gold, embellished with pearls and precious stones, like the *enkolpion* cross from the Tournai treasury, or with enamel or even applied figures such as the one from Martvili now in Tbilisi Museum. Throughout the entire period, the forms – inherited from Palaeochristian art – adopted by precious metalware intended for liturgical use remained unchanged. The chalices from the San Marco treasury in Venice, for instance, like the "Chalice of the Patriarchs", are shaped like 6th-century chalices, with a knop and a base like a tall, sawn-off cone. Others, like the chalice which belonged to the Logothetes Sisinnios, with its sardonyx cup and twin silver-gilt handles, display the more mannered form of the two-handled classical cantharus. Like the patens, lamps and bookbindings from the same treasury, such artefacts were usually embellished with enamels, pearls, and precious stones. Icons were sometimes entirely coated with precious metalwork, like the two celebrated icons of the archangel Michael in San Marco. Reliquaries, however, make up the most remarkable ensemble. Some of these adopt an unusual aspect, like the small "lantern" from the Beaulieu-sur-Dordogne treasury, or the reliquary of St Demetrios in Moscow which, according to its inscriptions, was designed as a miniature replica of the saint's tomb in Thessaloníki. Most common are the *staurothekai*, or reliquaries purportedly containing fragments of the True Cross; their form – a small box with a sliding lid – dates back to classical antiquity. The lid usually depicts the Crucifixion, and the box contains the relic shaped like a twin-armed cross, often with the figures of Constantine and Helena at its foot. The largest and most sumptuous is undoubtedly the gold Limburg an der Lahn *staurotheke* embellished with enamels, pearls and precious stones. It was made for the Proedros Basil, an illegitimate son of Romanos I, and arrived in Limburg after 1204, brought back from Constantinople as Crusader booty. It displays a remarkable iconography, centred around the enthroned figure of Christ, the *deesis*, and the Apostles; the relic itself lies within its box, surrounded by a further series of smaller compartments, the lids of which are in turn decorated with angels and seraphs; and which formerly contained yet other relics, identified by inscriptions.

The contribution made to Byzantine splendour by gold and silversmiths is abiding and awesome. Already by the 9th century, their works displayed a sumptuosity and a sureness of touch that would be unfailingly maintained for more than three hundred years. One example is the ring which belonged to Basil the "Parakoimomenos" – the future Emperor Basil I, and at the time Michael III's favourite – bearing a delicate niello decoration of foliated scrolls and set with a table-cut emerald engraved with a bust of Christ. Most of the techniques employed were already current under Justinian, except for *opus interassile*, which had disappeared, and cloisonné enamelwork on gold. The exact origin of the latter

**Cover Plaque of the Reliquary
of the Stone of the Holy Sepulchre:
the Holy Women at the Tomb of Christ**

From the treasury
of the Sainte-Chapelle, Paris.
Second half of the 12th century,
Constantinople, silver gilt,
height 42.6 cm (16 3/4 in.).
Paris, Musée du Louvre, Département des Objets d'Art.

Pala d'Oro

Constantinople, 12th century (enamels);
Venice, 13th century (enamels in the
frame of the lower section),
and 1345 (Gothic mount),
gold, silver gilt, cloisonné enamel
on gold, pearls, precious stones,
height 212 cm (83 1/2 in.),
length 334 cm (131 1/2 in.).
Venice, Procuratoria di San Marco.

technique, which involved fusing enamels inside little compartments formed by metal strips fixed onto the metal base, remains open to debate. It may however have been imported from the West in the 9th century, as it had already been mastered by Carolingian goldsmiths half a century earlier. In Byzantium, it was to flourish spectacularly. Among the oldest enamels are those that have been categorized around the votive crown of Leo VI (886-912) in the treasury of San Marco, and which are characterized by the use of full enamel, transluscent green backgrounds, bright colours and simplified compartmental design. But in the mid-10th century, cloisonné enamel embedded in gold – a procedure by which the enamels stood out against a glittering gold background – became prevalent. The mid-10th-century enamels on the Limburg reliquary for instance are among the earliest examples. The elegance and nobility of the figures on the lid, the large Islamic-style fleurons on the interior bands, and the majestic repoussé gold cross on the back are all features which make it the unchallenged masterpiece of the Macedonian renaissance. This classicizing trend continued into the 11th century; but by 1050 or thereabouts the proportions of the figures became more elongated, the design increasingly more intricate and ornamentation more emphatic, a development which affected all precious metalworking, and particularly enamelwork, as is visible in the case of the plaques of the Monomachos Crown. On another Byzantine crown – the one offered by Michael VII (1071-1078) to King Géza of Hungary – the figures have a lively air and look sideways; their clothes are laden with brightly-coloured ornamental droplets, hearts and pearls. Towards 1100, this trend became more pronounced in the full-length icon of St Michael in the San Marco treasury, and in the oldest enamels in the Venice *Pala d'Oro*, notably the series of prophets in the lower section. The *Pala d'Oro* is of course one of the most famous works of medieval art. It also contains the finest surviving ensemble of Byzantine enamels, covering the entire Komnenian period. The original *pala* was made in Constantinople in 1105 for the Doge Ordelafo Falier; the second version, in 1209, probably included plundered elements, spoils from the Fourth Crusade. In 1345, the *pala* was once again completely remounted, this time within its surviving Gothic frame. Today, only the enamels are (almost) all Byzantine. Those which, in the lower section, portray the Empress Irene – wife of Alexios I –

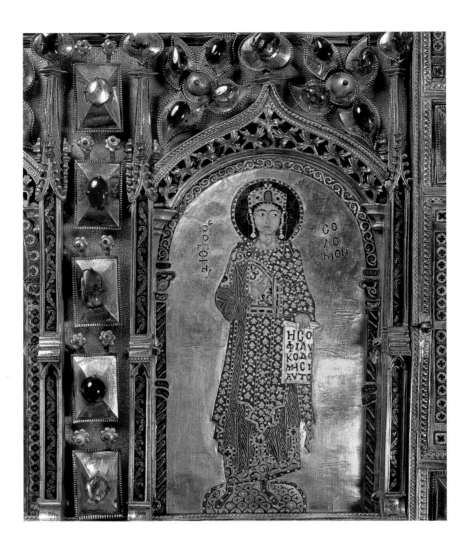

PALA D'ORO: THE PROPHET SOLOMON

Detail. Early 12th century,
Constantinople,
gold and cloisonné enamel on gold,
height 19 cm (7 1/2 in.).
Venice, Procuratoria di San Marco.

and the Doge Ordelafo Falier, date from the original *pala*. The plaques on the register surrounding the large central figure of Christ are a little later. The graphic intensity and robust portraiture of the six plaques depicting a cycle of twelve feasts in the upper section place them in the ultimate phase of Komnenian art. Indeed, in the course of the 12th century, artists elongated proportions, painted smaller hands and feet, and introduced a more expressive, mannered treatment of gestures. The reliefs on the repoussé silver gilt lid plaque of the reliquary which once contained a fragment of the Stone of the Sepulchre – formerly in the Sainte-Chapelle treasury in Paris and now in the Louvre – no doubt represent the crowning moment of this mannerist trend: the sheer depth of feeling conveyed by the awe-stricken figures of the Holy Women as they are greeted by a majestic angel at Christ's tomb on the morning of the Resurrection is of a rarely matched intensity.

In 1204, the Crusaders put a brutal end to this cultural revival. The indiscriminate and rapacious pillaging of the treasures that lay in the churches and palaces of Constantinople was, in itself, an avowal of centuries-old Western fascination with the universal splendour of Byzantium.

4. THE LATIN "INTERLUDE" (1204-1261)

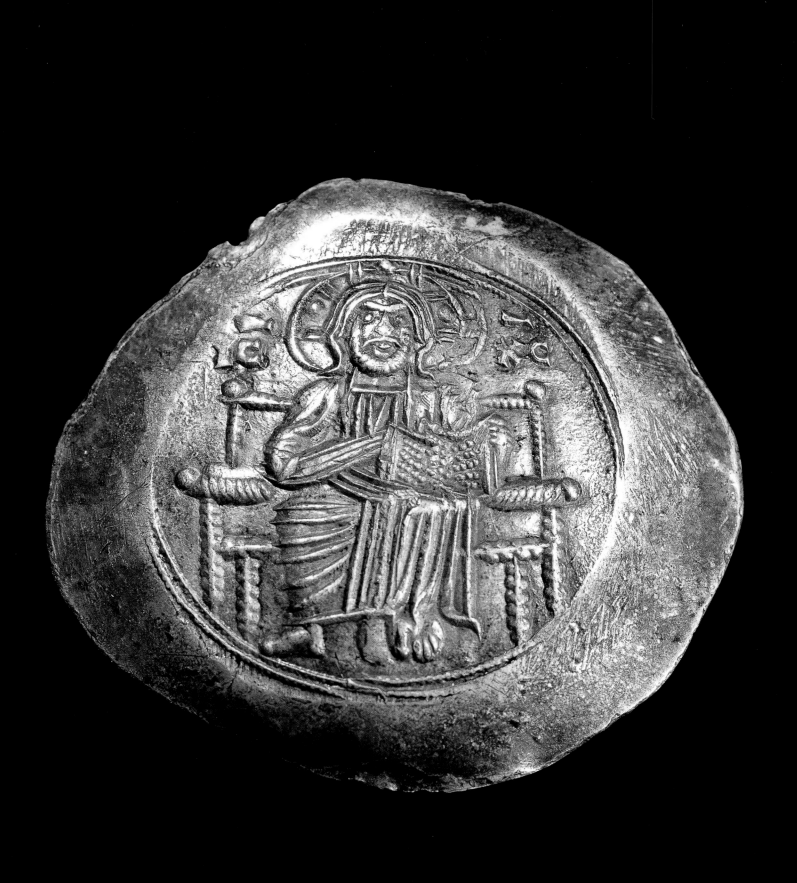

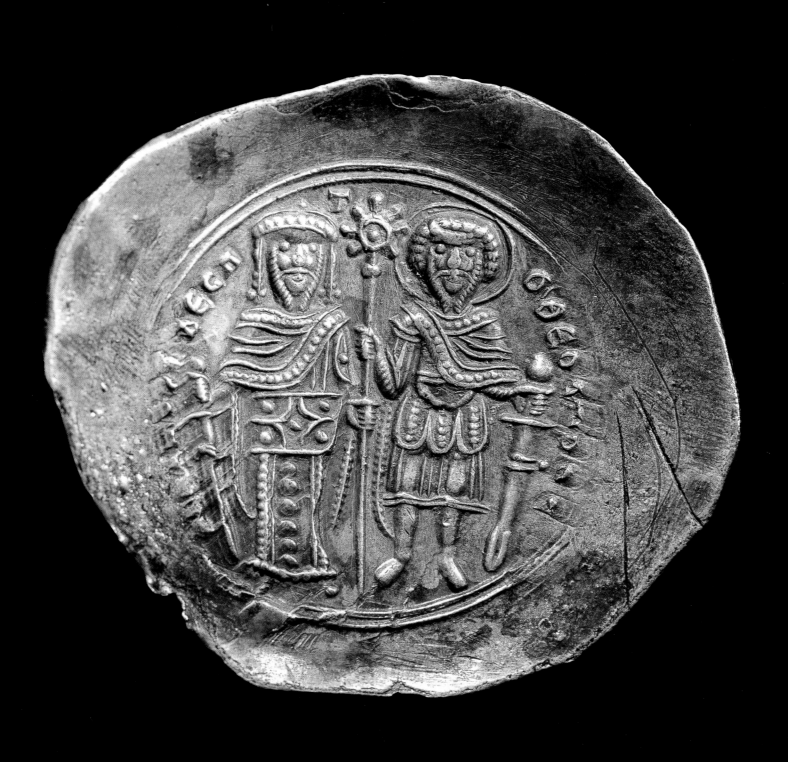

On 13 April 1204, Constantinople fell to the Crusaders who immediately portioned out the spoils of the Empire. Count Baldwin of Flanders, elected Emperor by the crusading armies, was awarded a quarter of the imperial domains – essentially Thrace and Bithynia, along with Constantinople in the centre. The remainder was divided into two equal parts. The first was allocated as fiefs to the Crusade leaders: Othon de La Roche became Duke of Athens, and Geoffroy de Villehardouin Lord of Achaia, or Morea, in the central Peloponnese; in northern Greece, the turbulent Boniface de Montferrat carved out a kingdom around Thessaloníki and soon set his eyes on Macedonia and mainland Greece; other leaders obtained fiefs in Thebes, Naxos, Euboea and elsewhere. The second half fell to the Venetians, who had financed the campaign; above all, their share included most of the islands and ports of Albania, Epirus, the Peloponnese, Euboea and Crete, which became staging posts for their powerful navy and merchant fleet. The island of Cyprus did not belong to the Latin Empire. It had been seized from Byzantium in 1191 and was ruled by the Lusignan family.

The Latin Empire

The reorganized Empire suffered from an inherent structural weakness. The Emperor had scarcely any real authority over either the often rival feudal principalities, or the Venetian possessions which were jointly governed by an autonomous *podestà*. Moreover, Venice exercised a de facto monopoly over the Empire's economy and thus deprived it of a large part of its resources. By 1236, the Emperor was even reduced to pawning his last remaining treasures, the Holy Crown of Christ and the principal relics of the Passion, which St Louis succeeded in purchasing. In addition, the peripheral regions which had escaped Latin takeover set themselves up as independent Greek principalities: this was the case with Rhodes, the Despotate of Epirus, or again, the Empire of Trebizond, founded by Komnenian princes. In the end, however, the Byzantine Empire did not disappear, and managed to survive in Asia Minor. Forced to abandon Constantinople, it withdrew to a new capital in Nicaea – although the Emperor preferred to establish residence in Nymphaeum – and controlled a continuous band of territories stretching from Smyrna on the west coast as far as Amastris, on the Black Sea, in the north. The Greek patriarchate along with a number of intellectuals sought refuge in Nicaea, and it was from there that the reconquest was launched under John Vatatzes (1222-1254). Taking advantage of the Mongol invasions which plunged the entire Muslim Orient into disarray, and conducting a skilful policy of alliance with the Bulgars and the Genoese – excluded from a share in the 1204 spoils by the Venetians – he captured Rhodes and Thessaloníki, gained control of Thrace, dominated Epirus, and gradually encircled Constantinople, upon which Michael VIII Palaiologos, who seized power in 1258 and founded a new dynasty, was free to concentrate his efforts. Michael's victory over the Latin West at Pelagonia

| Pages 162-163
**SILVER COIN (TRACHY)
OF THEODORE I LASKARIS
EMPEROR OF NICAEA**
Obverse: Christ enthroned.
Reverse: St Theodore
and the Emperor.
1208-1222, Magnesia,
silver, diameter 3.2 cm (1 1/4 in.).
Paris, Bibliothèque Nationale de France,
Cabinet des Médailles.

**VILLEHARDOUIN
FORTRESS**
13th century.
Mistra (Peloponnese), Greece.

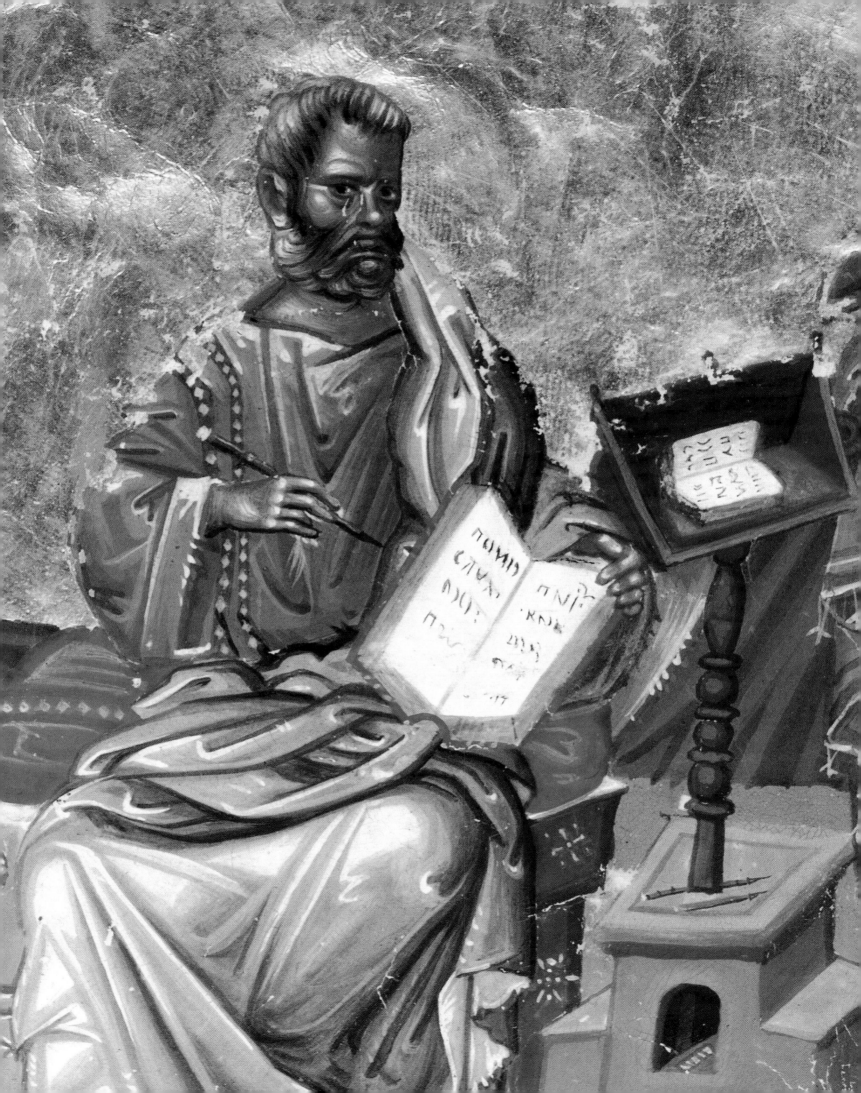

in 1259, and the alliance with the Genoese, reinforced by the treaty of Nymphaeum in March 1261, placed the capital at his mercy. At this point, the West deserted Baldwin II, who finally fled on 25 July. On 15 August, Michael VIII made his solemn entry into the liberated city. Constantinople, however, had been bled white. Its churches and palaces had been stripped of their riches, a wealth so great, according to Villehardouin, that "it was infinite and incalculable". The Crusaders had shared out among themselves the gold, silver, silks and all the treasures accumulated over centuries. The Venetians obtained the lion's share of the loot. They confiscated the bronze horses in the Hippodrome, helped themselves to the group of Tetrarchs, and snatched the finest marble sculpted reliefs, shipping all this booty back to Venice. The Latin Crusaders even stooped to violating the imperial tombs: the Greek historian Pachymeres records that the naked corpse of Basil II was found lying beside its empty sarcophagus, in an abandoned church that had been converted into a cattle shed. Relics and their precious containers did not escape the Crusaders' rapacity; hundreds of them were carried off to church treasuries in the pillagers' homelands, not to mention Venice of course. And the looting went on as long the Latin Empire itself lasted. Its supporters also converted the churches to their own rite. They made Hagia Sophia their cathedral and installed their patriarchate in the monastery of the Pantokrator. In 1261, the last Latin patriarch, Giustiniano Pantaleone fled, absconding with the last remaining treasures in the church including, it is said, the plaques depicting the twelve feasts which today adorn the upper section of the *Pala d'Oro*. Dominican and Franciscan friars, in their turn, moved into the monasteries from which the Greeks had been hounded, while the Hippodrome became a venue for jousting and tournaments.

Thus, over a period of more than fifty years, the centuries-old splendour of Constantinople ground to halt. The Latin invaders built nothing. They took over the finest buildings in the city and showed scant interest in the others. In their churches, they did little more than introduce images of unfamiliar Western saints, such as a fresco painting of St Francis of Assisi executed by one of their artists, discovered in the supposed church of Christ Akataleptos (Kalenderhane Camii). Besides, the swift collapse of the Latin Empire condemned its capital to inertia. Nevertheless, a small group of manuscripts may have been produced in Constantinople under Latin rule. One of these is a sumptuous bilingual (Greek and Latin) Gospel Book, now in the Bibliothèque Nationale in France (Gr. 54). It was probably intended for the use of a Latin prince or prelate and includes several fine paintings which combine the classical traditions of Byzantine art and Western iconographic features in a relatively smooth manner. The manuscript, however, is only half completed – a sign of the evident precarity of Latin Constantinople.

In the occupied territories, activity focused essentially on defensive works. The Crusaders built a few Gothic-style churches which contributed to

GRAECO-LATIN FOUR GOSPELS: THE EVANGELIST ST MARK
Mid-13th century, Constantinople (?), painting on parchment, Greek Manuscript 54, fol. 111, 33.5 × 20 cm (13 1/4 × 7 7/8 in.).
Paris, Bibliothèque Nationale de France.

RELIQUARY OF THE TRUE CROSS

From the church of Jaucourt
(Aube Department), to which
it was probably brought during
the 13th century. 12th or early
13th century (reliquary and sliding lid),
and Champagne c. 1320-1340
(base and angels), silver gilt
on a wooden core, copper gilt
(base), gemstones, overall
height 25 cm (9 7/8 in.).
Paris, Musée du Louvre,
Département des Objets d'Art.

**ICON OF THE VIRGIN
OF MANUEL DISYPATOS**

Before 1261, Thessaloníki (?),
painted wood, silver gilt,
cloisonné enamel on gold
and champlevé enamel,
height 27.8 cm (11 in.).
Freising (Bavaria), Diözesanmuseum,
Cathedral Treasury.

the lasting introduction, particularly in Frankish Morea, of Western architectural features, such as the pointed arch and the cross-ribbed vault, or the use of figurative sculpture; these co-existed alongside the generally small, and rarely imaginative churches which the Greeks were building at the time. But above all, they erected a remarkable series of fortresses, in particular in the Peloponnese. One of the best known is the Villehardouin castle at Mistra, at the foot of which a small town was soon to spring up. Admirably located on the summit of a rocky outcrop towering over the valley in which ancient Sparta had lain, it was intended to command all Laconia. Nevertheless, it was forced to surrender to the Greeks as early as 1262. Although these castles were home to small, yet often brilliant courtly circles, the central figures were the knights and men-at-arms whose images were overwhelmingly present in daily life. One of them, armed with his lance and rectangular shield, is represented by a few incised strokes on a ceramic chalice in the Louvre, while a praying, and likewise armoured St George is depicted on a painted sculpted wood icon in Athens Byzantine Museum.

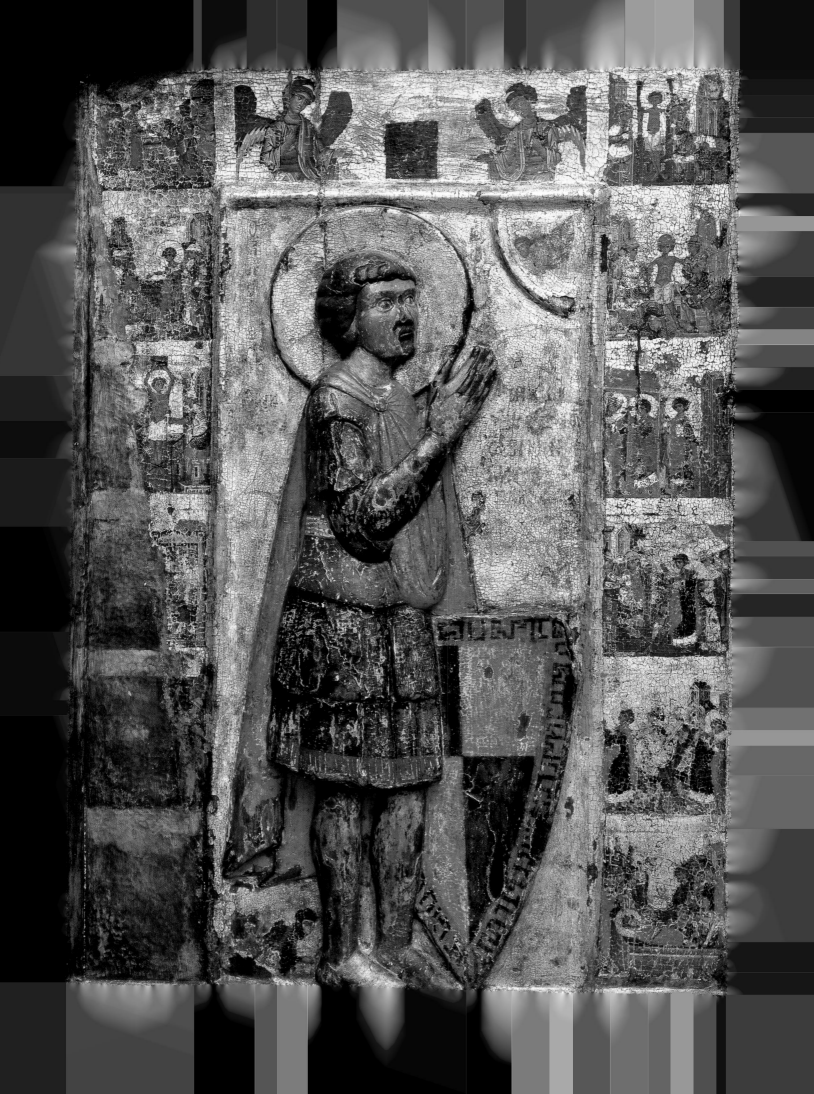

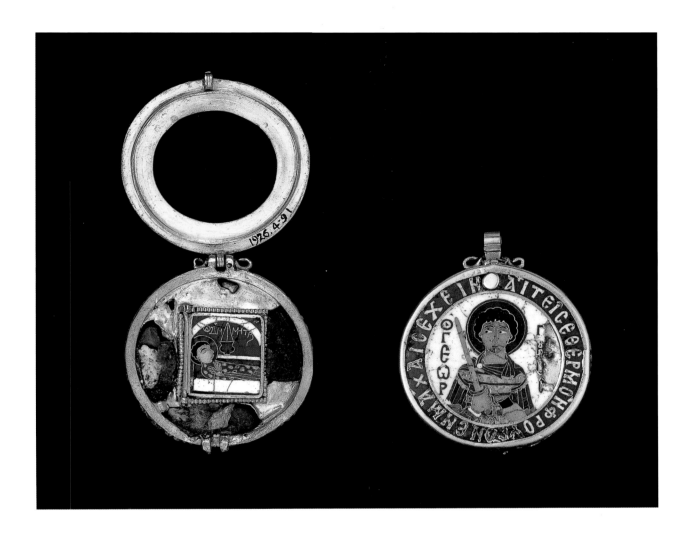

Byzantine traditions and identity

Byzantium retreated Nicaea, exiled intellectuals set up an imperial college. Not content to accept the laments of writers like Niketas Choniates, they pondered the catastrophe that had befallen them. Growing religious feeling drew strength from Aristotelian sources in Blemmydes' writings. The Hellenic past and its classical roots were rediscovered; this gradually led to the forging of a new Byzantine identity with nationalist overtones. But Nicaea, as described in a poem by Theodore Laskaris, was a small town consisting of churches, monasteries, a few palaces and houses, without even enough buildings to fill the available limited space within its ancient ramparts. Painters left Constantinople for Athos, the independent Greek states, Macedonia and Serbia. Around 1220-1230, those working in the *katholikon* at Mileseva monastery in Serbia left, in the narthex, a moving, nostalgic yet optimistic portrait of an Emperor, perhaps John Vatatzes, alongside the symbolic figures of Constantine and Helena. Thessaloníki, Greek again from 1224, safeguarded part of the Byzantine heritage. The precious frame of an icon of the Virgin, now in Freising in Bavaria, boasts a lengthy dedicatory inscription to Manuel Disypatos, probably metropolitan bishop of Thessaloníki (1235-1260).

ENKOLPION: OPEN AND CLOSED
13th century, Thessaloníki, gold and cloisonné enamel on gold, diameter 3.8 cm (1 1/2 in.).
London, British Museum.

ICON OF ST GEORGE AND SCENES FROM HIS LIFE
13th century, carved and painted wood, height 109 cm (42 7/8 in.).
Athens, Byzantine Museum.

Religious fervour associated with St Demetrios' shrine continued unabated. Two small gold and enamel *encolpia*, now in London and Washington, have been attributed to goldsmiths in the city because inside each is a faithful representation of St Demetrios' sarcophagus in his eponymous basilica; displaying affinities with the ornamental enamels on the frame of the Freising icon, they may well date from these same unsettled times. There were almost a hundred churches in the prosperous city of Trebizond which, within its walls, largely built in the 13th century, already looked much as it would two centuries later. It's major edifice, St Sophia' cathedral where the Trebizond Emperors were crowned, was built under Manuel I, between 1238 and 1263. Its architectural style – inscribed cross plan, elevation, and dome standing on four columns – is Komnenian. Traces of a fresco décor remain, notably in the narthex where the refined touch of Constantinopolitan artists can be detected in the scene of Christ among the Doctors. The rulers of Trebizond revived the opulent traditions of the *basileis*: the enamelled gold reliquary cross belonging to the Princess Palatine, in the Notre-Dame treasury in Paris, bears a dedicatory inscription to one of them, probably Manuel I. The spirit of Byzantium lived on in Trebizond, Thessaloníki, Nicaea and Mount Athos. Under Michael VIII Palaiologos it would return to Constantinople.

BOWL: WARRIOR
Late 12th or first half
of the 13th century, ceramic,
diameter 15.4 cm (6 1/8 in.).
Paris, Musée du Louvre,
Département des Objets d'Art.

5. The Palaiologos Dynasty (1261 - 1453)

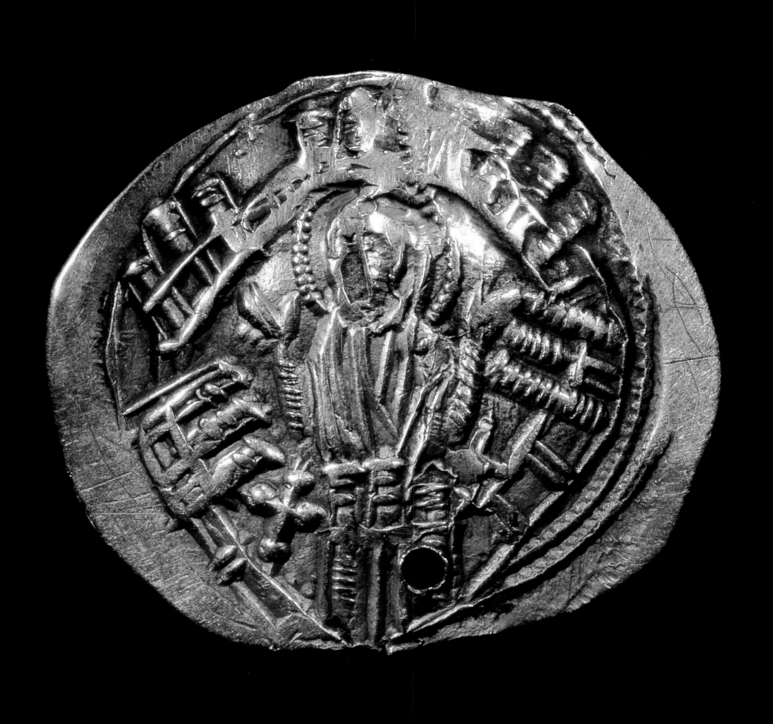

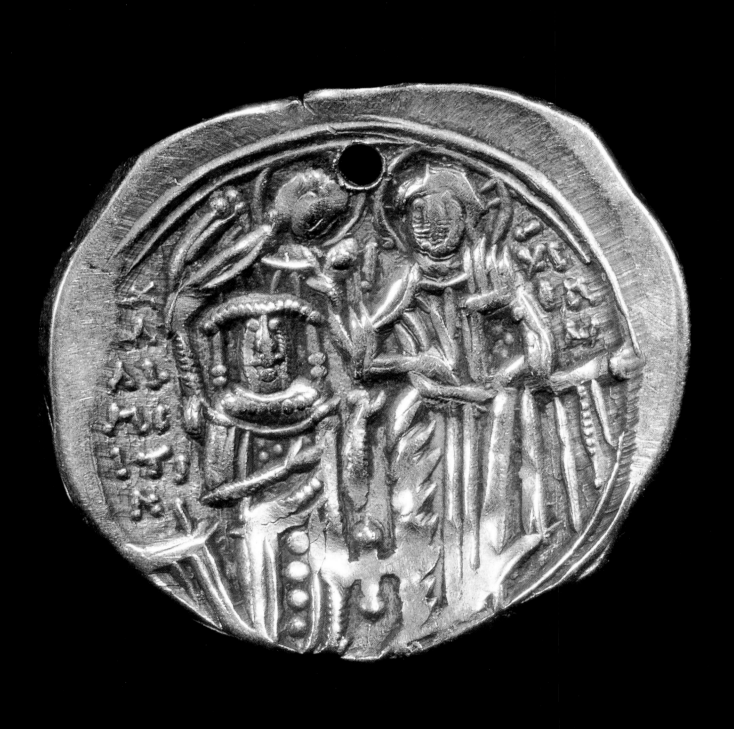

With the triumphal entry of Michael VIII Palaiologos into Constantinople and his coronation in Hagia Sophia on 15 August 1261, the Empire at last reclaimed its capital. The coronation procession was headed by a miraculous icon of the Virgin *Hodegetria* which the Venetians had forcibly removed from the Pantokrator. In the elation of victory, as if to erase the reality of a fifty seven-year-long occupation at one fell swoop, the icon was returned to the monastery where it had stood before 1204. But the Empire re-established by Michael VIII (1258-1282) now ruled over a shrunken domain stretching from northern Greece to the west of Asia Minor. It did not include the Despotates of Epirus and Morea; Trebizond was still independent; Cyprus, Rhodes, Crete, Euboea, and most of the Aegean islands were in the hands of Westerners with whom relations were often troubled. Finally, the Turkish menace still loomed in Asia Minor. For the time being, however, the principal danger lay in the West. Charles of Anjou, King of Sicily, moved against the Empire in 1266. Michael VIII retaliated by forming an alliance with the Mongols against the Turks, and joined forces with St Louis and the Papacy against Charles. In return, however, he was forced to accept, at the Council of Lyons in 1274, the reunification of the Greek and Latin Churches which had been separated since 1054. His diplomatic stratagems proved fruitless. Only the insurrection led in 1282 by the people of Palermo, and known as "the Sicilian Vespers", finally put paid to Angevin machinations.

An Empire condemned

Byzantine opposition to the reunion of the Churches was so bitter that Andronikos II Palaiologos (1282-1328) was forced to abrogate the decision. The Serbs were proving aggressive, while in Asia Minor the Turks were once again on the march. The Catalan mercenaries recruited to fight them drained the State coffers and pillaged the countryside. Towards the end of Andronikos II's reign, insecurity and oppressive taxation led to civil war between the Emperor and his grandson, the future Andronikos III: the party of the populace against that of the princes. Under Andronikos III (1328-1341), Byzantium suffered a new Serbian onslaught, and could only watch helplessly as the Ottoman Turks swarmed through the Asian territories. At home, acrimonious controversy broke out over *hesychasm*, an essentially contemplative monastic doctrine. Neither of the opposing camps hesitated to seek foreign backing and the affair swiftly took a political turn. The State was on the brink of bankruptcy. Anne of Savoy, acting as Regent in place of her young son, John V, even pawned the crown jewels. Supported by the landed aristocracy and the hesychast party, John VI Kantakouzenos (1347-1354) mounted the throne in an attempt to save the Empire. Civil war resumed, together with its attendant foreign entanglements. Kantakouzenos' initiative failed and he retired to a monastery. John V returned to power (1355-1391). But the Empire was condemned. The Turks had captured

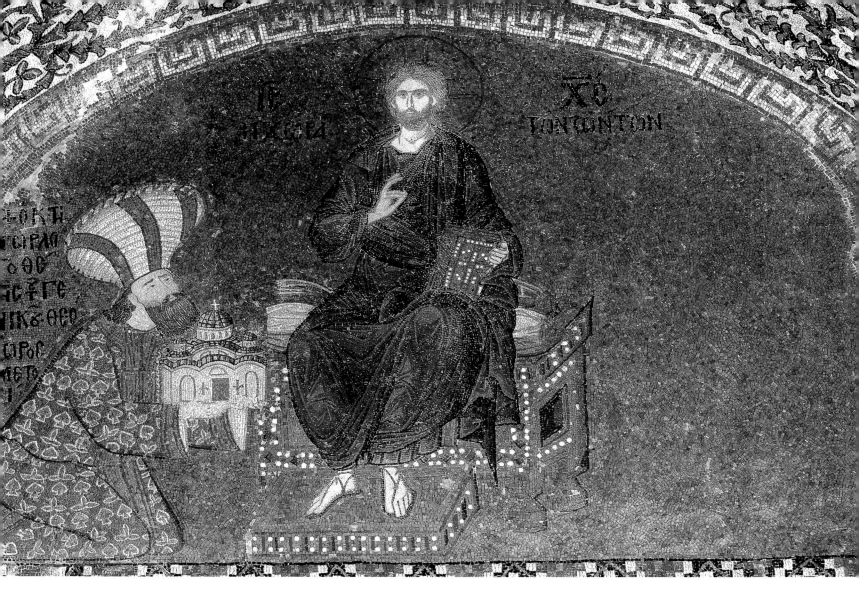

THEODORE METOCHITES KNEELING BEFORE CHRIST
1316-1321, mosaic.
Istanbul, Church of Christ in Chora
(Kariye Camii), inner narthex.

all of Asia Minor; they crossed into Europe and occupied Gallipoli on the straits (1354), then seized Adrianople (1365), wiped out the Serbs on the banks of the river Maritsa (1371), gained control of Athos (1383) and took Thessaloníki (1387).

Soon Constantinople alone was all that remained of Byzantium, and the Turks laid seige to the city in 1394. In 1402, just as it was about to fall, it was saved by the crushing defeat of the Turks in Asia Minor by the Mongol Timur Lenk (Tamerlane). At that juncture, Manuel II (1391-1425) attempted to raise the alarm in the West. He spent four years, from 1399 to 1402, travelling in England, France, Italy and Spain, but to no avail. In his turn, John VIII (1425-1448) personally accompanied the Patriarch to the Council of Basle in 1439 where, in the hope of urgent assistance, he finally accepted the union of the Churches, a move which drove the Greeks once and for all to despair. In 1453, Mehmet II besieged Constantinople. Constantine XI, the last Emperor, courageously joined in the last-ditch defence of the city which fell to the Turks on 29 May. Turkish conquest was sealed by the capture of Athens (1456), Mistra (1460) and Trebizond (1461). The curtain had fallen on the thousand-year history of Byzantium.

The eleventh-hour revival

Yet in the course of these two tragic centuries, Byzantium managed to sustain a new "renaissance". As soon as imperial power was re-established in Constantinople, Michael VIII encouraged repopulation of the city, restored as best as he could public buildings, and even, so Pachymeres informs us, had a bronze statue cast of himself kneeling before the archangel Michael – the same pose he adopted before Christ in effigy on the imperial gold coinage. The Emperor, his family, and the princes rebuilt the ruined churches and monasteries looted by the Latin Crusaders. The treasury inventory of Hagia Sophia, drawn up in 1396, reveals that the Great Church had by then recovered sufficient riches to partly make up for the gaping void left by Crusader pillaging. Fourteenth and 15th-century Russian pilgrims like Anthony and Stephen of Novgorod, Ignatius of Smolensk or Zozima, and Western emissaries and travellers such as the Castilian Clavijo or the Florentine Buondelmonti, have left written accounts of the dazzling court ceremonial and the magnificent Constantinopolitan churches with their plentiful store of relics and beautiful icons. Artistic revival affected the whole Empire and took place on a comparable scale in Thessaloníki or Mistra, at the Mount Athos monasteries, and in new monastic foundations such as Meteora. But gold was becoming a rare commodity, increasingly replaced by silver gilt, gossamer filigree, or even gilded and painted leather. From the mid-14th century, pewter and ceramic were being used instead of precious metals for imperial tableware. John VI, like the last Emperor, had even to resign himself to melting down church ornaments in order to mint the inferior coinage of a moribund Empire.

This final Byzantine renaissance expressed itself in an extraordinary outburst of intellectual activity. Pachymeres, Manuel Philes, and Nikephoros Gregoras breathed new life into history, poetry and philology. Influenced by Classical, Oriental, and Western chivalrous models, fictional "romances" flourished. Along with John VI Kantakouzenos, Gregory Palamas, the advocate of hesychasm, revived theology and mysticism. Manuel II was a sincere theologian, and a writer. Above all, the philosophy, drama and poetry of ancient Greece were rediscovered. A renowned – and already authentically "modern" – philosophical school grew up around George Gemistos Plethon, the reformer of Platonic studies. Plethon, considered a heretic and suspected of paganism, sought refuge in Mistra, where he died in 1452. His disciple Bessarion, a convert to Catholicism in 1439 and later a cardinal of the Roman church, was one of the many intellectuals who found asylum in Italy after the collapse of the Empire and brought with them a considerable number of manuscripts, introducing Western Renaissance scholars to Hellenism. As with its Macedonian forerunner, the effects of the artistic revival were uneven. Inspired by classical sources, particularly those of late antiquity, it occasionally drew on these directly, yet much more often through the brilliant interpretations given to them by the Byzantine renaissance of the 10th-12th centuries. This

JOHN VI KANTAKOUZENOS,
THEOLOGICAL WORKS:
DOUBLE PORTRAIT
OF JOHN VI KANTAKOUZENOS
AS EMPEROR AND MONK
1370-1375, Constantinople,
painting on parchment.
Greek Manuscript 1242, fol. 123 v,
33.5 × 24 cm (13 1/4 × 9 1/2 in.).
Paris, Bibliothèque Nationale de France.

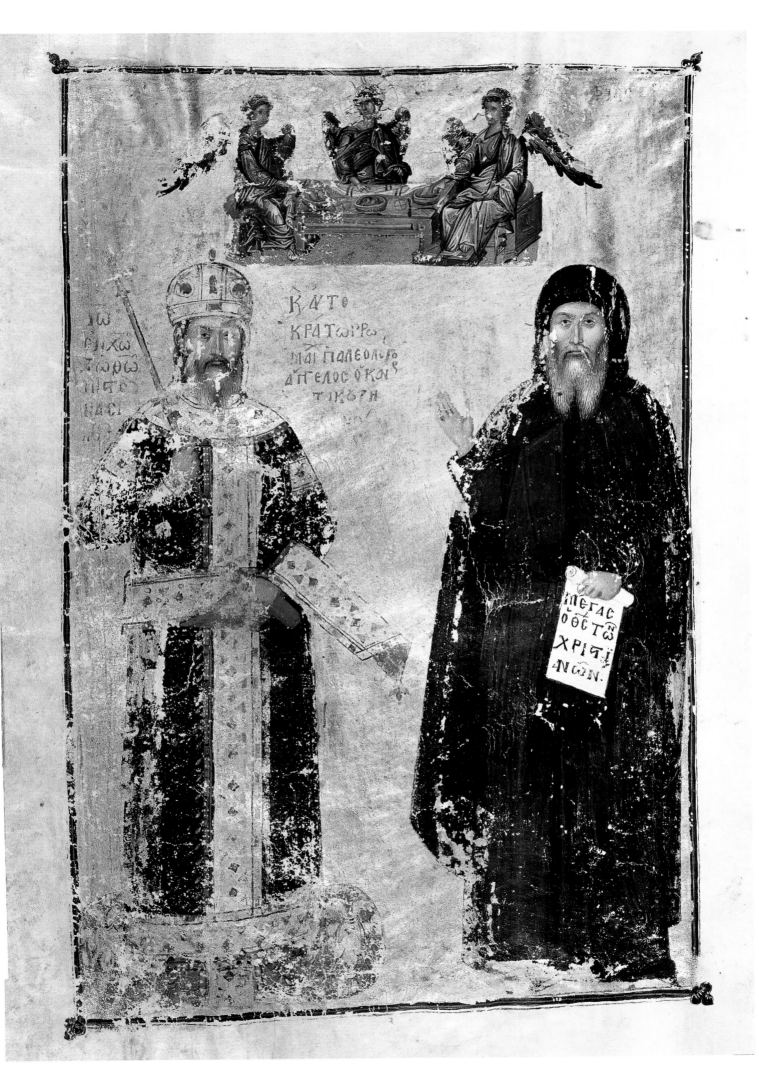

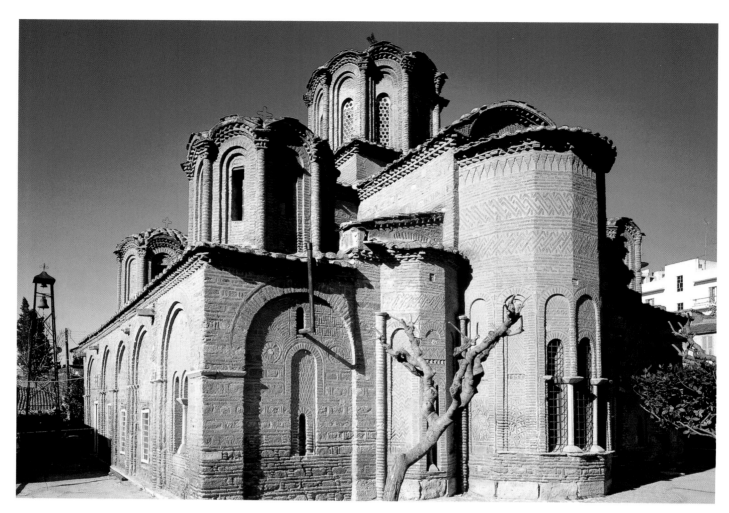

CHURCH OF THE HOLY APOSTLES

Exterior view and plan.

First half of the 14th century.

Thessaloniki, Greece.

explains the traditional aspect of its formal, iconographic, and ornamental repertories and, to a certain extent, its style. The prevailing climate of insecurity, however, exacerbated sensitivities. This phenomenon, already latent under the Komnenians, could assume – notably in painting – a dramatic, even pathetic expression, sometimes leading to an imagery that was either complex and symbolically charged, or, on the contrary, idealized and almost disembodied. Byzantine art still turned to the Orient with its rich storehouse of exotic or picturesque themes. Occasionally, it also sought new inspiration in Western art. But the hybrid, ungainly nature of such works confirmed the genuine inability of Byzantine art to adapt to foreign traditions. Finally, the art of the Palaiologan period was characterized by diversity. The political fragmentation of the 13th century entailed the definitive dispersion of artistic centres. A veritable craftsmanship developed in the monasteries, while in the place of the anonymity of the Constantinopolitan workshops, outstanding individual artists emerged.

CAPITAL: SOLDIER-SAINTS
14th century, Constantinople (?),
marble, height 41 cm (16 1/8 in.).
Paris, Musée National du Moyen Âge
et des Thermes de Cluny.

Architecture and monumental décor

The return to tradition was conspicuous in architecture. In Constantinople, the south church at the Lips monastery (Fenari Isa Camii), founded by the Empress Theodora, wife of Michael VIII, was built on top of the ruins of an older edifice in the style of an 11th or 12th-century church. In the early 14th century, the chapel in the *parecclesion* at the church of the Pammakaristos (Fethiye Camii) still adopted the inscribed cross plan, and its dome stood on four columns. Seen from the exterior, the narthex, which is as high as the nave, creates an overall cubic impression – a characteristic visible in other buildings. At the Kilise Camii, the narthex – which was added during this period to a nameless 11th-century church – forms an elegant twin level façade, the lower level consisting of a marble-columned enclosed portico. These churches are distinguished from their models by the size of the annexes – narthexes or *parecclesia* – with their clearly projecting domes. Inside, emphasis was also placed on rows of funerary monuments set in niches along the walls of the nave, narthexes or *parecclesia*. One of the best examples is the church of Christ in Chora (Kariye Camii) which was restored between 1316 and 1321

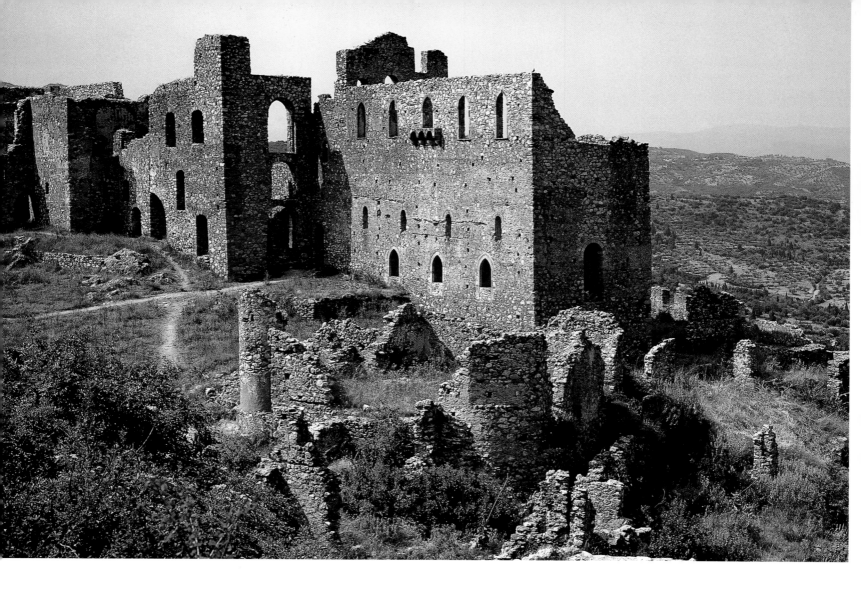

THE DESPOTS' PALACE, OLD WING

Latter half of the 13th century-
first half of the 14th century.

Mistra, Greece.

by Theodore Methochite, a powerful minister and connoisseur collector who had grown rich through his exactions. The nave, which dated back to Komnenian times, was provided with a new dome; it was surrounded, to the west, by two high narthexes and, to the south, by a vast twin bay *parecclesion* intended to house several sarcophagi in recesses. The exteriors of these buildings were distinguished by walls featuring cornices and projecting windows, and by a refined ornamentation consisting essentially of geometrical motifs in brickwork, or occasionally in alternating courses of stone and brick. This style appears once again in the only surviving secular monument, the vestiges of the palace of Tekfur Sarayi, built in the late 13th century, the façades of which feature a partially preserved décor of multicoloured stone diamond motifs. From the 1350s on, however, such architectural activity in the capital was doomed by the pressure of events. In Thessaloníki, more durable prosperity explains the number of churches and monasteries built under the Palaiologi. The Holy Apostles, St Catherine, and the church of the Vlatades monastery all display similar characteristics. On the other hand, the church of the Prophet Elijah drew its inspiration from other models, adopting the traditional trefoil plan of the Athos churches. The regions displayed greater diversity. In Arta, the capital of Epirus, churches such as

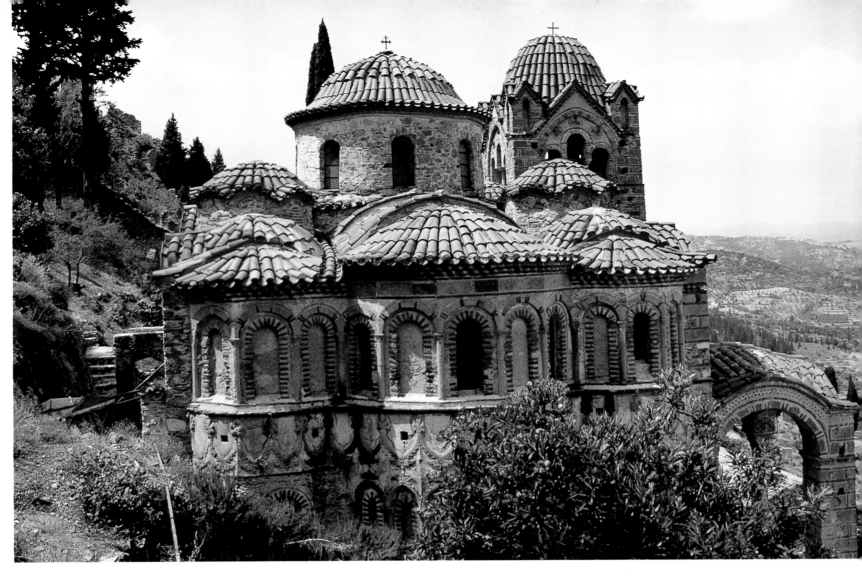

the Paragoritissa readily combined the Byzantine heritage with added Italian features. Although the interior elevation of the latter building is conventional, the exterior elevation, despite forcefully projecting domes, is concealed by tall façades with a rhythmical procession of large geminated windows. In Morea, the churches of Mistra – the Brontochion, the Peribleptos, the Pantanassa, and St Sophia – are all traditional in appearance but were readily embellished with graceful bell towers, and incorporate numerous Gothic features in the refined décor of their apses. The small, now ruined town still conserves vestiges of secular dwellings, above all the remains of the Despots' Palace consisting of two perpendicular wings. The later wing, with its porticoed ground floor, consoled cornice, large upper-storey windows surmounted by ogee arches and the oculi at the top of the façade must have greatly resembled a Mediterranean Gothic palace.

The design of monumental décor scarcely differed from that of the Macedonian and Komnenian periods. Accordingly, both inside and outside the buildings, there was only moderate recourse to sculpture. A renewed appraisal of classical works no doubt explained the sporadic reappearance on capitals of the monogram – beloved of 6th-century sculptors – and contributed to the revival of forcefully carved high reliefs,

CHURCH OF THE PANTANASSA
Chevet, seen from the east.
First half of the 15th century.
Mistra, Greece.

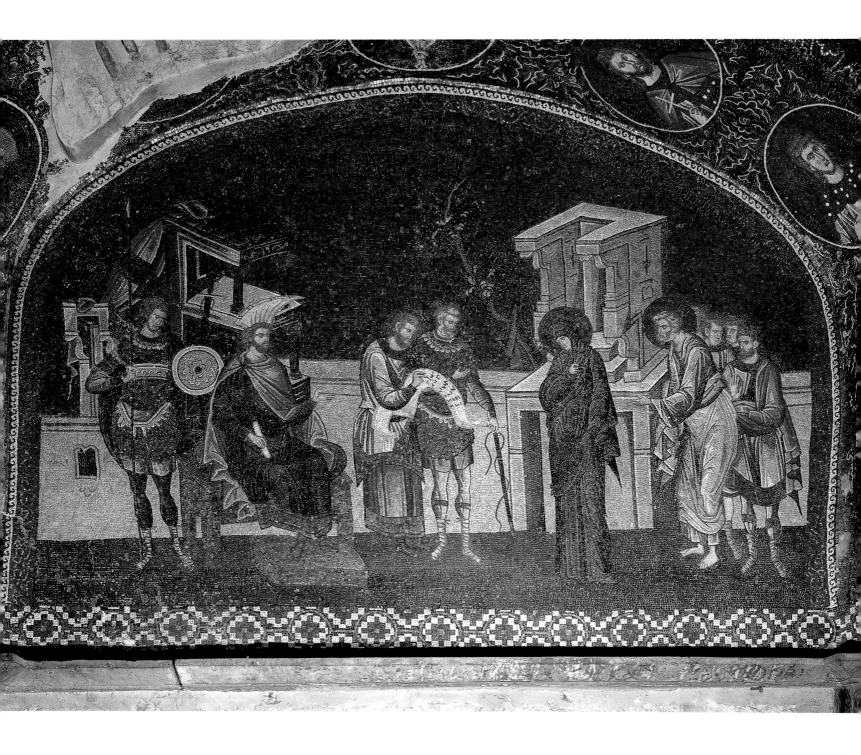

CYRENIUS SUPERVISING THE CENSUS

1316-1321, mosaic.

Istanbul, Church of Christ in Chora

(Kariye Camii), exonarthex.

ANASTASIS (CHRIST IN LIMBO)

1316-1321, fresco.

Istanbul, Church of Christ in Chora

(Kariye Camii), *parecclesion* apse.

DORMITION OF THE VIRGIN

First quarter of the 14th century, fresco.

Thessaloniki, Church of St Nicolas Orphanos,

west wall of the nave.

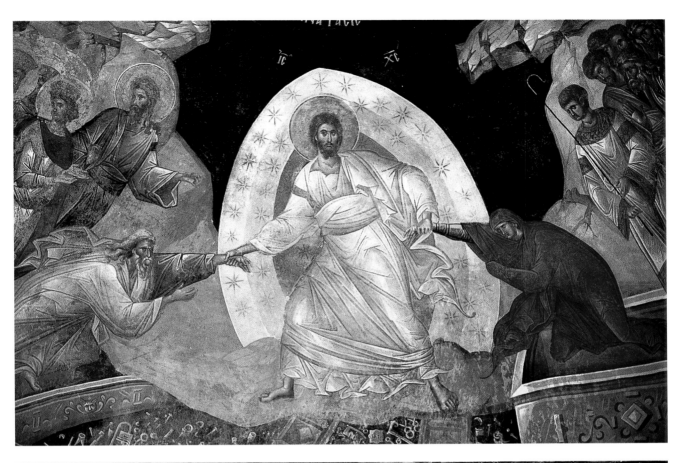

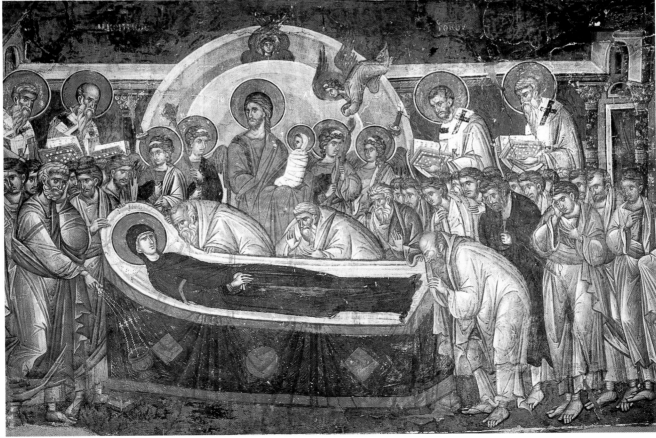

NATIVITY

Third quarter of the 14th century, fresco.

Mistra, Church of the Peribleptos,

south wall of the sanctuary.

<div align="right">

THE ARREST OF CHRIST

C. 1295, fresco.

Ohrid, Church of St Clement (Virgin Peribleptos),

west wall, south arm of the nave.

</div>

a feature which probably, however, derived just as much from Gothic models. The influence of the latter is to be seen particularly in the vogue for heraldic friezes, but also in the use – albeit extremely limited – of figurative sculpture on door lintels, arches of wall niches, and, even more rarely, on a few capitals, like the specimen in Istanbul Museum from the Pammakaristos monastery in Constantinople, or the one in the Musée de Cluny in Paris, decorated with bust portraits of soldier-saints. The grand iconographic programmes depicting liturgical themes were still reserved for frescos and mosaics.

The late 13th-century Constantinopolitan décors described in Byzantine texts have almost all vanished. Only the *deesis* in the south gallery of Hagia Sophia, with its delicate modelling and subtle gradation of colours, still bears witness to a genuinely classical perfection in the tradition of Komnenian art. There is also a striking contrast between the monumental scale of the figures and the almost intimate treatment of the sorrowful faces of St John and the Virgin, so profoundly human. This style, grandiose and at the same time imbued with humanism, had already revealed its potential at Sopoćani in Serbia, notably in the admirable series of frescos in the naos and narthex at the church of the Trinity, executed from 1263. At Sopoćani, however, the building of additional narthexes and *parecclesia*, and the raised domes – characteristic of late Byzantine churches – led to a division of the pictorial space; more narrative scenes were introduced, and the traditional iconographic

programme was broadened to include new compositions, such as the cycle of the Life of Joseph in the narthex. This partitioning fostered a return to elaborate landscapes and often complex architectural backgrounds, in the style of the mosaics of late antiquity; in turn, notions of perspective developed, as at St Clement in Ohrid (episodes from the Life of the Virgin, and scenes illustrating the Life of St John the Baptist) and, around 1300, at Staro Nagoričino where the Greek painters Michael Astrapas and Eutychios worked. As the number of figures increased they adopted expressive gestures and movements, highlighted by forcefully treated drapery. Colours were enhanced by the introduction of a wide variety of shades and lively chiaroscuro effects. Such tendencies culminated in the mosaics and frescos at the Holy Apostles church in Thessaloníki and those at Christ in Chora (Kariye Camii) in Constantinople, to a large extent the work of the same artists. At Chora, the mosaics in the twin narthexes depict the parallel cycles of the Life of the Virgin, the childhood of Christ and the miracles he performed, and draw extensively on the biblical accounts in the Apocrypha. The decorative features display the same lavish diversity as those in the Ravenna churches. The architecture has a dreamlike, ethereal grace. The narrative zest abounds in realistic details and lifelike touches. By means of an exceptionally rich palette, the pictorial content is alternately muted or enhanced, and the golds are made to shimmer. The picturesque and the fantastic are combined in a universe tinged with poetry and full of emotion that

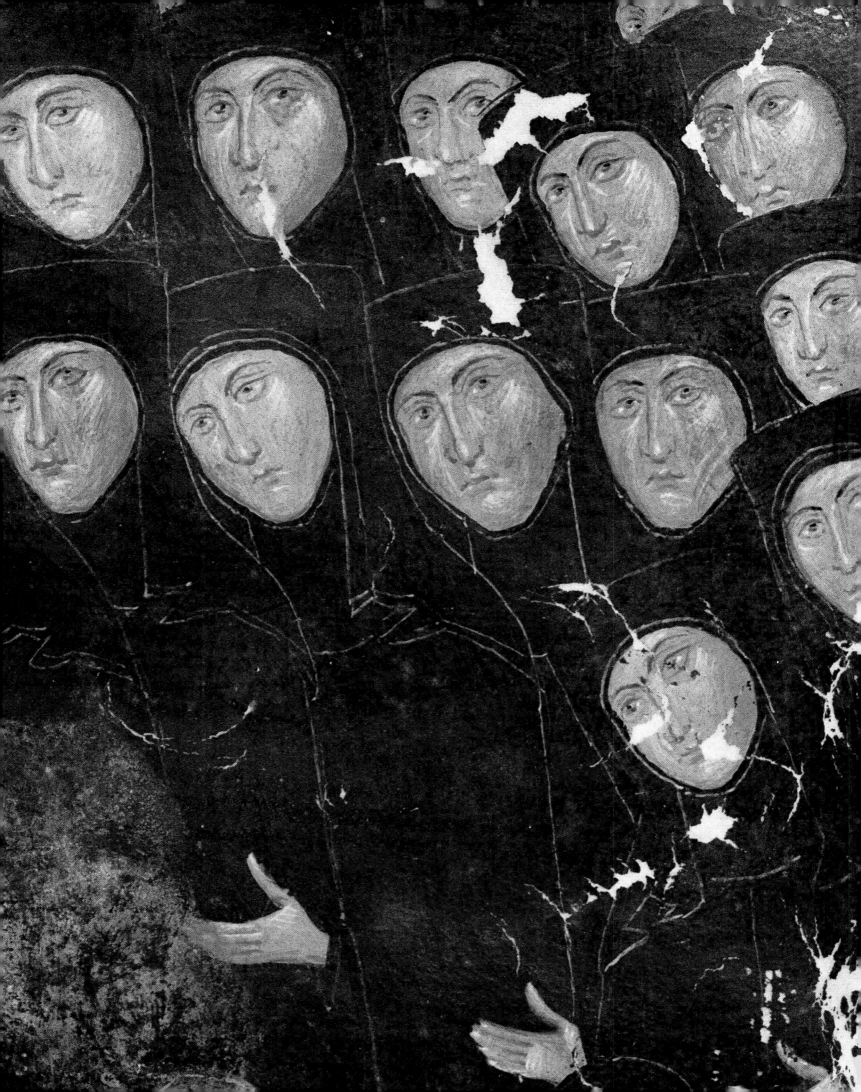

αὐ ἀυ τοῦ πρ Ε Ο Γ ὑ τ Ελ

BOOK OF JOB WITH COMMENTARIES

1362, Mistra, Manuel Tzykandyles,
paint on paper.
Greek Manuscript 135, fol. 18 v,
39 × 28 cm (15 3/8 × 11 in.), detail.

Paris, Bibliothèque Nationale de France.

occasionally verges on the baroque, as in the famous scene of *Cyrenius Supervising the Census*, where Mary and Joseph appear before the Roman officer. The poetic tone becomes lyrical and visionary in the frescos in the *parecclesion* which were intended as funerary pieces and were devoted to the theme of the Last Judgement; this is particularly conspicuous in the famous *Anastasis* (Christ's Descent to Limbo) on the domed roof of the apse.

The art of Constantinople radiated far afield in the 14th century and is to be found in Serbia, notably at the church of the Dormition at Gračanica monastery, around 1320, and at Dečani some thirty years later, where the virtuosity of the dramatic scenes nevertheless tended to formality. In Greece, at the Peribleptos church in Mistra, graceful, elegant figures are portrayed in the midst of vast, rugged landscapes. From the late 14th century, however, this creative momentum, still apparent at the Pantanassa church in Mistra, for instance, or at Dečani, was superseded by a deliberate return to tradition, expressed, with a varying degree of success, in regional schools in Greece, Crete, Serbia and Moravia. It was at this juncture that Theophanes the Greek brought the lessons of

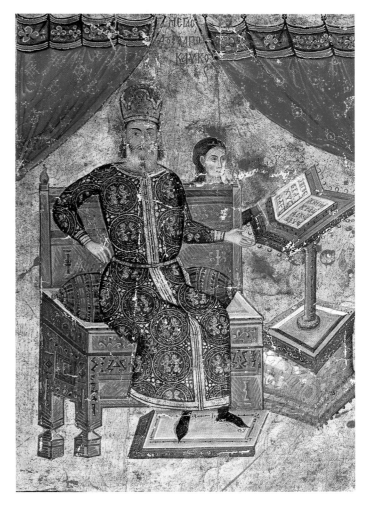

HIPPOCRATES, *WORKS*: THE GRAND DUKE APOKAUKOS
C. 1338, Constantinople,
paint on paper.
Greek Manuscript 2144, fol. 11 r,
42 × 31 cm (16 1/2 × 12 1/4 in.),
detail.
Paris, Bibliothèque Nationale de France.

Constantinopolitan art to Novgorod (around 1370) and to the Kremlin in Moscow. But his St Macarius in Novgorod, an idealized, disembodied creation bathed in a supernatural light, already paved the way for 15th-century Russian painting and the pioneering work of his pupil, Andrei Roublev.

THEOCRITUS, *IDYLLS*
First half of the 14th century,
paint on paper.
Greek Manuscript 2832, fol. 48 v,
23.5 × 15.5 cm (9 1 × 6 1 in.),
detail.
Paris, Bibliothèque Nationale de France.

Painting and the luxury arts and crafts

Contrasts were just as much to the fore in the fields of manuscript illustration and icons, and even more so in the luxury arts and crafts. The revival of Macedonian and Komnenian models in book illustration explains the remarkable permanency of formats, types of works illustrated, and iconography. Painters adopted the *pylai* and even the style of their predecessors to such a degree that not so long ago an entire group of sumptuous parchment manuscripts, executed in Constantinople in imperial circles around 1300, was still being attributed to the 12th century because of the archaic features they displayed, down to the very writing. The illustrator of one Patmos Gospel Book (ms. 274) was quite content to reproduce scenes borrowed from the Komnenian period, while another

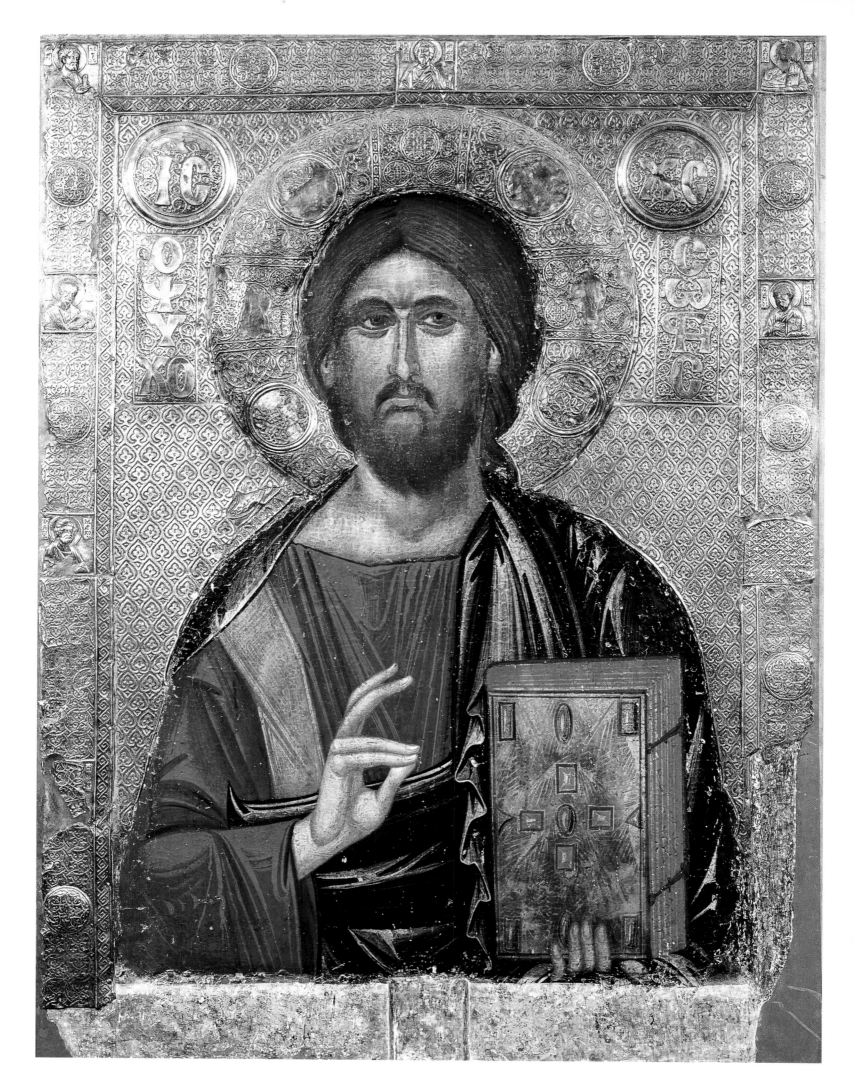

painter, in a Gospel dated 1335 (ms. 81) depicted Komnenian-style evangelists within frames copied from the late 10th century. However, paper was beginning to replace parchment, which was both expensive and already, according to Maxim Planudes, difficult to procure by the late 13th century. The number, and above all the quality of illustrated books diminished and the production was a very mixed bag. Western influences also appeared although they rarely led to masterpieces, except in the case of a paper *Book of Job*, completed by Manuel Tzykandyles in 1362 in Mistra. Besides borrowing Gothic features (pinnacles, headgear and personal accessories), the painter has managed to avoid too many ungainly effects and to interpret fairly skilfully a traditional Greek cycle in a Westernizing style (sinuous drapery, treatment of the faces). But the innovating, virtuoso expressive trend in 14th-century monumental painting does appear in a few grandiose images such as the Transfiguration in a manuscript copy of John VI Kantakouzenos' *Theological Works* in Paris (Gr. 1242), and particularly in an admirable series of portraits: the twin portrait of John VI as Emperor and monk in the same manuscript, the portrait of Grand Duke Apokaukos in a Parisian copy of Hippocrates (Gr. 2144), or the even stranger portraits of the nuns at the monastery of Good Hope, assembled around their superior (Bodleian Library, Oxford), all definitely represent supreme achievements of Palaiologan painting.

Icons occupied pride of place, and hundreds were painted. Some of the oldest often display the imaginative touch found in the best monumental painting. One notable early 14th-century Constantinopolitan group, which also includes a remarkable series of mosaic icons, is characterized by backgrounds featuring lively landscapes or architectural scenes, a sense of volume and spatial mastery, and realistic details. The St George in the Louvre, the Forty Martyrs at Dumbarton Oaks and the Annunciation in the Victoria and Albert Museum in London all share the almost baroque note found in the narrative compositions at Christ in Chora. Iconography was also enriched by new themes, some of which enhanced the lives of Christ, the Virgin and the saints with complex allegories. Others, intended for private personal devotions, were extracted from much larger compositions, like the Pietà or, in the case of the Virgin for instance, introduced endless variations aimed at arousing feeling. To the more traditional and hieratic images of the Virgin Orans or the *Hodeghetria* were thus added representations in which she was depicted as tender, merciful, comforting or grieving. From the end of the century, even regional variants emerged, at a time when Constantinopolitan painting was transfixed in a more linear style employing stark gold backgrounds. Distinctive local schools sprang up in Greece, Crete and the Balkans. In the 15th century, they broke free from Constantinopolitan influences and assumed their own specific characteristics – already virtually those of post-Byzantine art.

For the luxury arts and crafts, the economic climate was hardly propitious. Only the art of textiles, in the form of rich gold and silver-thread

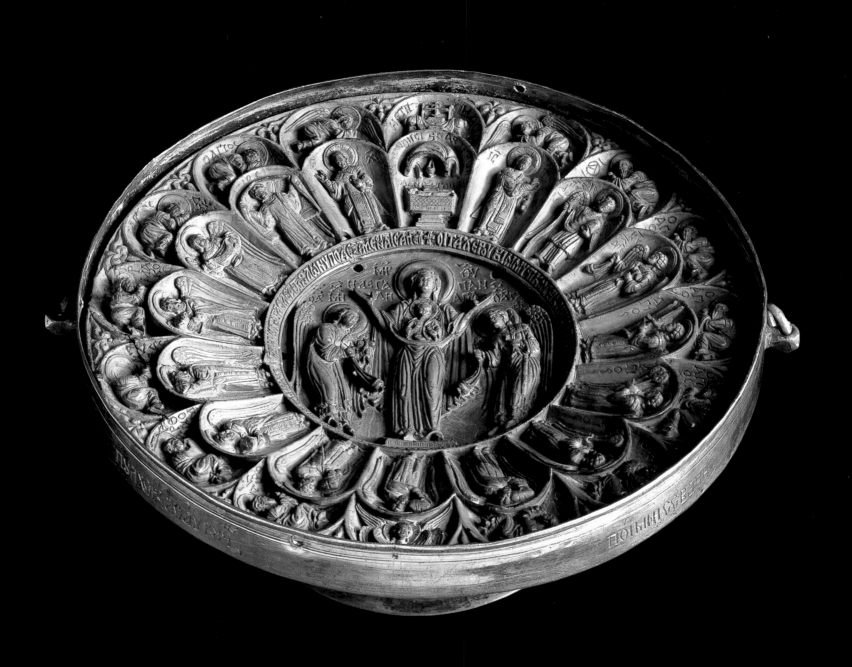

THE "PULCHERIA" PATEN:

VIRGIN PLATYTERA BETWEEN TWO ANGELS;

CHRIST DISTRIBUTING THE EUCHARIST;

ANGELS AND ARCHANGELS

14th century, steatite, silver gilt mount,
diameter 16 cm (6 1/2 in.).

Mount Athos, Xeropotamou Monastery.

CHALICE BELONGING TO THE DESPOT MANUEL
KANTAKOUZENOS PALAIOLOGOS OF MISTRA

1349-1380, jasper and silver gilt,
height 19.5 cm (7 5/8in.);
width including handles. 32 cm (12 5/8 in.).

Mount Athos, Vatopedi Monastery.

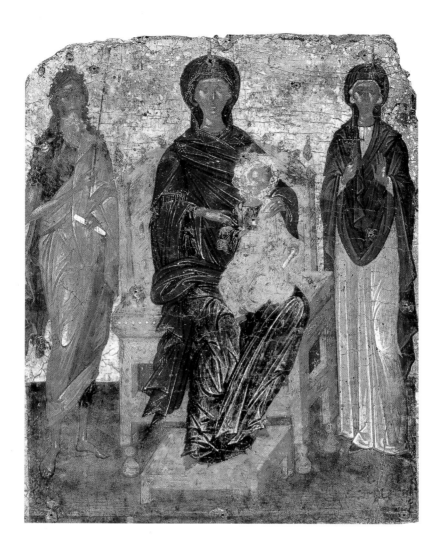

embroideries highlighted with pearls, really flourished, in particular in monastic workshops. The Thessaloníki *epitaphios* is probably one of their most remarkable creations. For lack of ivory and precious metals, steatite was very widely used to make small crosses, icons or other religious objects, sometimes of high quality. The monks also carved softwood. Significant pieces in precious metal, such as the Despot Kantakouzenos' admirable chalice in the Athonite monastery of Vatopedi, are rare. Only an exceptional group of icon facings stands out. The oldest of these, dating from around 1300, like those on a pair of icons from Skopje depicting the Virgin and the Angel of the Annunciation, still display affinities – by their repoussé and occasionally enamelled décor of stylized fleurons – with Komnenian art. The more recent group, however, produced in Constantinople around 1400, hardly uses more than filigree, applied in a dense and quite dazzlingly fine mesh. The icon of the Holy Face in Genoa is no doubt one of the most striking achievements in this genre, and indeed in the entire art of the final golden age of Byzantium.

CONCLUSION

The long history of Byzantium came abruptly to an end on 29 May 1453. The last surviving remnants of the ancient Roman Empire of the East vanished. Constantinople, conquered by the Turks, became the new capital of the Ottoman Empire, soon to be renamed Istanbul. For more than a thousand years, the successors of Constantine had managed to preserve their share of the ancient Graeco-Roman heritage. Until the very end, they had also been able to reconcile this fidelity with the most pressing demands of the Christian faith. Although Byzantium as a polity was dead, it would nevertheless continue to live on through its heirs. In the former Byzantine domains, now occupied by the Turks, the flame of the Orthodox faith was kept alive and the key features of Byzantine art were preserved. These would play their part in the emerging awareness of national identities and, in the early 19th century, lead to the birth of the modern Greek state.

Beyond the former imperial frontiers, among the Slavs, the aura of Byzantium remained intact. In the 17th century, the harrowing episode of the fall of Constantinople was still being painted on the walls of Balkan churches and, under the Turkish yoke, the Orthodox faith remained the rallying point for resistance. But it was in Russia that the triple heritage of religious orthodoxy, political theocracy and Byzantine art endured longest. In 1472, when Ivan III of Muscovy married Zoe-Sophia, niece of the last Palaiologos Emperor, the Tsar was deliberately asserting his claim as heir presumptive to the Emperors of Byzantium. He incorporated the Byzantine double-headed eagle into his coat of arms and granted his protection to the Athos monasteries, proclaiming that Moscow would be the Third Christian Rome. Up until the Enlightenment, and even longer in the religious field, Russian art perpetuated the traditions of Byzantine art. Finally, before the October Revolution, the theocratic conception of Russian imperial power claimed to be rooted in this heritage.

Byzantium would also play a considerable, albeit more discreet role in Western Europe. It had fascinated the entire medieval West. Its art aroused admiration. The *maniera greca*, practised in medieval Italy, lay at the very origin of European painting. In the 15th century, when Byzantine intellectuals fled the advancing Turks, Italy and soon all of Europe discovered Hellenism. Ancient Greek thought, preserved in manuscripts that for centuries had been patiently copied in Byzantium, contributed to the emergence of modern political, philosophical and moral concepts. The Reformation, Jansenism in France, and most of the major religious or mystical movements also turned to the writings of great Byzantine theologians. Byzantine history provided a rich storehouse of themes for playwrights and painters. Even in the 20th century, the influence of Byzantine art has left its mark. Byzantium, like Rome, counts among the progenitors of the modern world.

ICON OF THE HOLY FACE OF CHRIST
Before 1384, Constantinople,
paint on wood and silver gilt,
39 × 29 cm (15 3/8 × 11 3/8 in.).
Genoa, Convent of San Bartolomeo degli Armeni.

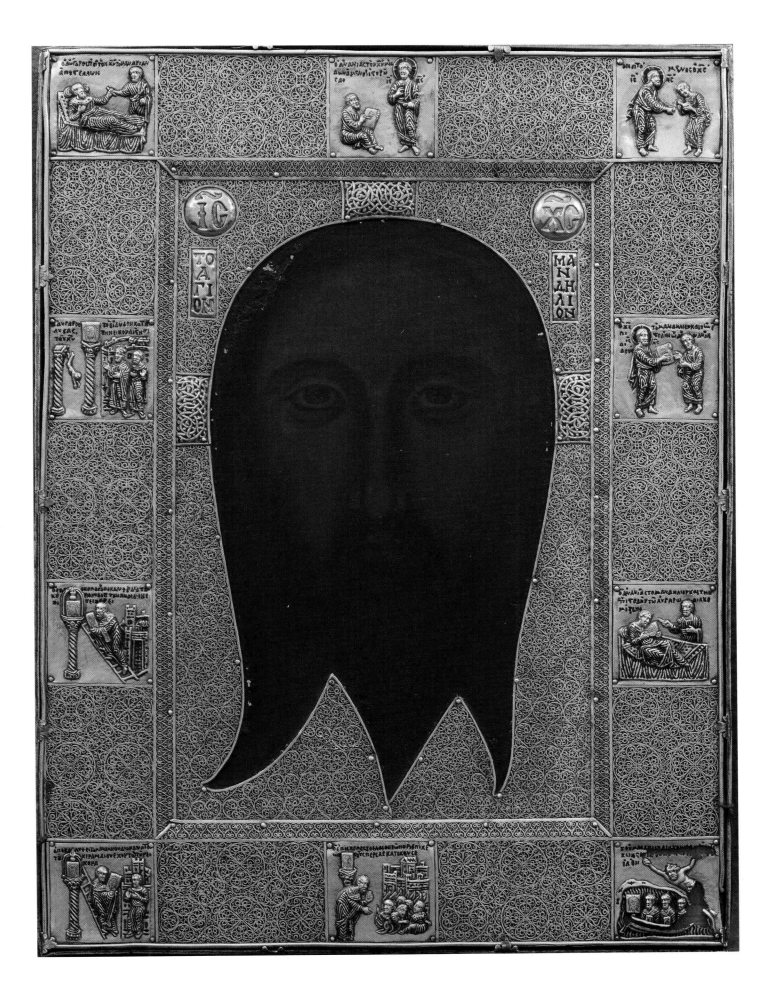

The Empire of Justinian in the mid-6th century

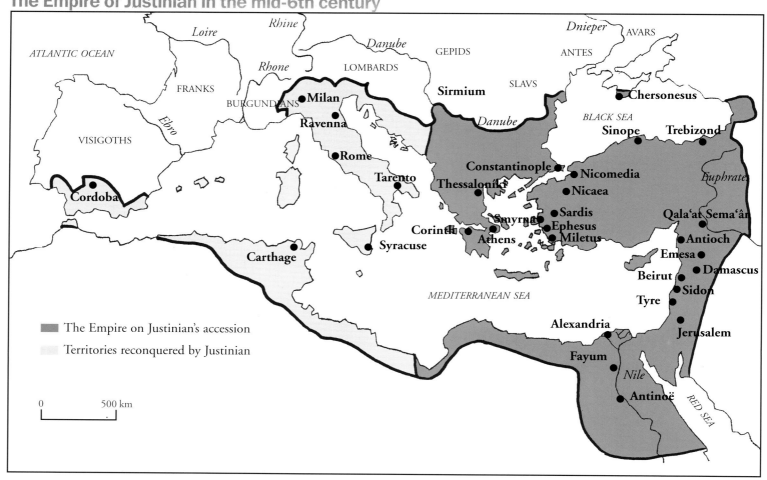

ATLANTIC OCEAN

Loire *Rhine*

Rhone LOMBARDS

Danube GEPIDS

Dnieper AVARS

ANTES

SLAVS

FRANKS

BURGUNDIANS

Milan

VISIGOTHS

Ebro

Ravenna

Rome

Cordoba

Tarento

Carthage

Syracuse

Sirmium

Danube

Chersonesus

BLACK SEA

Sinope

Trebizond

Constantinople

Nicomedia

Thessaloníki

Nicaea

Euphrates

Corinth

Smyrna

Sardis

Athens

Ephesus

Miletus

Qala'at Sema'ân

Antioch

Emesa

Damascus

Beirut

Sidon

Tyre

Alexandria

Jerusalem

Fayum

Nile

MEDITERRANEAN SEA

Antinoë

RED SEA

The Empire on Justinian's accession

Territories reconquered by Justinian

0 500 km

The Empire under the Macedonians and Komnenians: 10th-12th centuries

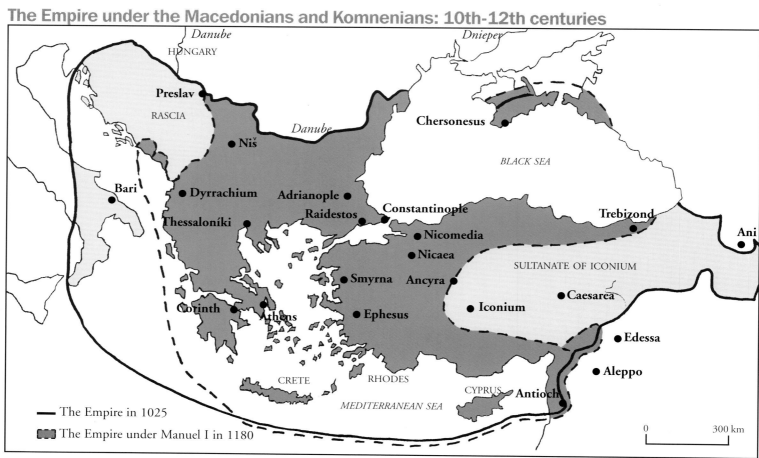

Danube HUNGARY

Dnieper

Preslav

RASCIA

Chersonesus

Niš

Danube

BLACK SEA

Bari

Dyrrachium

Adrianople

Raidestos

Constantinople

Trebizond

Thessaloníki

Ani

Nicomedia

Nicaea

SULTANATE OF ICONIUM

Smyrna

Ancyra

Corinth

Caesarea

Athens

Ephesus

Iconium

Edessa

CRETE

RHODES

Aleppo

CYPRUS

Antioch

MEDITERRANEAN SEA

The Empire in 1025

The Empire under Manuel I in 1180

0 300 km

The Empire under the Palaiologos dynasty in the mid-14th century

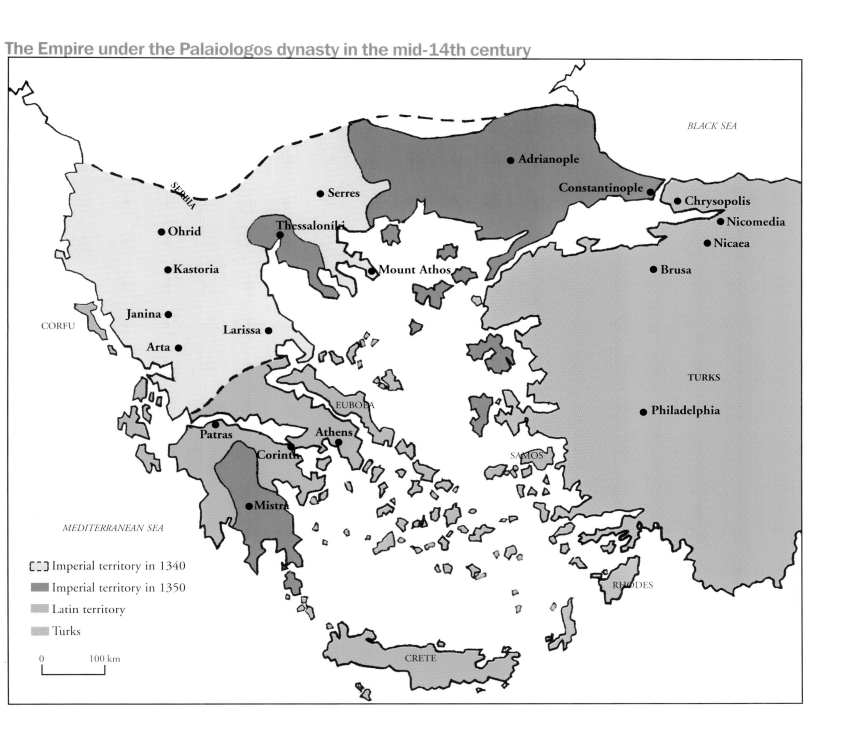

BLACK SEA

SERBIA

● Adrianople

● Serres

Constantinople ●

● Chrysopolis

● Nicomedia

● Ohrid

Thessaloníki

● Nicaea

● Kastoria

● Brusa

Mount Athos

CORFU

Janina ●

Larissa ●

Arta ●

TURKS

EUBOEA

● Philadelphia

Patras

Athens

SAMOS

Corinth

● Mistra

MEDITERRANEAN SEA

RHODES

Imperial territory in 1340
Imperial territory in 1350
Latin territory
Turks

0 100 km

CRETE

CHRONOLOGICAL TABLE

• 312	Constantine's victory over Maxentius at the Milvian Bridge.
• 312-313	Edict of Milan: imperial subjects granted religious freedom.
• 325	First Ecumenical Council of Nicaea: Nicene Creed adopted.
• 11 May 330	Dedication of Constantinople.
• 361	Reign of Julian the Apostate: restoration of paganism.
• 378	Battle of Adrianople.
• 392	Pagan cults proscribed.
• 393	Olympic Games abolished.
• 395	Death of Theodosios I: Western and Eastern Empires definitively split.
• 410	Alaric, King of the Visigoths, sacks Rome.
• 429	Vandals invade Africa.
• 431	Ecumenical Council of Ephesus: Nestorianism condemned.
• 451	Ecumenical Council of Chalcedon: Monophysism condemned.
• 452	Huns invade Italy.
• 455	Genseric, King of the Vandals, sacks Rome.
• 476	End of the Western Roman Empire.
• 529-533	Promulgation of the Justinian Code and the Digests.
• 533	Reconquest of North Africa.
• 535-555	Military campaign in Italy.
• 541-544	Plague epidemic.
• 568	Beginning of the Lombard invasion of Italy.
• 582	Avars capture Sirmium. Slavs settle south of the Danube.

• 586	First siege of Thessaloníki by the Avars and Slavs.
• 614	Persians capture Jerusalem.
• 626	Avars besiege Constantinople.
• 628	Total defeat of the Persian Empire.
• 632	Death of Muhammad.
• 636	Arab victory over the Byzantines at the Yarmuk.
• 642	Fall of Alexandria.
• 674-678	First siege of Constantinople by the Arabs.
• 680	Bulgars settle south of the Danube.
• 717-718	Leo III delivers Constantinople from the Arab siege.
• 726	First iconoclastic controversy.
• 732	Charles Martel halts the Arabs at Poitiers.
• 740	Leo III defeats the Arabs in Asia Minor.
• 741	Fall of Ravenna.
• 754	Iconoclastic Council of Hiereia.
• 783	Arab-Byzantine peace.
• 787	Second Ecumenical Council of Nicaea: cult of the images reinstated.
• 815	Ecumenical Council of Constantinople: second iconoclastic controversy.
• 825-830	Arabs occupy Crete.
• 11 March 843	Orthodoxy re-established.
• 863	Mission of Cyril and Methodios to Moravia.
• 864	Conversion of the Bulgar Tsar Boris.
• 867	Basil I founds the Macedonian dynasty (867-1056).
• 911	First treaty with Russia.
• 924	Simeon's Bulgar army besieges Constantinople.

• 959-969	Reigns of Romanos II and Nikephoras Phokas: reconquest of Crete, Cyprus and Antioch.
• 961	St Athanasios founds the Great Lavra monastery at Mount Athos.
• 972	John Tzimiskes drives the Russians out of Bulgaria.
• 975	John Tzimiskes reaches the gates of Jerusalem.
• 989	Vladimir of Kiev baptized.
• 1018	Bulgars defeated and their state annexed by the Byzantines.
• 1032	Capture of Edessa.
• 1044	Annexation of the Armenian kingdom of Ani.
• 1054	Great Schism between Eastern and Western Churches.
• 1071	The Normans capture Bari, the last Byzantine foothold in Italy. Romanos IV Diogenes defeated at Mantzikert. Asia Minor open to Turkish invasion.
• 1081	Accession of the Komnenian dynasty.
• 1081-1085	Guiscard the Norman fails to conquer Byzantium.
• 1096-1097	Army of the First Crusade passes through Constantinople.
• 1137	John II Komnenus in Cilicia and Antioch.
• 1147	Capture of Athens and Thebes by Roger of Sicily who transfers silkworkers to Sicily. Second Crusade.
• 1173	Serbia defeated.
• 1176	Defeat at Myriokephalon dashes Byzantine hopes of reconquering Asia Minor.
• 1204	The Crusaders sack Constantinople and found the Latin Empire. Foundation of the Empire of Trebizond and the Despotate of Epirus.

• 1206	Crete occupied by the Venetians.
• 1208	Theodore Laskaris restores the Empire in Nicaea in Asia Minor.
• 1222-1254	Nicaean Empire spreads into Europe.
• 1259	Michael VIII Palaiologos defeats the Latin Empire at Pelagonia.
• 1261	Alliance between Genoa and Byzantium (Treaty of Nymphaea). Michael VIII recaptures Constantinople.
• 1274	Council of Lyons reunites the Churches.
• 1303-1305	Catalan mercenaries fail to halt Ottoman Turkish conquest of Asia Minor.
• 1331	Nicaea falls to the Turks.
• 1341-1347	Civil war; victory of John VI Kantakouzenos.
• 1354	Turks occupy Gallipoli.
• 1366	Adrianople becomes capital of the Ottoman state.
• 1371	Battle of the Maritsa.
• 1389	Battle of Kosovo: crushing defeat of Serbs by Turks.
• 1394	Blockade of Constantinople.
• 1399-1402	Manuel II Palaiologos seeks help in Europe.
• 1402	Crushing defeat of Bayazid at Ankara by Tamerlane.
• 1430	Turks capture Thessaloníki.
• 1439	Churches united at the Council of Florence.
• 29 May 1453	Fall of Constantinople to the Turks.
• 1460	Fall of Mistra.
• 1461	Fall of Trebizond.
• 1472	Marriage of Ivan III, Tsar of Muscovy, and Zoe Palaiologa.

LIST OF EMPERORS OF THE EAST

* or XII, if Constantine XI Laskaris (1204) is taken into account.